The Artist's Guide to Public Art: How to Find and Win Commissions

Lynn Basa

ALLWORTH PRESS
NEW YORK

12 11 10 09 08 5 4 3 2 1

Published by Allworth Press
An imprint of Allworth Communications, Inc.
10 East 23rd Street, New York, NY 10010

Cover design by Derek Bacchus
Interior design/composition/typography by SR Desktop Services, Ridge, NY
Cover photo by Justin Lightly/Photographer's Choice RF

Library of Congress Cataloging-in-Publication Data
 Basa, Lynn.
 The artist's guide to public art : how to find and win commissions / Lynn Basa ;
foreword by Mary Jane Jacob with a special section by art lawyer Barbara T. Hoffman.
 p. cm.
 Includes bibliographical references and index.
 ISBN-13: 978-1-58115-501-3 (pbk.)
 ISBN-10: 1-58115-501-8
 1. Public art—Economic aspects—United States. 2. Art commissions—United
States. I. Title.

N8846.U6B37 2008
706.8'8—dc22
 2007042391
Printed in Canada

To Doug
Thanks for everything

Table of Contents

Acknowledgments

Many thanks to: Mary Jane Jacob for being a constant source of inspiration, support, and opportunity. Nicole Potter-Talling, Tad Crawford, Kate Ellison and the Allworth Press team who were my first choice as publisher for my first book. The contributors who lent their time and expertise to write big chunks and chapters that were beyond my scope of knowledge and without which artists would have been left with only part of the big picture. More specifically, the eminent public art attorney Barbara T. Hoffman; Nancy Herring, a financial expert who is an artist with a spreadsheet; Kristin Enzor, an artist turned broker for demystifying the deliberately arcane world of insurance for us; and Daniel Grant, whose books were the role model for this one, for the use of his definitive article on health insurance for artists.

Many public artists and art administrators generously contributed their considerable knowledge. In particular I want to thank the artists who contributed their frank and articulate insights to the "Voice of Experience" chapter. The "brain trust" of artists and professionals who were always there as sounding boards for questions and ideas, and who let me quote them freely throughout the book: Jack Mackie, Larry Kirkland, Guy Kemper, Ken vonRoenn, Marc Pally, Koryn Rolstad, Vicki Scuri, Kurt Kiefer, Porter Arneill, Jill Manton, Lee Modica, Joel Straus, Cath Brunner, Julia Muney Moore, Gail Goldman, Pallas Lombardi, Glenn Weiss, Jack Becker, Cliff Garten, Pam Beyette, Robin Brailsford, Dale Enochs, Aida Mancillas, Mike Mandel, Tad Savinar, Ellen Sollod, Carolyn Law, Clark Wiegman, Norie Sato, Dan Corson, Buster Simpson, Lajos Heder, Mags Harries, Patti Gilford, Sarah Hall, Alice Adams, Dennis Oppenheim, Janet Echelman, Sarah Hutt, Ned Kahn, Sara Schnadt, Benny Shaboy, Willow Fox, Heather Dwyer, Ruri Yampolsky, Peggy Kendellen, Eloise Damrosch, Michael Hale, Jason Salavon, Gabriel Akagawa, Mary Altman, Renee Piechocki, Liesel Fenner, Shirley Howarth, Richard Andrews, Caroyn Danforth, Mel Chin. And to all 120 of the artists who signed the Open Letter to Public Art Administrators, because this book sprouted from that community.

Also, thank you to the art fabrication specialists without which some of our work would not look as good as it does nor would this book be as informative as it is. They are: Saskia Siebrand, Kori Smyth, Jennifer

Hamilton at Mosaika Art & Design, Barbara Derix, Erica Behrens of Franz Mayer, Stephen Miotto, and David Santarossa.

I would especially like to thank my wonderful students at the School of the Art Institute of Chicago for constantly challenging me to think of some aspect of public art that never would have occurred to me, and for letting me use them as guinea pigs as I developed this book.

Finally, to my friends who have helped me so much by sharing their wisdom (and laughs) for this book and over the years: Lezlie Jane, Betsy Eby, Elizabeth Cline, Thomas and Patricia Basa, Scott and Laurie Noegel, John Nagus, Amy Clayton, Susan Bielstein, Kim Pence, John Balfe, Chana Zelig, and Mare Swallow.

Foreword

By Mary Jane Jacob

Art in situ has been around throughout human history, defining locations to such a degree that this art becomes synonymous with places, cultures, and peoples. Even if much of it now only remains as architectural and sculptural fragments in museums or as images in paintings, photographs, and other secondary sources, it is still these artworks and artifacts that tell us who we are.

Our own American tradition of art in public had its vigorous antecedent in the last century as a key part of the social programs in the 1930s, through which emerged some of the greatest American artists of that time. Their creations—murals in schools, post offices, and other government buildings; sculptural projects and photographs; urban park systems and public monuments; and more ephemeral but no less impactful efforts, such as community theater, educational programs, and writing and crafts projects—changed the American social landscape.

An alignment of creative forces brought us to this current chapter in public art when, in the late 1980s, tendencies toward installation, site, and environmental genres, along with theoretical discourses of representation, cultural diversity, and globalism met up with the then twenty-year movement of government-commissioned public art. Public art became hot—a hotbed of artistic activity both intellectually rich and materially experimental, and a volatile field of political and public controversy. Corporate funding and foundation sponsorship kicked in by the nineties to help engender laboratory projects. Foundations then institutionalized these artists' pioneering ways of working, setting standards for the practice of public art as they designed their own program initiatives and revamped guidelines. While the public art field is one, by very definition, outside the world of museums, and in contrast and complement to these storehouses and showplaces of art, museums also got in the act with outreach projects and the capital projects of new or expanded outdoor sculpture gardens.

Yet during these recent decades, another phenomenon occurred as public art exploded on the scene, encapsulating many of the cultural debates of the time: the public joined artists to reaffirm that art mattered. Artworks in our environs enriched our lives and became a part of them, signifying who we are today. Even classic, seemingly tired traditions of public art were renewed, as

cultural politics demanded that form be given to others' stories and tragedies in order to provide solace by memorializing gestures and to join in a continuum of human history that even the avant-garde notions could not sever. Thus, the commissioning of art had a mission and platform from which to operate.

These late-twentieth-century public projects proved to be critical in defining what art is today and to understanding how we engage the world. These works, created by artists in collaboration with fellow artists, architects, tradesman, other professionals, and, yes, sponsors, have made the difference and given us a sense of our culture and that of others, and of how culture and daily life are intrinsically bound.

My own work in the sculpture department at the School of the Art Institute of Chicago reflects this genesis as, in recent years, technical and studio-based directions have erupted into a range of interdisciplinary, environmental, sustainable, and other sculptural and public practices that take students out of the classroom and beyond the city. The School of the Art Institute has also provided a space for creative gestation and a testing ground for Lynn Basa's ideas. Here, she has helped students map out pathways to enter and pursue public art and to negotiate practical terrain through which proposals could be cultivated, resulting in projects that were both well-conceived and feasible. In fact, every artist entering the realm of public art has to acquire new language skills—those of sales, contracts, and fabricators—and must learn to trust that the business of art can complement, rather than override, the aesthetics of art.

The preparation of young artists for public art commissions fits well with other curricular initiatives at the School of the Art Institute of Chicago, all aimed to better equip students for life after art school and enable them to make a life in art. This was catapulted, too, by our work within a national consortium of the Emily Hall Tremaine Foundation. As one of a few select art schools, we look at the fundamental relationship between the study of art and professional practice. We recognize that public art is an important route—one that by its very nature can bring art and life together.

As to which came first—the existence of commission and government funding or the creative directions of art in the public sphere—the history of public art is much like that of the chicken and the egg. In any event, today the opportunities are numerous and no one has to wait to be called. The meaning and purpose of public art is wide and its role evolves as artists take on greater challenges—and many of these challenges come in the form of competitions and commissions that demand creative interpretation and excellent execution. What's more, public art-making can be a path to your own interests and ideas through various artistic practices and related fields.

It can foster personal and professional development as well as widen your scope to a wider, multifaceted artistic practice.

By working in this field and taking advantage of its opportunities with a greater awareness and skill set, you can contribute to the history of public art. The field of public art can, quite literally, be shaped by you—your work might just affect the places in which it is placed and those living there—and this book can help along the way.

Introduction

This book is part how-to and part manifesto. It's written from the perspective of working artists for artists who are serious about making a living as artists. Public art is a viable and growing path for financial self-sufficiency, with room for every kind of artist. But first you have to know how to navigate the system, work efficiently, and—this is where the manifesto comes in—stand up for your worth and your rights.

Even though I've worked my entire adult life as an artist and public art administrator, I will be the first to admit that I don't know everything about public art; therefore, I am extremely fortunate to be a part of a network of successful, smart, generous artists and other professionals who gave freely of their advice and experience because they believe it's time for a book like this.

Ask yourself: would you rather spend your time and energy helping someone else's business thrive, or would you rather invest in yourself? I know lots of artists who will choose the former, for reasons that are valid for their circumstances. They don't want the pressure of having to make money off of their creative process. They feel it would turn their artwork into a product, that they'd be prostituting themselves. Oh, and last but not least, some of you know yourself well enough to say "No thanks" to all the financial insecurity that goes along with being an artist entrepreneur.

That said, I suspect that many more artists aren't trying to make a living from their work because they simply think it can't be done. The "starving artist" brainwashing we get from our culture is intense. The truth of the matter is that many artists *are* making a living—a modest living, but one of freedom that allows us to travel to interesting places and meet all kinds of creative people, while making the kind of work we want.

My definition of public art is broad. For the purposes of this book, it's art that is seen anywhere people aren't planning to have an art experience—obviously, parks, plazas, and public buildings, but also hospitals, hotels, restaurants, and office building lobbies and corridors.

The point is, it's a great, big, wide-open world of opportunities for artists no matter what kind of work you do. To paraphrase Michael Stipe, "making art that doesn't suck is really hard." Fortunately, making a living at it isn't as difficult if you go about it armed with some basic skills, knowledge, and good habits.

I got the idea for this book when I began teaching a class called Public Art Professional Practices at the School of the Art Institute of Chicago in 2006. When I looked around for a textbook to use, there wasn't one. I found many fine books on the history, impact, and theory of public art, as well as numerous case studies of specific projects and the experiences of individual artists. As far as career guidebooks specifically for artists, there were scads on how to get your work in galleries, but none to help artists find their way into the parallel universe of public art.

I had even more practical reasons motivating me. When I quit my day job as a public art administrator in 1999 to take the plunge and support myself solely as an artist, I realized—through my own experience and from what other artists told me—how little consistency there was in the procedural and contractual hoops we were being asked to jump through. I saw seventy-page contracts where it was obvious that the words "General Contractor" had been crossed out and "Artist" written in, and budgets where little or no money had been figured in for the artist's profit. I don't know how many of the people who write those contracts and budgets will read this book, but my hope is that the artists who read it will come away with the knowledge and confidence to negotiate better deals for themselves. I imagine a new era in public art where artists are informed, organized, and brave enough to stand up for our collective rights, including that of earning a living wage.

In order to keep the focus on what you bought this book for in the first place—how to find and win public art commissions—there are some things I didn't cover. I left out an overview of the evolution of public art, as well as an examination of which works of art in public were successful or not (and what "success" even means in this context). I also threw overboard examples of specific pieces, as well as a discussion about collaborative working methods and how artists handle controversy that arises as a result of their work. And though I was dying to, I didn't go into the power relationships that affect the outcome of what kind of art ends up in public spaces and the kinds of compromises artists must negotiate, nor did I discuss where the money comes from and how that affects what gets funded. Fortunately, other writers, many of them practicing artists, have dealt with those topics in depth. I've listed as many of those books as I could find in the bibliography.

I have intentionally avoided discussing the deeper meaning and purpose of art to humankind, its soulfulness, its connection to larger spiritual forces in the universe, or any of the metaphysical, mystical attributes often ascribed to art and art-makers. At times, that omission will make this book seem like it considers art only as a commodity. I know that will be off-putting to people who don't believe art should be sullied by commerce, but this notion of purity—that we're only making art for the love of it or because we're driven by a higher power—is an example of the sorts of stereotypes that keep artists

poor, as if we're in some kind of priesthood and have taken a vow of poverty. I believe that earning enough money as an artist to live without worry affords you the freedom to make artwork that is meaningful to you.

In the spirit of full disclosure, I should tell you that I don't subscribe to the idea that in order for my work to be taken seriously, I have to live like a pauper, suffer, or make art for public spaces that provokes The Establishment or my fellow citizens. While I am a cheerleader for artists who want to bring about social, environmental, and political change through their work, it's not the type of art I do very well—not that I haven't tried. But no matter what the philosophy that drives each of us, I feel nothing but solidarity with other artists, knowing the amount of work and sacrifice we have each invested in our respective callings.

To make a living as a public artist requires a great deal of personal initiative. Fortunately, anyone drawn to a career as an artist usually has an abundance of such motivation. Artists are, by definition, entrepreneurial thinkers. We have unique ideas that we realize with very little outside structure. We have a high tolerance for risk to have chosen a career that isn't considered practical by, nor received with much positive reinforcement from, the mainstream of society. Granted, there are other professions where you can make more money just from the sheer volume of dollars flowing past. But then, you already know that. There's a reason you've chosen to be an artist and not an attorney, real estate developer, or hedge fund manager.

There is more than a *place* for artists in our economy, there is a *need*— and a whole lot of people with money looking for art to buy. Once you realize that, you'll see public art opportunities everywhere. This book will show you where to zero in on those opportunities, how to increase your chances of winning grants and fellowships, and how to successfully complete commissions without losing your shirt. In short, it's the book I wish someone had given me to read when I first started in public art.

Chapter 1:
Public Art Fundamentals

Art is everywhere in our urban landscapes. While some of those murals and sculptures, artist-designed floors, windows, benches, railings, and light and digital installations got there the old-fashioned way—through private patronage—many of them were funded by government "percent-for-art" programs. As of this writing, there are 350 such programs in the country. Together, they spend over $150 million annually to commission artwork.[1] According to the Public Art Network, a nonprofit lobbying organization, the typical agency budget nearly doubled between 1998 and 2001, increasing at an average of 23.5 percent annually.[2] The money comes from federal, state, county, and city governments that set aside between .5 percent and 2 percent[3] of their construction budgets for art. One percent is the most common allowance, but it is inching upward as art becomes a more accepted, and expected, feature of our built environment. By the time this book is published, more programs will have been added and, with those, more opportunities for artists.

The evolution of public art in both selection and conception has been one of increasing inclusiveness, challenging artists not only to respond to the physical characteristics of sites, but to the communities that inhabit them as well. Government selection panels for public art commissions now attempt to include a diversity of voices, instead of being solely that of art experts and patrons. Institutionally sponsored art for public spaces was once an extension of pedestal art, emblematized by large sculptures on plazas and sometimes called plop art. The social intervention, guerrilla art, and community-based practices that grew out of the sixties have begun to infuse the process. There are still plenty of artworks—perhaps most of them—commissioned to adorn already-built spaces or to be "Band-Aids for bad architecture."[4] The difference now is that artists are also being invited (or are inviting themselves) to engage more with the users and planners of these places. The practice of public art includes investigating large sites such as parks, transit lines, and entire neighborhoods in consultation with community members in order to create public art master plans. Public art agencies such as those in Seattle, Portland (Oregon), Minneapolis, and San Francisco have programs specifically designed to partner artists with neighborhoods or city departments in order to understand their inner workings before creating art in response to their observations and interactions.

While treating "the citizens of the city as experts on their own space"[5] does not guarantee success, failure, or anything in between, public art has

become less about impassive monuments to be gazed upon and more about enhancing places and engaging their inhabitants.

"Current practice in public art engages with issues of spatial, social, and environmental concern: artists, with others, are leading in these fields, precisely because they operate independently, free of hierarchies. They are the first to recognize potential and to act in the transformation of space. Artists characteristically lead the way in urban regeneration. At the same time they open new sites of debate—in ecology, music, choreography, geography, or science," according to Vivien Lovell in *Public:Art:Space*.[6]

A new form of public space created by the Internet and mobile media, such as cell phones and PDAs, is being explored by individual artists and collectives. It is no doubt on the verge of being discovered by institutional public art funders as artists begin to propose networked approaches in response to calls-for-artists for traditional bricks-and-mortar projects. Christiane Paul, adjunct curator of new media arts at the Whitney Museum and the author of *Digital Art*, writes, "Internet art, which is accessible from the privacy of one's home, introduces a shift from the site-specific to the global, collapses boundaries between the private and public, and exists in a distributed nonlocal space."[7] The new frontier created by the "networked commons"— publics defined by shared interests and issues, not geographical proximity—is tailor-made for the community-contribution aspect of public art.

Trend Spotting

One of the highlights of the Public Art Network annual conference is the "Public Art Year in Review" slide show. Artists and arts administrators all over the country submit recently completed major projects to be juried by prominent guest curators. In 2007, artist Larry Kirkland was one of the jurors. I asked him if, after reviewing the 242 entries, he could spot any trends.

There were a surprising number of performance or temporary works. My own narrow life looks at permanence over the ephemeral so I was curious to see what these new "public" works were about. I was impressed by a number of them for taking on hot issues or difficult subjects. Their funding, however, was not typically from Percent for Art sources or linked to a specific building, so the range of subject matter might be freer than for a site-specific work funded with public funding.

Light, specifically LEDs, is a medium quickly being embraced by artists. The technology is more accessible—the LEDs are long lived and they change in mood with evolving color or programmable sequences. It has really caught on and is being used in innovative ways. This is significant because the previous decade of art, which utilized fiber optics, created a backlash by conservators and art managers because the technology was

forever breaking down, causing troubles, or not delivering on the promise of illumination. Because the LED technology is so accessible, it was used in some wonderful ways, but also in some rather tedious ones.

Terrazzo floors were also in abundance. Artists from painting or graphic backgrounds have really pushed the idea of floor surface as canvas, with some beautiful results. There were surprisingly few works in traditional media. I don't recall more than one piece from stone, and only a few from cast bronze. Figurative works were rare. It struck me that there is certainly an opportunity because an artist interested in the figure, even the heroic, has an opportunity if they have a vision beyond the hackneyed soft porn nude works that dot the galleries of vacation destinations. Someone who really has a unique vision of the human form, the human condition (Otterness and Botero come to mind), might bring something fresh to the media.

At the same time, there were few purely abstract works that spoke strongly. No Calder or Caro or Snelson that had refined a vision of pure form, space, and color.

The best works showed a balance of the understanding of the design challenges of working in the public arena as well as an artistic vision that pushed the work to art over function or decoration, and showed a mastery of the craft and medium. The standouts are those works that are well designed, handsomely made, and thoughtfully conceived.[8]

WHY DOES THE GOVERNMENT BUY ART?

What motivates politicians with their endemic attitude of "not in my backyard" and "no new taxes" to support legislation that spends the public's money on a lightning rod for controversy like contemporary art? What benefit do they expect from it for their communities, and how does that affect the panel's choice of artist and artwork? These questions are not academic. Just as artists need to understand how their work will relate to the context of a site, they need to understand what motivates their governmental clients to commission art in the first place.

One answer is economics. As manufacturing jobs decline and the U.S. economy depends more on the technology, service, and entertainment industries, urban regions need to make themselves attractive to the sort of people who work in those sectors. And nothing says "Welcome" to a creative, educated, and taxpaying workforce like the outward symbol of civic enlightenment embodied by public art. Of course, the crime rate, weather, affordable housing, quality of schools, and availability of jobs may have more tangible weight in the livability equation. According to some social theorists, it's the ability to attract and retain this "creative class"[9] that gives cities a competitive

edge. Public art is a sign that innovative thinking is encouraged, that diversity is tolerated, and that the city's vital signs are strong. A place that can afford art can surely afford good health care, police protection, schools, and social services. These more quantifiable, economic rationalizations enable politicians to feel comfortable about presenting this agenda to taxpayers.

There's another, more altruistic reason besides economic improvement and image that led to the establishment of public art programs: to bring the art experience out of the museums and galleries and into places where everyone can have free access to it. In the early days of public art, advocates relied mainly on this justification despite its "we know what's best for you" subtext. In a capitalist economy that nominally condemns elitism and believes itself to be classless, that argument can hold water for only so long. As examples of public artworks have accrued over the past thirty years, so has the body of evidence about what they can accomplish aesthetically, socially, economically, and environmentally.

"Governments legally cannot spend the public's money on things that do not bring a measurable return back to the public," says Julia Muney Moore, public art administrator for the new Indianapolis International Airport. "They spend money on education because the return is a citizenry qualified to get jobs. They spend money on public services like trash collection, road salting, animal control, food stamps, all with a direct benefit to the public. But public art isn't like that. The benefit to the public is not measurable except in the aggregate, and even then it is indirect. But if a government can say, 'Hey, we spent half a billion on a new convention center and we will make that up in three years from increased convention tourism and assorted spillover spending in local businesses, so the rest is pure gravy that we can use to salt your roads more often, and by the way, there's some cool art in it that you can stop by and look at any time you like,' it's not only a good way to get public art, it's responsible government. Very, very rarely will you see a government using arguments like 'it helps people understand art better if they see it in their everyday environments.'"[10]

I asked several managers of established public art programs to go beyond what their official mission statements say and speak to their motivations.

One thing I've seen in working on public art advocacy in the region is that typically the incentive to do public art comes from the community. Coming out of the City Beautiful movement, it didn't take long for people to see that city centers need to have beauty—attractiveness apart from basic building infrastructure. It's just an innate aesthetic desire to beautify where we live.[11]

—PORTER ARNEILL, Director/Public Art Administrator,
Kansas City (Missouri) Municipal Art Commission

I used to believe that there was only one reason why governments buy art—to support the cultural life of the community. Now I think it's much more complex. Governments buy art to support the cultural life of a community, to support the regional cultural economy, to support the larger business climate (and the tax base) by making a community's quality of life better; to commemorate people and events, to cover up design mistakes, to mitigate the effects of sterile streetscapes and buildings, to support the missions of government, to decorate, and finally (and most ickily), because they have to (it's been mandated).
　　　　　　　　—KURT KIEFER, Campus Art Administrator,
　　　　　　　　　　　　　University of Washington, Seattle

Really good public art alters our experience in public places, improves our lives, changes our way of being in the world. It is a gift.
　　　　　　　　—PALLAS LOMBARDI, Arts-in-Transit Program Manager
　　　　　　　　　　　Charlotte (North Carolina) Area Transit System

I like to quote a member of the general public who said that public art adds dignity to a place. It creates a lasting cultural legacy and shows the government's commitment to building a quality environment that reflects pride of place. It adds to the city's character, consistent with San Francisco's reputation as one of the nation's cultural capitals. Public art contributes to the quality-of-life issue, making the places distinct and the environment humane. It elevates the importance of artists in society.
　　　　　　　　—JILL MANTON, Public Art Program Director,
　　　　　　　　　　　　　　San Francisco Arts Commission

Here in Florida, where we're all competing for tourism dollars and we want to feel good about our spaces, each community wants to show what is special about their place. Public art helps brand a community. Public art supporters will look down the coast at another city's public art program and say 'look how beautiful their plazas are and look at how popular the artwork is.' It's a bandwagon that's very popular. A community isn't just a collection of houses and businesses. It comes from an urge to make a place special, unique. It's not for the artists; it's for the citizens that the artwork is created.
　　　　　　　　—LEE MODICA, Arts Administrator, Art in State Buildings Program,
　　　　　　　　　　　　　Florida Division of Cultural Affairs

Does the issue of consciously using art to enhance the tax base ever arise in Jill Manton's discussions with San Francisco's public officials? She replies, "While we don't generally speak of this as the motivation or primary objective of our program, perhaps it is an inevitable benefit. Civic improvements generate

a pride of place, which may serve to deter crime and vandalism, which in turn results in improved property values. Maybe there is a cause-and-effect relationship. Our program guidelines don't speak about increasing property values but rather about beautifying the environment, making places more humane, contributing to the quality of life in the city, etc."[12]

These are the voices from mature agencies, in places where public art has been established as a public good. What of areas where they have only recently introduced a public art program? What is motivating their efforts?

In a public/private partnership between the city and corporate donors, El Paso recently hired Richard Florida, author of *The Rise of the Creative Class* and community consultant, to help them attract and retain talented, innovative people. According to Florida, "We've found over and over again that people are the leading economic driver of prosperity. Companies will go where they can tap a quality workforce." He adds, "We know from our research that in order to prosper, cities must support innovation, be open to self-expression, and create great places to work and play."[13] El Paso's civic leaders plan on deploying public art, among other strategies, to make their city more attractive. Their Plan A is to ask Christo and Jeanne-Claude if they are interested in doing something like *The Gates*. If that fails, then they will ask area artists to do large-scale public art works instead.[14]

Baltimore isn't coy about the connection it sees between the arts and civic prosperity. It has created a new quasi-governmental, nonprofit organization called The Baltimore Office of Promotion and the Arts. Among its stated missions are "inspiring and promoting literary, performing and visual arts, and artists" and "forging partnerships that make Baltimore a premiere visitor destination."[15]

San Diego's 2004 public art master plan states, "Research has shown that cities with a robust and lively public art program have sustained economic strength and attracted businesses and individuals who can foster and facilitate prosperity for all citizens."[16]

Joliet, Illinois, is about to install four giant mosaic-covered frog and salamander sculptures around town. A spokesperson for their public art group, referring to the fountain in Park Guell entirely designed by Antoni Gaudí, says that "Barcelona, Spain has a mosaic-covered dragon, and the sculpture has become a key to its tourism marketing." She hopes the salamanders will do the same for Joliet.[17]

An alderman in little Petal, Mississippi, paid for public murals out of his own pocket because on a recent cross-country road trip, he saw that "public art is a key component of any strong vibrant community" and that "the art can also be an economic development tool."[18]

Bentonville, Arkansas, is making its first foray into public art by allowing sculpture from the Walton Arts Center to be placed on city-owned

property. Says Councilwoman Mary Baggett, "We're known as the home of Wal-Mart. That's just clear and simple. I think that for the city to be well-rounded, it will have to have art."[19]

Numerous small towns across the U.S. and Canada are using artists themselves to jump-start their economy by creating arts incubators. Towns such as New Harmony, Indiana, Dover, New Hampshire, East Bay, Rhode Island, Oil City, Pennsylvania, and Cobalt, Ontario, are changing their zoning and offering relocation incentives, such as attractive home loan packages and art marketing support, to lure artists to live and work on their once-thriving Main Streets. Paducah, Kentucky, led the way with an artist relocation program complete with a Web site featuring beautiful old homes available for sale to artists and a full menu of incentives. Since 2000, seventy artists from other parts of the country have taken them up on their offer.[20]

Millennium Park

The spectacular recent success of Chicago's Millennium Park[21] is Exhibit A in making the case for public art as an economic asset. Completed in 2005, this extravaganza of interactive sculptures, artist-designed gardens, free performance spaces, restaurants (not to mention an ice skating rink and a building that generates its own electricity) has raised the bar for what can be accomplished with public art. Anchored by Jaume Plensa's *Crown Fountain*, Anish Kapoor's *Cloud Gate*, Frank Gehry's *Pritzker Music Pavilion* and *BP Pedestrian Bridge*, and the art and design team GGN's *Lurie Garden*, it already receives three million visitors annually.[22]

Its success manifests itself most tangibly when one sees the delight, and even wonder, on the faces of the throngs of people who constantly fill the park, interacting with the artworks. People of all ages, races, classes, and nationalities mingle in this public art melting pot.

And it's put wonder and delight in the eyes of local politicians, business owners, and developers. According to a 2005 study,[23] the economic impact directly attributable to the "Millennium Park Effect" is projected to come over the next ten years and will include:

- An adjacent real estate market, $1.4 billion
- Hotel, restaurant, and retail revenues combined, $1.63—$2.16 billion[24]

In one way, it's misleading to use Millennium Park as an example of public art because none of the "enhancements" (i.e., the artworks) were funded through the percent-for-art model mentioned earlier in the chapter, nor did their selection involve public process in the usual way. The art was

built on public property, but it was funded by private donors. Private art committees selected the artists from a short invitational list. The city's public art committee was offered the courtesy of a review without having an official vote.[25] The artists were given enough money and freedom to do their best work. It defies the prevailing belief in the selection of public art that there needs to be involvement by the community in order to create a place where public art fosters "democratic interaction."[26] Is there a lesson in there somewhere for how public art should be delivered in the future, or was it a fluke of right time, right place, right mayor, and right economy? We'll find out as other cities try to emulate Chicago's success.

PUBLIC ART TRAINING

Dozens of art schools are beginning to include courses on public art practice as part of their studio programs, with a few even offering degrees. However, there's really no such thing as public art as a separate practice. The majority of us entered the field through the portal of our studios as painters; sculptors; ceramists; muralists; fiber, multimedia and street, performance, or installation artists; with a smattering coming out of architecture and other design professions. Many of us have studied art formally and view making art for public spaces as an expanded part of who we are and what we do as artists.

While there are still many examples of art in the public realm that were achieved without much collaborative input, the one thing many of us practicing in this field do have in common is the ability to subject our ideas and egos to a process involving disparate opinions, agendas, and art expertise outside the protective shell of the studio. It's not for everyone. The sheer volume of human contact (and paperwork) required to take a public piece from start to finish can be overwhelming to the type of personality that was led in the first place to an art form generally practiced in solitude. And there are different ways to approach public art. Some artists are simply doing a variation of their studio work on a grander scale, while others reinvent themselves for every project. Jack Becker, artistic director of the *Public Art Review*, writes, "I tend to divide artists like doctors: There are specialists and general practitioners. Specialists are typically product makers, focusing on one thing and doing it expertly. GPs are into process and working laterally across many disciplines."[27] Fortunately, there are plenty of opportunities to fit most approaches.

In the gross generalization department, I've attempted to point out the differences between studio art and public art. I'm sure that some of you will have fun thinking of exceptions within each of my categories, but in the meantime, please humor me.

Studio art	Public art
• Your work consists of whatever your imagination can contrive.	• You respond to parameters set by client.
• You develop concepts in isolation.	• Concepts evolve through idea exchange with people invested in the project.
• You are responsible only to yourself.	• You are responsible to others.[28]
• Discrete objects.	• Site-specific and-integrated installations.
• Existing work purchased.	• New work commissioned.
• You likely make the work yourself.	• You often subcontract with fabricators.
• Business is conducted between you and your gallerist, art consultant, or collector.	• The project manager is your main contact to a much larger bureaucracy.
• You get paid a commission when the work sells.	• You get paid in stages throughout the production process.
• You submit your portfolio for review.	• You respond to a call-for-artists competition.
• Consignment agreement. There's an opening.	• Commission contract. There's a dedication or celebration ceremony.
• Work is viewed by few who are predisposed to look at art.	• Work is viewed by many who may not have a particular interest in art.

In the next chapter you'll learn how to find competitions to enter and get some solid tips on creating a bridge from your studio practice to making art for the public realm.

End Notes

[1] Jack Becker. "Public Art: An Essential Component of Creating Communities." A monograph for *Americans for the Arts Public Art Network* (March 2004): p. 2.

[2] Becker, p. 4.

[3] According to the *Public Art Program Guide 2005–2006*, seventeen cities have 2 percent or greater public art allocations. (Americans for the Arts, Washington, D.C., pp. 216–217).

[4] From a conversation with Richard Andrews sometime in the 1980s. With permission.

[5] Tom Finkelpearl. *Dialogues in Public Art*, Cambridge, MA: MIT Press, 2000, p. 45.

[6] Vivien Lovell and Sara Roberts, eds. "Foreword." *Public:Art:Space: A Decade of Public Art Commissions Agency, 1987–1997*, London: Merrell Holberton, 1998, p. 11.

[7] Christiane Paul. "Digital Art/Public Art: Governance and Agency in the Networked Commons." *First Monday*. Via the author, *http://firstmonday.org/issues/special11_9/paul/index.html*, accessed January 31, 2007, p. 6.

[8] Larry Kirkland, via e-mail, June 9, 2007.

[9] Term coined by Richard Florida, *The Rise of the Creative Class: And How It's Transforming Work, Leisure, Community and Everyday Life*. New York: Basic Books, 2002.

[10] Julia Muney Moore, public art administrator, Blackburn Architects, Inc., in an e-mail, January 29, 2007.

[11] In an interview with Porter Arneill, February 2, 2007.

[12] Jill Manton interview, January 22, 2007.

[13] Vic Kolenc. "El Paso tries new route to economic growth." *El Paso Times*. January 28, 2007.

[14] Ibid.

[15] Baltimore Office of Promotion and the Arts, "About Us", *www.bop.org*, accessed January 22, 2007.

[16] Jerry Allen and Associates. "Public Art Master Plan: The Vision and Benefits to San Diego." March 2004. *www.sandiego.gov/arts-culture/pdf/pampmarch2004.pdf*.

[17] Joe Hosey. "A Leap of Art: From the President to Giant Frogs, It's in the Plans to Adorn Joliet." *The Herald News*, March 17, 2007.

[18] Nancy Kaffer. "Petal Murals Find Criticism." *Hattiesburg American*, *www.hattiesburgamerican.com*, accessed January 27, 2007.

[19] Richard Dean Prudenti. "Bentonville Adopts Art Policy." *The Morning News* (Bentonville, Arkansas). *www.nwaonline.net/articles/2007/02/14/news/021407bzvcillecouncil.prt*, accessed February 14, 2007.

[20] Paducah Arts, *www.paducaharts.com*, accessed February 11, 2007.

[21] Edward K. Uhlir, *The Millennium Park Effect: Creating a Cultural Venue with an Economic Impact*, *Economic Development Journal*, vol. 4, no. 2 (Spring 2005). *International Economic Development Council*. *www.americansforthearts.org/NAPD/files/11989/Millennium.pdf*.

[22] Karen Ryan, communications manager, Millennium Park interview (September 6, 2006).

[23] Uhlir, p. 22.

[24] Uhlir, p. 21.

[25] Ed Uhlir, via e-mail, April 8, 2007.

[26] Finkelpearl, p. 45.

[27] Jack Becker. "Public Art's Cultural Evolution." *Community Arts Network: Reading Room*, *www.communityarts.net/readingroom/archivefiles/2002/02/public_arts_cul.php*.

[28] Mary Jane Jacob, from a comment made in a seminar at The School of the Art Institute of Chicago, October 12, 2006.

Chapter 2:

Start Here: Where to Find Public Art Competitions

Remember those 350-and-counting public art agencies I mentioned in chapter 1? Each of them must be contacted separately in order to respond to their commission opportunities. There is no centralized database, unified form, or standard procedure that they all share. While there are lists you can sign up for that will notify you about upcoming competitions, you'll still need to submit an individual application to each competition.

In any given month, there are at least thirty "calls-for-artists" that will come across your desk once you sign up for a couple of these announcement lists. Your work will not be appropriate or you will not be eligible for many of the competitions, but that's okay. As we'll discuss later, it's as important to know when not to apply as it is to know when to go for it.

To answer your unspoken question—yes, those thirty monthly calls are not only going across your desk, they're going across the desks of at least 2,500 other artists. They're mainly from the more established agencies run by savvy arts administrators who know how to reach a lot of artists. Here are some reasons why you shouldn't be discouraged by these numbers:

1. The majority of those artists will decide not to apply because:

 - They're not inspired by the project description
 - Their work doesn't fit the project
 - They're too busy with other projects
 - The budget isn't large enough to make it worthwhile
 - They think that so many other artists will apply that they shouldn't bother
 - They can't deal with the paperwork and people-work

I recently applied to two national calls. One of them received twenty applications, the other forty-four. And they were good ones, too, with budgets over $150K. (Reader, I won one.)

2. Of those who do apply, most won't make the first cut either because their work isn't right for the project or their application will be substandard in some way. Things like submitting incomplete information or lousy images, missing the deadline, or otherwise not following instructions will disqualify them. As one arts administrator told me, it's the bottom two thirds that's crowded.

3. Public art agencies want and need to find artists they haven't worked with before. A recurring topic among arts administrators is how to cultivate

artists who are new to the field. They not only want to commission new work, but they cannot justify giving jobs to the same artists over and over again. It makes their job easier if you find them first. Don't think of yourself as a supplicant asking for favors. You have something they want. If you get rejected, see if you can find out why and try again for another competition at the same agency because there will be a whole new selection committee for each project.

4. According to the most recent survey, there are nearly 4900 active public art projects each year in the United States.[1] You can do the math and see that the thirty calls you see every month don't add up to anywhere near that. That means that for each call that goes out to the multitudes, there are dozens more floating around under the radar—and that doesn't even count all of the commissions generated by the private sector. If you go off the beaten path to make your own opportunities, this will narrow your competition considerably because relatively few artists will take that extra step. As you'll see in chapter 12, there are many ways to be your own "rain-maker." You'll be able to find new markets for your work because creative problem solving and looking at situations with fresh eyes are what artists are good at.

5. There's a certain amount of attrition among the older, experienced artists, which means the competition may not be as stiff as you think. Not because they give up and have to get a straight job, but because they don't have to work as hard at chasing down work. They've built up a network of repeat or word-of-mouth clients and they're able to charge more and focus on fewer projects. Some will have transitioned into doing master planning or teaching. They may not feel the hot breath of the wolf at the door because they've married, saved, and/or inherited enough money to live in modest comfort for the rest of their lives while only pursuing the work that interests them.

How Public Art Agencies Find Artists

Here are the main ways public art agencies find artists.

Slide Registries

Some agencies maintain a list of prequalified artists from which they draw as commission opportunities arise. There are two kinds of lists:

1. Prequalified: You must compete to get chosen for the juried, pre-qualified artist pool. For example, the San Francisco Arts Commission did a call for their registry in 2006 and received 700 applications, from which they chose 150 artists to be considered for upcoming competitions.

2. Open: You simply submit your work by following the agency's application instructions, and you're automatically accepted into its slide registry.

It is important to get included in as many slide registries as possible because for agencies that mainly choose artists from their pool, if you're not in there, you're not eligible. Even well-established artists have to submit their work to the registry in order to be considered.

Open Calls

These are announcements that go out regionally, nationally, or internationally looking for artists for specific projects. These projects could be anything from a mural for a library to a public art master plan for a transit line, paying anywhere from $10,000 to $2 million. Open calls are issued to apply for slide registries, too.

Invitational

Individual artists are invited to apply because certain attributes found in their past work, medium, ethnicity, or relationship to the community are sought for a specific project. Often, these artists are chosen from the pre-qualified artist slide registry. Artists who have a track record of interesting projects, have been written about in magazines, were included in the Public Art Network's annual conference "Year in Review" slide show,[2] or have kept the agency updated about their work have a better chance of being on the radar of the project managers who compile the list of invitees.

Direct Purchase

Sometimes agencies will issue a call for existing work to add to their collection. Even though this may seem like the simplest route for an agency to take because there's no guesswork about what the finished artwork will look like and no long time delay to receive it, there are relatively few calls for completed work. As we'll discuss in chapter 10, however, it's a different story on the private sector side, where art advisors buy volumes of prints, paintings, photographs, and sculptures for the hallways and offices of their corporate, health care, and hospitality clients.

RFQs and RFPs

Calls for artists most often come in the form of a Request for Qualifications (RFQ) or Request for Proposals (RFP). An RFQ simply asks you to submit evidence of your qualifications based on past work. From there, a handful of finalists are invited and paid (usually between $500 and $3,000) to create proposals after having the opportunity to research the site. Some agencies only ask

to interview each finalist before choosing one to create a final, detailed proposal. Many artists prefer the interview method; first, because it saves the time and expense of putting together a proposal for a competition that they have a 66 to 80 percent chance of losing (if there are three to five finalists) and second, because once they're chosen, if it's early enough in the project, they can get the access they need to the team and the community to research the site in depth.

The RFP is more burdensome. It asks you to submit an idea in the form of a drawing, a concept narrative, and, sometimes, even a preliminary budget *at the open call stage*, not after having been chosen as a finalist. The problem with this is that an RFP asks artists to come up with an idea that has relevance to a specific site that they may not have had a chance to see, let alone get a feeling for the sort of work that would be meaningful for that place. As Lucy Lippard writes, "Because place-specific (as opposed to drive-by) art begins with looking around, the artist needs to understand far more about a place than what it looks like or the tales told by the local chamber of commerce."[3] Artists who have a chance to understand each location more fully would see the opportunities it presents through different lenses. That unique perspective is the principal benefit of hiring artists, which is, unfortunately, diluted when the RFP process is employed.

The creative concept is the value artists bring to the table for each project. When every artist responding to an RFP is asked to submit a concept, we are, in essence, being asked to work for free. And if the artist is asked to develop a budget without seeing a sample of the agency's contract—no matter how "preliminary" the agency says it will be—it is particularly problematic because of all the unanticipated expenses it could contain. Furthermore, the agency is shortchanging its constituents by not giving artists a chance to fully understand the site before proposing an idea.

The RFP approach was patterned after those of architectural competitions. It's one of those things that probably made sense at the time when public art was a new field and needed a process model to latch onto. The problem is that public art project budgets are in the tens or hundreds of thousands of dollars—not millions, as for building design—and we do not get paid for construction administration as architects often do. Artist Mike Mandel spoke for many of us when he wrote to the Public Art Network list-serv: "Do not compare artist and architect. Do not compare a $100,000 public art commission with a $100 million architectural commission. The architect has resources by the sheer scale of their financial support that puts them in a completely different sphere."[4] Most artists don't have a staff or several large projects going on at once across which to spread the risk of potentially wasting our time and talent. When you think of dozens or hundreds of artists each spending many hours responding to an RFP, that is a huge expenditure of manpower relative to each artist's chances of winning.

It's not a great system for architects, either. In fact, architects very rarely respond to an RFP with an actual design proposal. Instead, they create a fee proposal based on the scope and scale of the prospective project. If they make the cut, the next stage is an interview. There, they present thoroughly researched case studies to show their experience with similar projects in the past and how the firm would manage this prospective one. While the average fee awarded to them to develop a finalist proposal is typically $25,000, it is not unusual for a firm to spend over $100,000 and several months of staff time fully researching the site, creating models, PowerPoint presentations, color renderings, and so forth because that's what their competition will spend. Again, however, the potential payout if they win is worth that degree of effort.

There is an upside to RFPs that I should mention despite the fact that I would like them to go away: they're a good avenue for artists new to public art to get a foot in the door. If you don't have a portfolio strong on completed public artworks, it's possible to win over a selection committee on the strength of your vision for a particular project as long as you can also convince them of your ability to follow through with it. Additionally, RFPs are usually issued by smaller, less established agencies that aren't as concerned with getting a big-name artist as they are in minimizing their upfront risk by commissioning work their public can live with and that they can afford. You won't have as much competition, either. Experienced artists are less likely to apply because smaller agencies mean smaller project budgets, and they don't have the time to come up with an idea on speculation.

Perhaps if agencies were more intentional about the fact that they are asking artists to work for free, and they understood that they weren't going to get a truly site-specific artwork or as many artists applying as they would if they issued an RFQ, then some improvements to the process could be made. As it stands, most RFPs seem to be issued by agencies that just want to go shopping at artists' expense. The opening salvo to bring about change was launched on June 2007 in the form of "An Open Letter to Public Art Administrators," published in the *Public Art Review* signed by 120 artists and sympathetic public art managers. And change is already in the air; 4Culture, one of the most respected public art agencies in the country, has stopped accepting RFPs for its monthly and bimonthly opportunities announcement list.

WHERE TO LOOK

You'll see many of the same calls-for-artists overlapping on these lists, but it's worth keeping tabs on each of them anyway. I've listed them, starting with the ones most dedicated to public art and ending with those that have other visual arts opportunities mixed in.

(Due to the Internet being the fluid source of information that it is, some of these links may no longer work by the time you are reading this. Should that be the case, try searching for the name of the organization listed to find an updated link, or check the Web site associated with this book.)

1. 4Culture—The Public Art Calls List *(www.4culture.org/publicart/calls/default.asp)*

4Culture and Milestones (below) provide the two main lists where larger agencies submit their announcements when they're seeking artists. 4Culture sends out an average of forty to fifty public art competition opportunities to nearly 3,000 subscribers every four to six weeks.[5] According to their list-master, Willow Fox, in addition to receiving artist posts from agencies that contact her, she combs a dozen other Web sites to find calls-for-artists for 4Culture's mailings. In other words, she's doing some of the legwork for you. To subscribe, fill out the online form.

2. Phoenix Arts Commission Public Art Program—Milestones Mailing List *(http://phoenix.gov/MAILLIST/MILESTONE/subscrbe.html)*

Phoenix sends out a notice every couple of weeks reminding subscribers on their mailing list to check their site whenever there are new announcements for public art commissions and other opportunities. They found that they were getting so many competition announcements—as many as thirty at once—that to send out a full list each time was clogging in-boxes. There are currently 1,900 subscribers who receive their reminder e-mails. To subscribe, go to the URL above and submit your e-mail address on the form.[6]

3. Western States Arts Federation—CAFÉ *(www.callforentry.org/)*

This is WESTAF's valiant attempt to create the Holy Grail of a centralized, standardized public artist application system. For no fee, artists can upload up to one hundred digital images of their work to be stored in their secure server. At the other end, public art agencies post their competition announcements for artists to respond to using the format and online forms provided on CAFÉ. Sometimes, the agency that issued the call will send out an announcement to its mailing list otherwise, you have to remember to go back to CAFÉ and check.

If every agency used CAFÉ, artists would no longer have to spend hours formatting their digital images in a different configuration for every call or have to worry about getting slides made. It could all be done in one place online. So far, only a handful of agencies are using it, perhaps because it involves new technology and can cost an agency anywhere from a few hundred to a few thousand dollars in setup fees to post their announcements.

They're just starting out, though, and constantly improving their services as user feedback comes in.

4. UrbanArts Institute at Massachusetts College of Art (UrbanArts) *(www. urbanartsinstitute.org)*

Based in Boston, UrbanArts sends out weekly announcements of national public art opportunities to the 2,500+ artists who have submitted their work to the artist registry. I've included instructions later in this chapter on how to get listed in their registry.

5. *Public Art Review (www.publicartreview.org)*

The trade journal of our profession, it is one of the magazines most read by those in public art. Essays by public artists and administrators fill each issue. It's a good place to find current calls-for-artists, recently completed projects, and fabricators. It's not available online. A hard copy subscription costs $24 for two-issues per year.

6. *Sculpture* Magazine *(www.sculpture.org)*

In the glossy art magazine vein, *Sculpture* is one of two publications (the other is the *Public Art Review*) that public art managers routinely read and advertise calls in. You can buy it on about 1,000 newsstands around the country, but if you join its parent organization, the International Sculpture Center, you get access to public art listings on its Web site. Recently it had forty one day. Some were the same ones that I'd seen in other sources, but some were farther afield than what you might find on some of the other lists I've mentioned. The quality of their listings is consistently high without being cluttered by those for fellowships or gallery exhibitions. It's also a good source for finding fabricators of all kinds of materials who want to work with artists. Or, you could just read it for the articles, which often include features on artists who work in public spaces in mediums ranging from the traditional to high tech. The basic membership starts at $100 for the U.S., Canada, and Mexico, with a discounted membership rate of $65 for students, seniors, and young professionals who have been out of school for three years or less.[7]

7. Public Art Network listserv *(www.artsusa.org/services/public_ art_ network)*

I strongly recommend that you join the Public Art Network. A subset of the mammoth Americans for the Arts, it is public art's only professional organization in the U.S. It costs $50 a year for "base membership" ($25 for students). Membership allows you to join the listserv, provides discounts on books from its excellent online bookstore, and gives you access to the annual year-in-review image bank of notable recent public art projects. The listserv provides sedate, sporadic posts from public art program managers asking each other

technical and administrative questions. This backstage glimpse into their concerns is informative enough to justify the membership cost, but the real payoff is being able to find out when new calls for artists are going out. You'll often hear about them ahead of when they show up on the compiled lists from 4Culture and Milestones.

The vast majority of its 600 plus members are public art administrators. Relatively few artists belong, but most of those are serious, full-time professionals. I like being a member because I learn a lot from the arts administrators, whom I would otherwise only know from their names on competition announcements. It's only fair to warn you, however, that not all artists share this opinion. (They see PAN and its emphasis on issues that mainly concern arts managers, as not being relevant to them. Artists and administrators are working together to change that, but whether we'll succeed in getting more time on the agenda for artists' issues, or even in agreeing on what "artists' issues" are will depend on more artists joining.)

8. Public Art Online *(www.publicartonline.org.uk)*

This is the leading free Web site for public art in England. Published by Public Art Southwest, a development agency funded by the Arts Council of England, it contains how-to advice for artists on collaboration, managing projects, as well as a hefty list of current commission opportunities in the United Kingdom. To find those from their home page, go to News > Notices > Commissions.

9. A-N, The Artists Information Company *(www.a-n.co.uk)*

Also based in England, this site is so loaded with leads and useful business tips that it was hard to know which section of this chapter to put it in. Maybe that's because it's a small operation run almost entirely by artists who know what we want to know. The list of public art competitions is easily searchable and doesn't seem to overlap too much with those on Public Art Online. Besides opportunities in the U.K., they list those in Europe and the U.S. Some of the content is free, and the organization has different subscription packages. For $10, you can get a one-month trial subscription. The next level up is an artist subscription for $60 a year. The trial version is worth it to give you access to the articles in their knowledge bank on topics such as making a living, promotion strategies, and practical guides on contracts and figuring out what to charge for your work.

10. Art Opportunities Monthly *(www.artopportunitiesmonthly.com)*

For $20 a year, you'll get a monthly list via e-mail of every kind of art competition for artists. It's a bare-bones publication that is edited by one guy, Benny Shaboy. Nonetheless, I frequently find interesting, small public art competitions that weren't on the other major announcement lists. It also has

listings for grants, scholarships, artist residencies, "or other opportunities and venues normally outside the commercial gallery system." Shaboy extends a special offer to readers of this book to get a free sample issue by e-mailing him at *sample@ artopportunitiesmonthly.com*.

11. artDEADLINE.com *(http://artdeadline.com/)*

In existence since 1994, artDEADLINE.com publishes nearly 2,000 "income and exhibition opportunities for artists" each month. For $14, you can get a trial Internet version for twenty days or, for $24, a full annual Internet subscription. It's also available on paper or through e-mail. While the site has a section dedicated to public art, you have to pick through a lot of other stuff, like galleries looking for art to consign— not that that's a bad thing for some of us. One feature especially worth checking out once you become a subscriber is the "Registries" section under "Percent and Public Art RFQ/RFPs". When I looked recently, I found twenty-three state and local artist registries listed, without any extraneous entries. The site functions well, too, in that once you click on a particular agency's name, it gives you the option to go directly to that agency's registry form, as opposed to merely sending you to the agency's Web site for you to figure it out on your own.

12. ArtsOpportunities *(www.artsopportunities.org)*

An initiative of the Southern Arts Federation, it's a free, online bulletin board of opportunities for artists. Organizations looking for artists apparently get to decide where they want their announcement to appear, because when you search for "public art," you get a grab bag of competitions for artist residencies and gallery exhibits, in addition to those for public art. It has a good searchable database, though, and often lists public art opportunities not found on other announcement lists. The organization won't send you an update whenever there's a new listing, so you have to remember to keep going back to check the site.

13. The Art List *(www.theartlist.com/)*

For $15 per year, you can get an online subscription to "the leading newsletter of American art competitions." At any given time, there are several hundred listings, with 100 to 200 added each month and updated every day. You can zero in on public art competitions using their efficient searchable database. They don't have that many public art competitions, however, and most of those will be repeats of what you'll see if you're already signed up for the announcement lists mentioned earlier. The reason I'm including it is that since most of us have diversified our practices in order to make a living, it's a good place to find many different kinds of visual art competitions.

14. Internet search

One of my students, Cara Thayer, discovered a way to find obscure calls for artists by entering a search string like this "public art" + "RFQ" (or "RFP") + <current year>. She found that if you specify the current year you won't get a lot of calls with expired deadlines. You can also add the name of a state or city to pinpoint your search.

Lists of Individual Public Art Agencies

As you'll soon discover, if you are diligent in keeping up with every source listed above, you'll see a lot of overlap in the competition announcements. This is where you need to break off from the herd and start cultivating your own list of opportunities by contacting agencies one-by-one. Fortunately, there are a couple of places where you can find lists of the contact information for enough agencies to get you started.

1. Americans for the Arts Field Directory *(http://ww2.americansforthearts.org/vango/custom/directory.aspx)*

By entering "public art" in the program areas drop-down menu, you'll hit a jackpot listing of 500 public art agencies. The downside is that the only way I know to find announcement lists and artist registries is by going to each agency's Web site and, if you're lucky, they will make it easy and obvious for you to sign up. Increasingly, individual public art agencies are getting wise to posting their announcements through Milestones, 4Culture, and CAFÉ, but by signing up directly with the agency, you'll get calls sooner.

Unfortunately, much of the time, you'll encounter a public art agency's site that will say words to the effect of "no opportunities at this time, please check back later." Personally, I find it is not realistic to remember and find time to do that. Some agencies with more technologically advanced Web sites will let you set up a news feed, to be automatically notified when they have added new information.[8] If you're more industrious than I am, you could contact the program manager to find out when the next call will be so you can note when to go back. It's like checking your traplines or hunting down finds in thrift stores—you have to go back regularly to be rewarded.

2. *Public art by the Book,* by Barbara Goldstein ed.[9]

While not containing all of the program and contact details found in the *Public Art Program Directory*, the index at the end of this guide for public art program managers lists all the agencies by state, with addresses and URLs. You can purchase it in bookstores or from the Public Art Network's online bookstore, or find the same information on the PAN Web site in the *Public Art Program Directory*.

Artist Registries

The flip side to chasing down calls yourself is geting your work listed on some good artists registries—with an emphasis on "good." There are jillions of places for artists to list their work on the Web—mostly for two-dimensional portable works and crafts. Many of them just take your money and that's it. (I found one that charges artists over $200 to upload their images, and then gives *you* tips on how to promote *their* site without doing any promotion itself!) But there are a few sites where you won't be a needle in a haystack, and which public art administrators and consultants actually check. In case you're thinking that getting listed on a couple of registries is a substitute for the hard work of contacting individual agencies, it's the difference between passively waiting for them to find you and being proactive about promoting your work. If you're serious about making a living with public art, you need to do both pretty much constantly.

1. ArtistsRegister.com *(www.artistsregister.com)*

The Artists Register is another well-run WESTAF production. It's an online searchable database of visual art that costs between $30 and $100 to post up to twelve images. What sets it apart from the many other online artist registries is that it is selectively juried and actively promoted in art magazines and to arts professionals who actually seem to be using it. What's more, your page will be assigned a unique URL that you can use on your business cards or letterhead. As with any online slide registry, you'll be able to tell whether you want to be part of it by looking at the caliber of the other work on the site. I think you'll be pleasantly surprised.

2. CAFÉ *(www.callforentry.org)*

As mentioned earlier in this chapter, CAFÉ not only lists competitions—it's a place where you can submit images of your work. If you don't take the time to submit your work to any other registries, submit to this one. It's still in the early stages of development, but more and more agencies are using it to find artists. CAFÉ's free online registration process makes it easy to register and post your resume and up to one hundred of your images, including descriptions. The Web site provides clear instructions on how to format and upload your information.

3. UrbanArts Institute at Massachusetts College of Art *(www. urbanartsinstitute.org)*

In addition to the regular announcements it sends out about calls-for-artists, UrbanArts maintains an open registry that currently features the work of over 2,500 artists. The site does it right by actively marketing to curators, corporate art consultants, galleries, architects, landscape architects, and public art agencies. There is no fee to submit your work, but

there is no online registration process yet. You'll need to print out the form and mail it in with your slides. It's worth the effort, though, because once you're registered, you'll receive weekly e-mails from the listserv of public art opportunities, in addition to the benefit of the site's outreach efforts.

4. Individual agency artist registries

As I mentioned earlier, many of the hundreds of public art agencies have their own registries and processes. You need to dig into the lists of individual public agencies and contact each one to find out for yourself how to apply. Fortunately, the North Carolina Arts Council has put together a list that has enough registries on it to get you started, along with some that are specific to media and interest area. Go to the agency's Web site at *www.ncarts.org*, then navigate to Grants and Resources > Resources for Artists > Public Art > Artist Slide Registries.

Finally, there's a helpful article on NYFA Interactive (*www.nyfa.org*), in the "Business of Art" section called *The Skinny on Slide Registries* that's full of good questions for artists asking to find out which ones are worth submitting to. Go to the "For Artists" tab, to "Business of Art Articles," and to "Marketing," and look for it in the list of articles.

Other Useful Sources

While these sites don't focus specifically on competition opportunities, they contain a wealth of information for other funding sources and services to support an artist's practice.

1. Chicago Artists Resource *(www.chicagoartistsresource.org)*

A comprehensive artists' professional development Web site, CAR offers a universe of information artists need for their visual and performing art practices. Some of the content is Chicago-centric, but the vast majority of information it contains is useful to artists everywhere. National public art opportunities also include those found on 4Culture and Milestones, but it's the other resources throughout the site that make CAR especially useful, such as a searchable database of calls-for-artists; articles and artists' firsthand accounts about everything from setting up a nontoxic studio to grant writing; directories of suppliers, services, space, and facilities; a manual for acquiring space as an artist; community posting areas; many links to information about supporting a thriving art career curated by practicing artists; and a browser interface for the NYFA Source database (more information on this organization below), developed in partnership with that organization.

To find public art listings on CAR, follow this path: Practice > Public + Community Art > Programs/Opportunities.

2. New York Foundation for the Arts, NYFA Source *(www.nyfasource. org)*

The description on the Web site describes the free service thusly: "NYFA Source is the most extensive national directory of awards, services, and publications for artists. Listings include over 4,200 arts organizations, 2,900 award programs, 4,200 service programs, and 900 publications for individual artists across the country. More programs are added every day."[10]

3. Community Arts Network *(www.communityarts.net)*

By going to the home page and clicking on "public art" under the heading "Disciplines," you'll enter an extensive world of up-to-date links to national and international public art news, events, organizations, and individual artists that goes beyond the built environment to ecoart, interventionist art, socially based work, and much more.

4. Ixia *(www.ixia-info.com)*

Out of England, Ixia describes itself as a "think tank for public practice." Its site contains case studies, research on the economic and social impact of public art, and contact information for each of the Arts Council of England's regional offices.

5. The Artist Help Network *(www.artisthelpnetwork.com)*

If you look under "Exhibitions, Commissions, and Sales" for "Public Art," you'll come across a long list of publications and organizations that could provide leads to information and opportunities such as *Competitions* Magazine *(www.competitions.org)*, the NEA-funded Art and Community Landscapes Program, Creative Time *(http://www.creativetime.org/index.php)*, and many others.

6. art-public.com *(www.art-public.com)*

This is a portal to an extensive online library of public artworks, with over 8000 images on file. Its focus is Europe but it includes other countries around the world. The annual membership to access the collection is $245.

7. Google Alerts *(www.google.com/alerts)*

You can set up a virtual press clipping service just for public art. Go to Google's main page, click on "More" to get to the second layer on their site, then click on "Alerts" to type in the topic of your choice in the topic box. If you enter "public art" and choose "news" you'll get newspaper articles from anywhere in the English-speaking world that mention the phrase "public art." It won't give you direct notification for competitions, but it gives you the next

best thing: Early warnings for when a public or private organization announces the release of a chunk of money for commissioning art. For example, just now literally, as I was writing this I got a Google Alert for the *Arizona Daily Star* in Tucson, with a link to a story that read: "Public art is about to get a huge boost as several retail centers open up. The town requires all development to include artwork equal to 1 percent of its construction costs. The Oro Valley Marketplace at West Tangerine and North Oracle roads, for example, will provide $760,000 in public art" The alert even listed the contact information for the person running the project. When you come across a potential new source of public art funds, track down the agency that will be in charge of the call-for-artists (it may take a few phone calls and e-mails to get to the right one), find out when it will be issuing the call and if it will be regional or national, then ask how you can be notified. If you do this via e-mail, as always, be sure that your contact information (name, address, phone number, Web site, and e-mail address) is in your signature line.

PERSISTENCE PAYS

The thing that's going to keep you from winning commissions isn't going to be your artwork—assuming it's reasonably competent, original, and appropriate for public settings—it will be your stamina for sticking with the application process.

If it seems like a daunting amount of effort, take heart. As in any sales endeavor—because sales is what this comes down to—you'll only have to make cold calls for so long. The name of the game is to get some finished projects in your portfolio. Whether they're in Mongolia or Manhattan, temporary or permanent, private or public, paid or pro bono, it doesn't matter. Once you get a track record that shows you can complete projects on time and on budget and compile three solid references from happy clients, you'll no longer be an anonymous part of the herd in these cattle calls. You'll gradually receive more and more invitations from agencies asking you to apply, and from art consultants, interior designers, architects, engineers, and developers who saw your public work and want to commission you for private projects. All the while, your confidence and experience will be growing, and that will come across to potential clients. This isn't just happy talk to sell books. This is how it works. In chapter 12, I'll go into more detail about how to accelerate this cycle.

If you expect any of the galleries that represent you to do this work for you, forget about it. You already know more about public art than most dealers simply by having read this far. Besides, wouldn't you rather have them concentrating on selling your discrete works to private collectors than tying up their time sending out applications for you? And wouldn't you

rather have the entire commission fee rather than split it with the gallery, when you're the one who will be doing all of the heavy lifting of creating the artwork, keeping up with the paperwork, dealing with fabricators, and attending meetings? If your gallery does bring you a site-specific commission, be sure your hard costs, such as materials, fabrication, labor, insurance, overhead, and travel, are considered in the gallery's fee. As we'll discuss later, a 5 percent "finder's fee" of your artist's fee is reasonable.

If you run a large enough studio to have assistants, pick the one who is the best writer, has a nice phone manner, and is responsible about meeting deadlines to find and put together your applications. A good source for assistants is art school internship placement programs, where you can find bright, conscientious, ambitious young artists to help with applications. I know of several very successful public artists who have assistants who do nothing but search out and apply for commissions. What may seem like grunt work to you is a learning experience for them. You'll still need to supervise all of their work before it leaves your studio, but you might find that they're better at some tasks than you are, or don't mind doing them as much as you do. Plus, there's a lot of satisfaction in watching them grow into their own careers knowing that you helped them.

MAKING THE LEAP

About now, some of you may be saying to yourselves, "Assistants? I don't even have a portfolio!" Here's the thing about bootstrapping your studio practice into being able to compete for public art commissions: it's different for every artist. There's no one route. As you'll read in chapter 11 at the end of this book, you have to start from where you are and work with what you've got.

As Cath Brunner, the public art program director of 4Culture, has said, "An artist selection process is actually just like most job interviews. It is a long shot that an inexperienced artist will be selected for a highly complex, large-budget, technically complicated design team project. But it is equally unlikely that someone with very little business experience will be hired as the CEO of a large corporation. Look for entry-level jobs if you have no experience. More public art agencies should be persuaded to offer entry-level commissions for artists with no previous public art experience. Many do now—apply for those kinds of jobs."[11]

Students

Art students enter the field with seemingly insurmountable disadvantages. They have skimpy portfolios, even skimpier resumes, no experience, and no business skills, compounded by a general perception that they're immature

and irresponsible. Oh, and some calls-for-artists specifically exclude them from applying. Despite these strikes against them, there are other ways to build a portfolio. Below are a few examples.

1. Studio classes: Take classes that provide opportunities to create art in public places; work in a team; and develop skills such as making maquettes, budgeting for materials, and building work that is structurally sound in materials suited for each environment. Be sure to document every project with lots of detail and production images. These will come in handy for beefing up a sparse portfolio because it's better to show a few strong recent projects with several striking details rather than diluting it with many images of old, badly photographed, or irrelevant work.

2. Arts administration, business, and computer classes in 3-D modeling, Photoshop, and Web site development.

3. Internships, especially with practicing public artists, within public art agencies, or with art consultants.

4. References: Mentoring from and building relationships with professors who have established reputations for public work. School is one of those times in your life where you'll be in close proximity to people who are (a) respected in their field and (b) being paid to help you succeed. Take advantage of that by impressing your professors with your commitment to art as a profession, and don't be afraid to ask them for advice or to serve as references.

5. Public-art related summer jobs with nonprofit organizations such as for community mural or art-after-school programs: While art education funding may be on the wane in some public school systems, nonprofit organizations have cropped up in many cities to fill that void with after-school art programs. Check on the Association of Teaching Artists Web site (*www.teachingartists.com*) to see what opportunities there are near you. The Community Arts Network has job listings in their "Forums" section, under "Opportunities." There's also *Teaching Artist Journal* available through its publisher, Lawrence Erlbaum Associates at *www.leaonline.com/loi/taj*.

6. Independent projects: The opportunities for these are limited only by your imagination. I have one student who is going to create a living painting on a garden wall at his parents' home with the help of his father (a landscaper), and another student who is going to mold latex ears, stick them on the outside of buildings around town, and clandestinely photograph reactions to them. Striking, high-quality photodocumentation of

simple, low-budget projects can demonstrate an artist's imagination, initiative, and resourcefulness as much as one that costs ten times as much. Be sure not only to take photos of the finished project, but also of the process along the way. You may not use them in your portfolio, but they could come in handy for your Web site or simply for posterity. Video or time-lapse photos may be an even more appropriate medium, if your work is time-based, sequential, or interactive.

While students can't apply for calls that are closed to them, the commissions that they are eligible for are often a good start, with tiny budgets in small towns that artists with larger boats to float can't afford to apply to. In competitions, students can make up for their youth and inexperience by having a thoroughly researched concept backed up by a ton of accurate detail on the budget, materials, installation, and maintenance. And if you don't win, you've at least learned something in the process and have another hypothetical project for your portfolio.

Honesty

There was a student in my public art professional practices class, a very talented young artist, who asked me if it was okay to lie on an application to cover up for her inexperience. No. No, it is not. For one reason, it'll eventually catch up with you, because unless you're a sociopath, you won't be able to keep your lies straight. Another reason is that you don't need to lie. You can turn whatever disadvantages you perceive within yourself into an advantage. Or, as another artist once told me, "use your vulnerability as a weapon."[12] In the case of young artists, your vulnerability is that you're inexperienced, but the asset on the flip side of that is you have fresh ideas and are eager to work hard (and, unfortunately, probably for less money).

Practicing Artists

If you are a studio artist with a body of work and an exhibit history—no matter how modest—you are probably closer than you think to being able to compete for public art commissions. Here are a few things you can do:

1. Initiate a site-specific project.

2. Find a patron to foot the bill for materials. If there is a collector of your work or a well-heeled person you have a good rapport with, propose to her that you'll create a piece or installation for her if she pays the hard costs. Create a detailed proposal and budget for her to sign not only so she knows

what she is getting, but to give yourself practice for when the time comes to do this in a competitive situation. In chapter 12, there's an outline of what should go into a proposal and letter of agreement.

3. Partner with a fabricator or other artist whose track record is solidly established to apply for commissions. Because very few artists who receive public commissions do all of the work from concept to installation themselves, it will not seem unusual to a selection panel if you submit your application as part of a team. It can be especially reassuring to project managers if they already know of the good reputation of your partner, and there will be major bonus points if they've worked on another project from that agency before.

4. Include composite photos in your portfolio. By that, I mean adding Photoshop-proposed or existing work to photos of public sites. Anything you can do to help viewers visualize how your work will look at a large scale in public is legitimate as long as the application doesn't ask that you only include *completed* projects in your images. Because a skilled Photoshop cut-and-paste master could concoct a photo that looks to the untrained eye as if it exists in real life, be sure to clearly label your image as being a mock-up or composite. You don't want the jury to think you're trying to pull a fast one.

5. Actively seek out opportunities to place your work in public sites that have low-entry thresholds. Many little towns have temporary sculpture exhibits where, for a small honorarium to the artist and (maybe) insurance coverage, they'll hold a competition for work to display for a year.

6. Retool your portfolio and resume so that it exhibits aspects of your previous projects that involved a connection to place on any level—with, for example, people, history, natural environment, or social issues. Were there aspects to previous projects that were educational, remedial, or political? Were they temporary or permanent? There may be work you've done that was more about place and/or process than you realize. If you ever did a painting to reflect the tastes of a particular client, or volunteered your creative skills to a community project, include that in the description of the work. Look for value not necessarily in whatever art objects came out of the endeavor, but in the process itself.

Too many artists think that the first couple of rejections mean that their work isn't right for public art, or that they don't know the secret handshake. They give up just when they should be persisting. By applying for project after project that interests you, you streamline your application materials and process, learn a little more about how the system works, and most of all,

you're repeatedly getting your work and name in front of people who are always looking for art. You increase your chances of winning exponentially the more competitions you enter.

Now that you know how to find the many opportunities that are zinging by all around you, the next chapter will teach you how to decide which ones are worth pursuing, and will demystify how artists are chosen.

End Notes

[1] Renee Piechocki, with Barbara Goldstein, ed. "Public Art Education: Beyond the Ribbon Cutting." *Public Art by the Book*. Seattle: University of Washington Press, 2005, pp. 201–2.

[2] Public Art Network, Americans for the Arts. "Year in Review." *www.artsusa.org/services/public_art_network*.

[3] Lucy Lippard. *The Lure of the Local: Senses of Place in a Multicentered Society*. New York: The New Press, 1997, p. 181.

[4] Mike Mandel, via e-mail (with permission), posted to the PAN listserv, November 14, 2006.

[5] Willow Fox, 4Culture, via e-mail, March 7, 2007.

[6] Andrea Galyean, Phoenix Public Art, via e-mail, March 7, 2007.

[7] Laura Dillon, editorial assistant, *Sculpture* Magazine, via e-mail, March 27, 2007.

[8] An excellent description and how-to on setting up news feeds is included in the "Opportunities" section of the Artists Information Company Web site, at *www.a-n. co.uk*.

[9] Barbara Goldstein, ed. *Public Art by the Book*. Seattle: University of Washington Press, 2005.

[10] New York Foundation for the Arts, NYFASource, *www.nyfasource.org*, accessed March 11, 2007.

[11] Cath Brunner, via e-mail, June 22, 2007.

[12] Bolek Greczynski, founding director, "The Living Museum," Creedmoor Psychiatric Institute, Queens, New York.

[13] For a thorough examination of art and its relationship to place, see "Places with a Present," in Lucy Lippard's *The Lure of the Local: Senses of Place in a Multicentered Society*, pp. 276–284.

Chapter 3:

Anatomy of a Call-for-Artists: The Selection Process

A well-designed call seeking artists for a specific project, whether an RFQ or RFP, will contain similar basic components.[1] I've listed them here in the order I think makes the most sense in deciding whether to apply.

COMPONENTS OF A CALL

1. *Deadline.* Obviously, if you've missed the deadline or don't have enough time to apply, there's nothing you can do. A thorough call for artists will make the distinction between postmark deadline and actual deadline. "No postmarks" means that if the application was due at 5 PM by a certain date, it needs to be physically there. A postmark saying you mailed it at 5 PM on that day doesn't count. If it is unclear which type of deadline it is, call or e-mail the contact provided to find out if it looks like you'll be getting your materials in just under the wire. Your application will most likely be thrown out or returned unopened if you miss the deadline, because a public agency has to treat all applicants equally. Agencies can't hold the deadline open for one person if they don't do it for everyone, not only because it's a government procurement process but, because the ire of one irate applicant could cause a lawsuit or a stink in the press. Besides, it doesn't really work in your favor to make a first impression as the artist who expected special treatment for not being organized enough to get his or her application in on time.

2. *Artist Eligibility.* Read this section of an artist call next to avoid spending time getting excited about the call before you discover you're not eligible due to a technicality such as not living in the targeted geographic region.

Generally speaking, the larger the budget, the wider the net the agency will cast for artists—unless it's super prestigious, in which case it'll likely be an invitational. Conversely, small towns or cities with small budgets will tend to stick close to home to find artists. Also, find out if the call is open to students or to artists who have a lot or a little public art experience. The call should specify if the agency is encouraging applications from artist teams, those willing to mentor emerging public artists, or students.

3. *Selection Criteria.* This is where you will find out if you have the qualifications to apply. Once you get past "artistic excellence," which they all list

as a criteria, you'll find specifics on whether they're looking for artists with X number of years of experience in a certain art form and whether artists new to public art or students should apply. A more subtle request is for examples of completed projects. That means that if you were planning on showing images of ideas that weren't executed (such as models for finalist proposals) to beef up your portfolio, you're out of luck.

4. *Project Description.* Is the project for a design team, an artist residency, or a commission for a new or existing work? Are they looking for a suspended sculpture, landscape design, light installation, portable works, or what? If you only do 2-D work and they want an artist to write a plan for restoring a wetland, think about getting a partner or pass.

5. *Call Summary.* Some calls will open with a brief summary of the requirements and a description of the competition that you can use to decide whether you're qualified or interested enough to read on.

6. *Budget.* Read this with a cold eye to make sure that the scope of work they're asking for in the project goals meshes with the amount of money they have to do it with. Writing realistic budgets is a skill that comes only after years of experience, and some of the administrators who write these public art budgets aren't experienced enough to know how much it takes to make a work of art happen. (I know of one where they even forgot to include an artist fee, and another where they thought artists would work for free just for the "opportunity" to create artwork for their city.)

If it looks like the budget is too small but you're still tantalized by the project, it wouldn't be a waste of time to call up the project manager and ask him if he anticipates additional money from fund-raising or from transferring overlapping costs from the construction budget (called "construction credits"). Before you throw it away and move on to the next opportunity, ask yourself if there would be other benefits of applying beside money, such as gaining experience or exposure, or, simply, because you're inspired by the challenge.

For the sake of all working artists, however, I must insert a caveat: when you succumb to agency administrators who assume artists will work for little or nothing, it only perpetuates the practice of not paying artists a living wage and undercuts the rest of us who can't afford to subsidize large bureaucracies with our personal income.

7. *Project Timeline.* Like the project budget, this is another section that bears close scrutiny. Timelines, like budgets, take skill and experience to craft realistically. Consider it a red flag when the artist is given very little time for concept development, execution, or installation. It can be a sign that

the agency doesn't understand what goes into making a site-specific artwork, or that it is simply unorganized, unprofessional, inexperienced, or all of the above. That said, you can turn a situation like that to your advantage by how you present yourself. Go into it as someone who can help save the bureaucrats from their bad planning by being organized and professional, and with your eyes open—and cushion your timeline and fee to make up for the inevitable hassle that is to follow.

8. *Artwork Goals.* After checking out all of the technicalities you could get snagged on, if you still think you've found a project you can apply to, read this section between the lines. It's where the commissioning agency tells you its hopes, dreams, and fears for the project. There could be all manner of good information here, like how much the agency wants the artwork to tie in with the community, or whether it should be about the area's history or environment. You never know what you're going to find in this section. Then, do a gut check. Are you inspired by this challenge? Are you already starting to see in your mind how your work would look in the site?

The trick is, you don't want to ignore what agencies ask for—after all, it took someone, or several someones, hours to come up with this section—but you also don't need to be slavishly literal in conforming to it and limiting other creative solutions you envision. As I will emphasize more than once in this book, the value we bring to each project is our unique perspective as artists.

9. *Artwork Location Description.* The call will, you hope, go into some detail here about the physical location of the site(s) the agency is thinking about, often including a link to the architect's drawings, if it's a new construction, or photos of the existing site. If it's an RFP, it should go into a lot of detail, since you are being asked to come up with an idea for a place you probably won't get to visit at the open-call stage. Even if there's an X-marks-the-spot where the agency wants the art to go, cast about in your imagination for alternate, expanded, or additional sites for your work. (One artist I know responded to an RFP for a library mural with an idea for a text-based installation over all of the fluorescent light fixtures.[2])

10. *Site History or Description.* This will be a short history and general description of how the site is used—something like what you would find on the city's Web site or in a tourism brochure. It can be valuable information if you combine it with the section on the artwork goals.

11. *Application Requirements.* In comparison-chart form, the application materials you will typically be asked for are:

Application Materials	RFQ	RFP
Resume and/or bio*	X	X
Images of work (slides or digital)*	X	X
Annotated image list*	X	X
Letter of interest	X	X
Application form	X	X
Professional references	X	X
Sketch		X
Preliminary budget		X
Concept narrative		X

* You will always be asked for these; the other items will vary from agency to agency.

Take note of how many copies of each item they're requesting. They may want you to make copies for the entire committee and will have specific instructions, such as stapled and collated, or three-hole punched and not collated, etc.

13. *Selection Process.* Sometimes, the call-for-artists will let you know who comprises the selection committee (i.e., how many artists, architects, and community representatives will be making the decision). It's a good way to get a quick read on how big of a deal the project is to the agency in the grand scheme of things. If the mayor's wife, philanthropists, and world-renowned curators are on the panel, that tells you one thing. If it's artists and community representatives, as you will find most often, you'll have a better chance of having your work considered if you're not an art star.

DECIDING WHETHER TO APPLY

There's one more step you can take in deciding whether you should apply. Go to the agency's Web site and check out what types of other projects it has commissioned. See if it looks like a collection you want to be associated with or that would be amenable to your work. Be sure to ascertain if it has recently had a change in direction. For example, say the agency used to only collect figurative pedestal pieces, but now has a new program administrator who is looking for work that is more site-integrated.

In summary, ask yourself these questions:

- Can I meet the application deadline?
- Do I meet the eligibility requirements?
- Is my work a good fit for the project?

- Is the budget realistic vis-à-vis agency expectations, my income needs, and the cost of production? If not, are there nonmonetary benefits to applying, such as gaining experience or exposure?
- Is the project deadline realistic given what is asked for?
- Can I meet the project deadline given my schedule?
- Am I inspired by the project?
- Is the agency's collection a good fit for my work?

If you can answer yes to all of these, then start filling out the application.

THE SELECTION PROCESS

A typical transaction through a gallery that includes the dealer, maybe an art consultant, and the client is the most an artist will encounter before his work reaches its final destination in a collection. But as soon as an artist sets out on the path of accepting the public's money for his work, he encounters a chain of accountability that stretches up to the highest level that particular bureaucracy has to offer, be it the city council or state legislature, mayor or governor. It's these levels of fiscal responsibility that drive the selection process, and all the processes that follow, for government-funded art purchases.

The main thing you need to keep in mind is that the selection process is done by human beings. There's no scientific formula. This works out in your favor because:

(a) If you get rejected by one selection panel, you could get a call the next day from another one that you've won. It's not as if you've got "Loser" permanently tattooed on your forehead. It's more like the lottery, but with a much greater chance of winning.

(b) Human beings can be influenced. I'm not talking about anything nefarious like bribes or Machiavellian manipulation. I simply mean that by committing to your work and being persistent, professional, and smart about the business of art, it is possible to build up your reputation and get the attention of the people who make decisions about who gets chosen for commissions.

The selection process for public commission competitions is pretty much consistent across agencies no matter which government department the public art program is housed within—be it parks, building, tourism, transit, facilities, planning, or cultural affairs. For each call-for-artists, the project manager will put together a selection panel, the composition of which will be determined by the enabling legislation for the percent-for-art program. There will usually be two or three arts professionals (artists), one or two community representatives (folks from the population to be served), one or two "client" representatives (for example, if the artwork is to go in the public library, the director of the

library or her designees will be there), and sometimes, but not always, the architect will be present if it is a new building.

The project manager will often facilitate the process. Even though the public art agency staff does not usually get to vote, they can have a lot of influence. Because the project manager knows more about the work at hand than anyone else in the room and is considered an art expert in general, he or she will often be asked for an opinion by the committee. I've seen artists' work torpedoed with as little response from the project manager as a wrinkle of the nose and a hesitant "Well. . . . "

The bigger the budget and visibility of the project, the more high-profile and national in scope the selection panel will be. If it's a small mural, for example, the artists on the panel will be local. If it's a library designed by a famous architect, artists with a track record of major projects may be flown in to serve along with a prominent local artist. The community members and the client representatives will most likely be non-arts professionals. The inevitable dynamics occur where strongly opinionated people or those recognized as art experts will dominate or be deferred to. The same thing may happen when someone with perceived higher status in that particular hierarchy is on the jury—such as doctors if it's a project for a hospital, judges if for a courthouse, and so forth. A skilled project manager or committee chair will know, ideally, how to keep the alpha panelists from overrunning everyone else.

Jill Manton, director of public art for the San Francisco Arts Commission, observed about the selection panel process: "Sometimes, there is a lack of consensus between the people on the panel with an art or design background and those who do not have this background. Everyone ends up compromising by going with their second choice. Sometimes, that results in work that is acceptable, but not spectacular."

(Another take on it is from humor columnist Dave Barry: ". . . public art, defined as art that is purchased by experts who are not spending their own personal money."[3])

A Word about Project Managers

In the vast bureaucratic hierarchy you'll be dealing with when you work with a government art agency, whether at the federal, state, or local level, your point person will most likely be the project manager. In a large agency, there may be four or five such staff members in charge of specific projects who report to the head of the department, also known as the public art program director. In the smaller agencies, the program director could be the only employee, and in charge of overseeing each project himself. You can't assume this person even has an art background; he could come from urban planning, engineering, or architecture. Nor can you

assume that the municipality even has a public art department. You could be dealing with a manager whose main job is to oversee some other area such as planning, parks, or tourism.

The project manager is your point person for all things related to the agency, from the moment you get the call-for-artists to the dedication ceremony once you've completed the commission. Your goal is to develop a comfortable rapport with this person, but you must always remember that she is your client first and foremost—not your best friend, mother, teacher, or therapist. The manager doesn't need to hear how overwhelmed you are with obligations, that your marriage is breaking up, or that you have a lot of self-doubt about your work, or about any bad experiences you're having with other clients or artists. Even if all that is true, the face you show to your point person is always competent and can-do. You'll be glad you've kept a pleasant yet professional working relationship with her when it comes time to negotiate contracts, navigate conflicts, or get a referral instead of having used her as a sounding post for your personal history and problems.

Potential clients—in this case, public art project managers—begin to form an impression of you from the very first contact you have with them, no matter how small, such as the type of questions you ask when you e-mail them for clarification of the RFQ or RFP, whether you respond promptly with a thank-you note, your phone manner, the quality of your presentation materials, and how well you followed the instructions on the application. They will pick up on whether you have an innate desire to work with the public and your level of confidence and competence.

Contrary to what you've been told your whole life, there *is* such a thing as a stupid question. When dealing with the project manager, it's not the time to play the student or wide-eyed ingénue. You need to inspire confidence from your first contact.

An artist e-mailed me as I was in the middle of writing this book to say that she had given up applying for public art commissions because of a bad experience she'd had a couple of years ago. Right out of undergraduate school, she entered an open call, was chosen as a finalist, and was up against several other more experienced artists. She didn't know how to put together a finalist proposal and said that, despite repeated calls to the committee, she didn't receive any help or guidance. Eventually, she withdrew from the competition because she couldn't assemble the materials, saying she "felt hung out to dry by the committee." Assuming she meant that she was calling the project manager and not "the committee" (you shouldn't contact anyone on the selection committee unless it has been cleared by the project manager), what she inadvertently did was convey to the client that she didn't even have the experience to complete a proposal, let alone a site-specific installation.

There's nothing special about project managers beyond how any other human being is wired. We make our initial judgments of people from the smallest signals. Most of all, project managers will be watching to see if you are someone they can count on to take a commission through the long journey to completion, with minimum grief to them and their agency.

BACKSTAGE AT A SELECTION MEETING

Because the selection panel will be potentially looking at hundreds of artists' work, a three-tiered weeding-out process will most often be used to make it more manageable. After being briefed about the project goals and selection criteria from agency staff, the stages typically go like this:

1. *First cut:* All of the images are looked at quickly, with committee members giving each artist's work a simple "yes" or "no." The yes's stay in for the second round. The majority of artists will not make it through this stage, mainly because their work doesn't fit the criteria or their images are substandard. Sometimes, all the artists' names are deliberately withheld, which is called a "blind jury," so that the committee will focus only on the quality of the work. That doesn't always prevent panelists from recognizing artists from their work and asking aloud if they were right about guessing who they were. No matter how objective panelists are trying to be, if they remember your work from having seen it before, they will probably have formed an opinion about it, whether they are aware of it or not. In general, name and work recognition tend to act in the artist's favor.

2. *Second cut:* The images are viewed more slowly this time around. There may be minimal discussion for clarification or to indicate personal preference. Resumes may be consulted. A scoring sheet will often be used, with 1 being low and 5 (or 10) being high. The images may be gone through again. At the end, the scores will be tallied and the highest scorers will move on to the next round. Sometimes, panelists will be given a chance to bring one of their favorites forward if the artist didn't score high enough to qualify, in order to argue a case for him or her in the third round.

3. *Final cut:* Much discussion will occur at this stage. There may be only a dozen or so artists left to whittle down to three to five finalists. Letters of interest will be consulted. Resumes will be rereviewed. Images will stay up on the screen for a long time while the panelists take turns discussing the merits of past work and its applicability to the current project. Several votes may be taken, with more discussion and advocating for certain artists, until the finalists are decided on.

If the call-for-artists was an RFP, the deliberations will be even more lengthy, as the panel goes over the concepts submitted by each artist and analyzes the preliminary budgets and timelines for completing the work.

The finalists will be given several weeks or months to put together a more detailed proposal to present to the panel in person. In chapter 4, we'll go over the components of a finalist presentation.

SELECTION CRITERIA

As I mentioned earlier, artistic merit consistently tops the list of criteria agencies cite for choosing artists. While that is vague and subjective, selection panels all over the country manage to arrive at a consensus. Here is the stated criteria from five different calls, in which you'll see how they range from general to very specific.

Points Criteria

25 Artistic merit of proposed design and quality of materials.
25 Meets program goals and criteria. Ability to complete the project.
20 Degree of benefit to and involvement of the community; design reflects community characteristics.
10 Visibility of location to the public and accessibility for the disabled.
 5 Feasibility of long-term maintenance to the public art project.
 5 Inclusion of a public outreach/education component.[4]

- Ability to create art of unique vision and of the highest caliber
- Ability to create art that is sensitive to budgets, schedules, and maintenance issues
- Evidence of successful experience in public art commensurate with the particular commission for which one applies
- Ability to respond to the requirements of this call-for-artists
- Demonstrated career as a working artist[5]

- Professional qualifications
- Proven ability to take on the given project
- Artistic quality of the submitted materials
- Demonstrated ability to work with committees and community groups in the creation of a project[6]

- The artist's professional qualifications
- Proven ability to undertake projects of the described scope
- Artistic merit as evidenced by the slides and other supporting materials
- Appropriateness of submission to project intent and site[7]

Criteria for the Artist and the Resulting Artwork

- Incorporate elements from the surrounding environment into design.
- Only 2-D and 3-D art proposals intended to be permanent will be considered.
- Artwork must require low maintenance and be vandal and weather-resistant to the extent feasible.
- Proposals must focus pedestrian activity and/or seating areas toward the eastern end of (location).
- Artwork sited on the sidewalk adjacent to or in front of the (location) will need to comply with the county's building security objectives for emergency access and evacuation.
- Movement of pedestrians should not be obstructed.
- Designs must be in compliance with all city codes regarding safety, accessibility, and other structural and maintenance issues.
- Artists may apply individually or as a team. Professional artists or artist teams with experience in the field will be given preference.
- Artist designs will be presented to the community, the project advisory committee, the (location), city departments, and appropriate city authorities for review and approval.
- Artists will be required to collaborate with and be available for meetings during the design and implementation process with community members, project advisory committee, and city department staff.[8]

A spokesperson for the Metro Nashville Arts Commission said the two winning artists the committee selected from 171 applications "came down to who had best understood and creatively responded to the goals of the project, which were to enliven the space, to create a sense of place, and to add to the good job that the design team had already done with the space."[9]

Sometimes, the criteria or parameters of the project changes during the selection process as the panel sees approaches it hadn't considered in the submitted images. Because this is the first chance panelists have had to discuss the project as a group, a completely new direction from that stated in the call-for-artists could arise out of that synergy. Like I said, it's a process done by human beings.

In the next chapter, I'll go over how to put together an application that will show your work to its best advantage, and how to avoid disqualifying yourself with a bad one.

End Notes

[1] Section headings taken from Renee Piechocki, *Call for Artists Resource Guide*. Americans for the Arts Public Art Network, *ww3.americansforthearts.org/pdf/services/pan/CallForArtists ResourceGuide.pdf*, pp. 1–4.

[2] B.J. Krivanek (*www.krivanek-breaux.com*).

[3] Porter Arneill, via e-mail, February 2, 2007. Confirmed on *www.brainyquote.com*.

[4] Palm Beach County. "Public Art Improves Our Community." Matching Grant Program Description and Application, *www.pbcgov.com/fdo/art/Downloads/010207%20APR%20extend%20deadline%20GRANT%20APPLICATION.pdf*, accessed February 21, 2007.

[5] City of Pasadena. "Call for Artists: Request for Qualifications, Pasadena Center." *www.ci.pasadena.ca.us/planning/arts/Documents/PasCenter/PCRFQ.pdf*, accessed February 21, 2007.

[6] City of Laguna Hills, Public Art Program. "Request for Qualifications: Civic Center Early California History Display and Council Chamber Murals." January 23, 2007.

[7] New Mexico Arts, Art in Public Places Program. "Prospectus #185, New Mexico School for the Deaf." *www.nmarts.org/pdf/prospectus185.pdf*, accessed February 21, 2007.

[8] City of Las Vegas. "Lewis Avenue Justice Quarter Enhancement," *www.lasvegasnevada.gov/files/Lewis_Street_Corridor_RFQ.pdf*, accessed February 22, 2007.

[9] Jonathan Marx. "Two Art Projects Selected to Grace Public Square." The *Tennessean*, September 29, 2006.

Chapter 4:
Application Readiness

In the end, the quality of your work and its suitability for a particular project are the deciding factors in winning public art competitions. You're not going to blind the committee to inappropriate or incompetent work with a slick presentation, but there are many things you can do to increase your chances—and avoid sabotaging yourself right out of the starting gate.

The object is to apply for as many projects as you're qualified for and interested in, while cutting into your studio time and paying work as little as possible. Responding to a basic RFQ can take anywhere from forty-five minutes to several hours, depending on how you've organized your application materials. An RFP can take several days. If you have the basic components of an application ready to go, you won't have to start from scratch every time. In other words, strive to streamline the application process. It's the next best thing to money in the bank.

Basic/Tools
To make a good-looking presentation packet, you'll need access to the following:

Photo-Quality Color Printer
For less than $500, you can get a desktop printer from Epson, HP, or Canon that prints photo-quality images. Be sure to use paper that gives you the best clarity and color for that printer.

Computer with CD Burner
Unless your computer is a dinosaur, it'll have this function, along with an easy-to-use tutorial.

Slide Scanner or Slide Scanning Service
If you have recent work that is still on slides, you'll need to have them digitized, because so many public art programs are phasing them out. There are many places that offer this service. To find them, do an Internet search for "slides to digital."

Another option is to buy a slide scanner. But unless film is your art form or you have more than one hundred slides, I don't recommend making the investment. And no doubt you know someone (like me) who invested in a slide scanner and has it sitting in her studio, unused and covered with a towel so dust and cat hair won't get on it.

To get your digital images turned into slides, there are online services such as *www.iprintfromhome.com* or *www.imagers.com*.

Computer Applications

- *Word processing programs such as AppleWorks or Word.* The later versions let you insert pictures, which will come in handy when creating your annotated image lists.

- *Photoshop.* It's the best way to tweak images of your work and create composite pages and two-dimensional mock-ups of your idea, as well as resize and reformat images to send as PDF, JPEG, and TIFF attachments that your clients and fabricators will need. It's also your gateway software for preparing Web site images to maximum effect.

 The good news is that while Photoshop is a complex and powerful program, you only need to know how to use a few of its functions for presentation purposes. Unless you're doing serious photo work or running a print shop, all you have to learn is how to import digital images and resize, reformat, color manage, adjust image quality, and add text.

 Photoshop has a good tutorial through its help function, and there are Web sites and books where you can teach yourself the skills you need in a short time, as long as you don't get intimidated by the program's many bells and whistles.

- *PowerPoint.* If you're able to learn a few Photoshop techniques, PowerPoint won't be a challenge. It's simply a way to create a slide show presentation with digital images. More agencies are catching on that if they ask artists to submit their portfolios preformatted in PowerPoint they won't have to pay an office assistant to compile hundreds of images into a PowerPoint presentation.

 In PowerPoint you can add text, special backgrounds, and moving objects, but I suggest you not do that. You don't want selection panels to focus on anything but your work. So no busy backgrounds, swooping text, or sound effects. One great thing about PowerPoint is that you can insert DVDs (with sound) of your work to play as part of your presentation.

- *Graphics programs.* FreeHand, Illustrator, and CorelDRAW are some of the top applications in this category. These are useful for creating drawings of your idea that can then be easily manipulated and exported to Photoshop or other programs. They're also a good way to do layouts for tear sheets and other printed materials.

- *Desktop publishing.* InDesign, Adobe's successor to PageMaker, is the one I hear recommended the most by other public artists. It's geared toward designing a newsletter, magazine, or some kind of publication with text and image layout. Unless you regularly need to do extensive professional-looking publications, you can create good text and image layouts with Photoshop, Illustrator, FreeHand, and other graphics programs.

- *Accounting.* Software like QuickBooks allows you to set up and keep your books, track money that's coming in or going out, print profit and loss statements, automate bill payments, and much more. You can download a thirty-day free trial of their online edition at *www.quickbooks.com*.

- *Spreadsheets.* Excel is the spreadsheet program everyone uses, although word processing applications such as AppleWorks provide them as well. Excel comes bundled with Microsoft Office, along with PowerPoint and Word. Spreadsheet programs allow you to input and analyze information. Like Photoshop, it is a many-layered, powerful program that you could use to bestride the world like a Colossus. Or, you could use it to simply add and subtract columns of data. For example, it's a great program for setting up a log of the tasks and hours worked on a project, getting an overview of your cash flow, or designing your own inventory system. You can download a free trial at *http://office.microsoft.com*.

- *3-D rendering.* My personal favorite is SketchUp, because I was able to learn it in an afternoon and it's good enough for what I need to do, which is show how my work would look in a virtual 3-D model. It's available for free from Google and allows you to model geometric shapes, apply textures to them, and zoom and rotate freely throughout. You can create a slide show of views from different angles, and fly throughs, or export freeze frames as JPEGs. You can also place your model in Google Earth. For $495, you can get SketchUp Pro 6, which is less clunky to use. There's an eight-hour trial version you can download for free. If you're a teacher with an institutional ID, you can register as an educator and get the Pro 6 upgrade, also for free.

I asked one of my fellow instructors at the School of the Art Institute of Chicago, Gabriel Bizen Akagawa, for the low down on other 3-D rendering programs.

There are many 3-D-modeling programs available for different costs and purposes. For example, Maya is a software suite primarily used for creating 3-D animation, film, graphics, and video games, so virtual- experiences like "fly throughs" can have a high cinematic quality. Maya is fairly complex and has many bells and whistles to perform a wide array of tasks, but these features are relatively expensive. It maintains an industrial standard for highly sophisticated and realistic rendering but may not be the best choice for creating watertight surfaces suitable for model evaluation and rapid prototyping. Rhinoceros 3-D is a more essential and direct program for 3-D fabrication output applications from jewelry design to architecture. Rhino is available for PC, as PC is still the standard for fabrication and office processing, and has recently been released in Beta for Mac. For many Mac users, Form-Z is a standard since it is one of the oldest 3-D-modeling programs around. It is used by many architects and designers, but is notorious for being difficult to maneuver. There are free programs downloadable on the Internet, such as Blender, Wings 3-D, and MoI. MoI is released in Beta for a Windows platform produced by some of the creators of Rhino. Blender is a free open-source program suite that has been compared in complexity and comprehension to Maya. Google SketchUp has both a simpler free version and a professional, more expansive version for sale. It is an intuitive, user-friendly program with the added feature of being readily compatible with Google Earth, allowing projects to be placed into virtual landscapes.[1]

Architects and engineers use Computer Aided Drafting (CAD). Because I don't know much more about it than that, I'm going to let Michael Hale, an architect with Rowland Design in Indianapolis, explain it:

> The predominant software used for this in the industry is AutoCAD, produced by a company named Autodesk. The software permits architects and engineers to produce (primarily) two-dimensional construction documents with a high degree of accuracy, and the ability to modify those documents in a much more timely and efficient manner than by producing drawings by hand.
>
> Now, the coming thing is something called Building Information Modeling (or BIM). The primary difference between this software and previous configurations of CAD is that this software automatically draws everything in three dimensions. This facilitates much better coordination between architects' and

engineers' drawings, primarily enabling discovery of conflicts between architectural, structural, or mechanical and plumbing system elements in the design process, and thus reduces field problems during construction.[2]

Hale says that even as a trained architect, it took him six months of working in CAD every day to learn it. While it is second nature to him now, he can see how artists would find it too technical, cumbersome, and restrictive for more creative uses. Unfortunately, if you win enough site-integrated commissions, you're eventually going to encounter a fabricator, contractor, or architect who won't be able to interpret your drawings unless they can be opened in CAD. If you do an Internet search for "CAD converter," you'll be able to find plug-ins for graphics applications such as Photoshop and Adobe Illustrator, and third-party software that will allow you to export your files so that they're readable by AutoCad and vice versa.

Digital Images

Start with 300 ppi digital files of all of your work, preferably in Photoshop, because it is the best for tweaking image quality and offers many different formatting options for sharing your files. You'll need these to use as master files to downsample to the size and format the agency specifies. Until that happy day when there is an industry standard for image size or all the agencies are using CAFÉ, you'll need to start from scratch with almost every application. Right now, it's a Tower of Babel out there. Here is a sampling of the different digital file formats asked for in calls for artists that came across my desk while I was writing this:

- Maximum image size is four inches by five inches and 96 dpi.[3]
- Maximum dimensions of 800 × 600 pixels and minimum dimensions of 720 × 480 pixels inserted into a PowerPoint slide show presentation.[4]
- Resolution no greater than 200 dpi, 600 × 800 pixels.[5]
- Images no larger than approximately 300 dpi. Save each image as .jpg or .tif file.[6]
- Resolution should be no larger than 768 pixels along the longest dimension. JPEG image files should be in the 200–450KB range, depending on tonal complexity.[7]
- Maximum pixel dimensions—600 × 800; image resolution—200 ppi; Maximum file size—500 KB.[8]
- Not to be more than 1920 pixels in either height or width, baseline .jpg, files should not be larger than 1.2 MB.[9] (Note: This format seems to be emerging as a standard.)

Slides

As of this writing, there are still a few agencies not set up to review digital images. That is rapidly changing. There are so many that now accept digital and so few that ask for slides—usually very small agencies with correspondingly small project budgets—that some artists (me, anyway) don't even bothering applying to them. We're going to wait it out until they all go digital in the next year or two. (Kodak even stopped making slide projectors in 2004.[10]) Of course, this also means less competition for artists who are willing to mess around with slides to respond to the few holdout agencies that still require them.

As with digital formatting, there is no standard for labeling slides. You'll get asked for slides that are labeled only with the number of the image, artist's name, and title of the work; number, name, title, dimensions, year, and budget; all that but no name; red dot on the lower right corner; no red dot but an arrow indicating the top front of the slide; no arrow, but the words "top front" written on the slide; number, name, and title on the upper part of the slide, with dimensions and date on the bottom or a variation thereof; number and artist's name only; and so on. Despite my admonitions about the importance of following the instructions on the application, I must confess that I label all my slides the same way for every call and haven't had an application rejected yet. I'd rather spend the hours it would take to create slide labels customized for every application on making art—or almost anything else, for that matter.

ARTIST STATEMENT

In the hierarchy of whom our society perceives as the most creative, artists are at the top. Your artist statement shouldn't sound like you're applying for a job at an insurance company. That's why the agency issued a call-for-artists, not one for accountants or actuaries. I've said it before and I'll say it again: the value you bring to the table is your unique perspective as an artist. Your artist statement should reflect your originality and personality, and offer insight into the intentions behind your work.

There's no substitute for real-life examples. Here are some artist statements that are informative, persuasive, and a good read. Keep in mind as you read these that you don't have the advantage of seeing images of each artist's work as a selection panel would, so it's going to be like listening to music on headphones when one of the speakers isn't working.

Artist Statement, Example 1

I am a painter who hates painting. You might not believe me when you notice the stacks of paintings all around, but it's true. The act of

complacently standing like a statue at a canvas is nothing more than an exercise of the eye. My history as a dancer has created a strong connection to body and form and drives me to be highly active while working. This manifests in my work through the visible construction process. Canvas is torn and used to suspend, pull, and create geometry. Paint is not limited to the surface but absorbed into the materials. Soaked, stained, and scraped color creates organic variation. The paintings have a strong third dimension in defiance of the tradition of two-dimensional painting. I enjoy the limitations of trying to work within painting because I treat the rectangle of the stretcher bars and the history of painting as a site for installation.

If you asked me as a child what I was going to be when I grew up, I would have told you I was going to be a scientist. I thought that drawing and painting was something that everyone did and my sculpture was a form of scientific invention. When I got to high school, I contributed a mural to one of the classrooms, which was shortly thereafter painted over. It was this event that proved how important art really was to me. I became active with not only submitting works, but also volunteering to help with art shows at the school. While working towards my bachelor of fine arts at the School of the Art Institute of Chicago, I worked on several artist-initiated projects. On a piece of abandoned property in south Chicago, "Lost Winds," a twelve-foot-tall windmill structure, was built out of found objects, such as railroad ties, metal banding, and old tarps. It was erected in an open space visible from a commuter train, to bring attention to a site in balance between abuse and reclamation by Nature. As with my use of painting materials as part of site specificity, I use all aspects of a location to open up limitless visual and conceptual possibilities of my practice.

Cara Thayer received her B.F.A. in painting and drawing from SAIC in 2007. Her goal on returning to her hometown of Bend, Oregon, is to "take on local projects that would otherwise go to outsiders of the region"[11] and to expand her practice nationally from there. However, she has nothing but student projects in her portfolio to show for past public art experience. Her resume has to contain a lot of white space to fill even one page. Yet, with this statement, she gives you a sense of her approach to materials, an insight to her commitment to a career in art, and how her work can be applied to public spaces. Through anecdotes, her bio section tells you about her past experience without simply being a droning rehash of her resume. If you'll notice, she also avoids dwelling on the fact, without being deceptive, that she

is so recently out of school. I noticed a self-conscious tendency among my students to talk in terms of their art experience as students rather than as artists even though they'll only be students for a short time relative to the entire lifetimes they'll spend as professional artists.

Artist Statement, Example 2

Magnetized ghost chairs, oxygen-producing walls, fire tornados, stereoscopic anaglyphs . . . these are the kinds of things that run through my head. My art is anything I can think of. Ideas become my mental blueprints. Emerging from a figural background, I have begun to expand, stretch, and transform the figure in new media and technologies, be it digital sculpture through haptic devices, to eco-architecture. Even at a young age, I would scribble and render whatever whet my whistle or tickled my brain. . . . Imagination was the only reference I had. Further along, I was introduced to surrealism, then classical art, and have just grown from there. I'm not a "concrete" artist devoted to one single genre or medium. Gum is much more my style—pliable, always sticking to new ideas, forms, and processes. Pliable, in the sense that my art tends to mold and reflect the environment I'm in, from the people passing by to a fragrance I can't quite recognize. I'll get stuck on an idea for a while, then move on. I also have a very questioning nature; if something is round, I think, why can't it be square? If it's blue, why can't it be red? This kind of mentality has always helped diversify and expand the kind of art I've exposed myself to. Take the roads less traveled. I want to try and see it all, and have fun doing it. My life is just one big art show, and I say, free wine and cheese for everybody!

Isac Enriquez is still a student at SAIC. A talented figurative painter, he wants to move into working with new technology in ways that engage the public. Because his current portfolio contains only paintings, he will need to beef it up by taking classes and finding opportunities to do this new kind of work. He will also need to apply for RFPs, temporary projects, and competitions looking for young artists, where the strength of his idea and his artist statement will help selection panels see that he can do more than paint what he sees.

Artist Statement, Example 3

Thomas Gokey realized that he was an artist in grade school when he could draw noses that looked like noses while everyone else just drew check marks on faces. In first grade he was simultaneously

identified as a "high potential" student and enrolled in the remedial reading curriculum known as "Title 1" in Minnesota. Interesting things he has done include living in grass huts with a stone age tribe in New Guinea, seeing two naked nuns (one of them being Mother Teresa) getting struck by lightning, and authoring the internationally famous "Poopsicle Story." His work deals with the overthrow of global capitalism, the protection of democracy through nonviolent methods, and the purity of true love.

I hesitated to include SAIC M.F.A. candidate Thomas Gokey's statement because he's not easy to define as a public artist—but then, some of you reading this may not be either. He started his own feminist publishing company, Heart and Lungs Press, invented a very high efficiency refrigerator that can be placed in a window like an air conditioner and uses the outside air for cooling, and is currently working on a military counter-recruitment video to play on MTV. He says he sees his every action in the world as an artwork. His intriguing, inventive statement doesn't tell one much in the conventional sense (although everything in it is "technically" true), but it conveys a singular creativity. Accompanied by his resume and images, it forms a complete picture of his conceptual, expansive practice.

Artist Statement, Example 4

R.M. Fischer's artwork is a contemporary, site-specific experience that includes functional aspects such as clocks, gateways, or lighting elements. His work with lighted interior and exterior sculpture lends itself to the development of architecturally-integrated designs. R.M.'s public art experience includes working on design teams that involve architects, landscape architects, urban planners, lighting designers, and other artists and participants.

Many of R.M.'s past projects are responses to large-scale interior and exterior spaces. Rector Gate, a fifty-foot-high skeletal structure in lower Manhattan, received the Award for Excellence in Design in 1987 by the Art Commission of the City of New York. More recently, he provided an extensive environmental design treatment for the Bartle Hall Convention Center Complex in Kansas City, a project for which he won two awards. R.M. has also participated in numerous design team projects. These include a fifty-acre "art theme park" on Key Biscayne, art opportunities for the Newark, Elizabeth rail link in New Jersey, and an entrance corridor for Kennedy International Airport in New York City.

This is a textbook example of a statement by an accomplished public artist. It starts out with a description of what he does and how he works, and ends with his credentials. He doesn't need to pad. In fact, his challenge is simply to convey a lifetime's worth of experience in a couple of paragraphs. The question of first or third person depends entirely on the context. When an artist's statement is put out to the public—such as this one, which was taken from 4Culture's Web site—the third person seems most appropriate. When you're trying to make a connection with a selection panel or potential client who is holding a letter from you to them, use the first person.

Artist Statement, Example 5

For the past thirty years, Mike Mandel has been working as an artist, creating art for public spaces. He received a masters of fine arts from the San Francisco Art Institute, concentrating in photography. Among his awards are four fellowships from the National Endowment for the Arts, a Fulbright fellowship, a MacDowell Colony fellowship, and numerous other grants and awards. His work is represented in museum collections throughout the world, and he has published extensively.

When Mandel recognized that photography was being transformed into a digital medium, he began to work with photographs on the computer. A digitized photograph is comprised of numerous square units of color called pixels. Mandel's interest in public art and, specifically, in finding a way to translate photographs into a more architectural scale, led him to the idea of a mosaic based on electronic imagery. A one-inch ceramic or glass tile could be considered a real-world analog to the electronic pixel, and thousands of these tiles could add up to become a wall of photographic imagery.

Another bio from an accomplished public artist, this one reads more like that of a studio artist rather than emphasizing design team or community interaction. In Mandel's case, this makes sense because his work takes more of an easel art approach—except the easels holding the work are monumentally scaled and permanently fixed.

RESUME

Following a heading that contains your complete contact information, a good format to use is to open with a short artist's statement about the type of work you do and your philosophy toward it, especially if you're just starting

out and need to fill up the page. If you've done recent public art projects, list them first with brief descriptions. If you're a studio artist making the transition to public art, you can list site-specific projects done on your own (describe these as "artist-initiated") or one-of-a-kind portable works commissions (for example, if you've ever been commissioned to do paintings or sculptures). If you're still an art student or not long out of school, mention projects you did in class, including group projects (describe these as "collaborative" or "with a team of artists"). Divide the rest of the resume by exhibits (indicate solo shows), collections your work is in, awards, relevant work experience, publications, memberships in professional organizations, and education. There's no hard-and-fast format for artist resumes, so you can reorder these sections any way that makes sense to you. Make it as long as you need to. You can always condense it or use smaller type if you run into an application that imposes page limits.

Foreground your strongest qualifications. If you've got an M.F.A. from a prestigious school, list your education first. If you're still a student, put education last so they can be impressed by your other accomplishments before they dismiss you as too inexperienced. You can use this format: degree, year ("expected"), discipline, school, city, and state.

Be sure your resume is organized and sharp looking. Put the first page on your own letterhead, with your name and page number on each of the secondary pages. Some calls-for-artists will ask you to keep your resume to a certain number of pages; others will not. Do what they ask even if it means using eleven-point type, setting narrow margins, and leaving out lesser or older exhibits in order to squish it into two pages.

ANNOTATED IMAGE LIST

Using Photoshop, Word, or another program that allows you to easily manipulate text and images, create a master list consisting of thumbnail images of all your completed work accompanied by text that lists the title of the work, date, dimensions, materials, location, client, fabricator(s), total budget, firms of design team members involved (if any), and any other collaborators. You can cut and paste from your master copy when you're tailoring your images to specific applications.

Remember that the selection panel will be reading this in semidarkness, so be sure to use fourteen-point type and plenty of space between each section. While they may ask that resumes be kept to one or two pages, they never ask that there be a page limit on slide lists. Err on the side of readability. And don't forget to put your contact information on the first page with your name on every subsequent page. You want them to remember whose work they're looking at.

As far as image order, there's nothing magic about it that's going to make the difference between winning or losing, but one rule of thumb is to start and end with your strongest images. The first one makes the initial impression, while the last one is usually what's left up on the screen if there is discussion about your work. In between, try not to jump around. There needs to be some logic to the order. Group by commonalities, such as style or medium, rather than chronologically.

The more complex and dimensional each piece is, the more details will be needed to show it to its best advantage. For two-dimensional work, a site shot and a close-up of the surface material should be enough. Sculpture, interactive, and time-based work will need more details. If you're not allowed to submit a DVD as part of your application, a sequence of photos can create an effective visual narrative that will give the selection panel a feel for the work.

Some artists put all of their thumbnail images at the top of the page with corresponding numbers; others place them along the side. It's up to you if not specified in the application instructions. Here's one possible format for a single image:

01.	Title	Date
	Medium	Budget*
	Client (or commissioning agency)	
	Collaborators/Fabricators (if any)	
	Description (one to three sentences)	

Budget: If the project was self-financed, such as for a student assignment or done on speculation, include the amount it would cost if you were to factor in your artist fee, profit, labor, insurance, travel, and other expenses. If it's an object for sale, put "price" instead of "budget."

With the ability to manipulate images digitally, it's easy to do a convincing virtual mock-up so that it looks like the work exists in real life. It's perfectly legitimate to include finalist proposals in your portfolio even if they were not realized. After all, they're still a product of your creativity. If you do submit this hypothetical work, however, be sure it is clearly labeled as "unrealized," "concept drawing," "unfunded," "mock-up," or to that effect. Independent public art consultant Joel Straus says inexperienced selection panels don't get it when these composite images are mixed in with finished projects. "They feel like they've been swindled" once they sort out what's real and what's not.[12] And if the agency specifically requests that only *completed* projects be submitted in your application, then positively do not include these speculative ones. It will backfire on you because your credibility will be called into question.

Also, I've seen artists who go text-crazy on their composites with blocks full of tiny type everywhere, their unreadability compounded by light fonts

on black backgrounds. No one can read that when it's projected at 72 dpi, and it's so distracting that by the time viewers figure out where to rest their eyes, the screen has switched to another image. Take pity on the committee. Keep your images clear and simple.

REFERENCES

Current references who will vouch for your work, professionalism, and integrity are important to have on hand. They're not often asked for in the initial call, but will be required when you become a finalist. In order of strength, references often include:

- Public art program managers and other clients who have commissioned your work
- Prominent public artists
- Curators and critics
- Former art professors
- Art advisors and dealers who have a stake in selling your work

Be sure you get permission from everyone whose name you use (and be sure to thank them). While you're at it, ask them if they want to be notified every time you use them as a reference or give you blanket permission. One of my references likes to be told every time so that she can tailor a rap in my favor for each specific project. Another said I don't need to ask him every time, that he's prepared to be there for me. Don't let your references get stale. Keep them up to date with your work so that you're not calling them out of the blue every few years to ask for the favor of a reference.

SUPPORT MATERIAL

These are tear sheets, catalogs, postcards, exhibit announcements, and copies of any articles written about your work. Once in a while, an agency will ask for "support material." For the most part, though, they don't want to have to deal with all that paper. Art consultants will be much more interested than public art managers in those kinds of materials to keep in their files.

Tear sheets are printouts on letter-size paper of either an image of your artwork that you compose yourself or can be copies of a page from a magazine article about you. Making your own tear sheets to have on file is well worth the effort. Art consultants, in particular, find it an easy way to show work to individual clients. If they're in a hurry, you can e-mail these pages as high-resolution JPEG or PDF attachments for them to print out. The actual color on the page will depend on how well they've calibrated their printer and

the type of paper they use, so if at all possible, keep control of the quality of your images by printing them yourself and mailing them to the client.

If you make your own tear sheets, keep the format as clean and easy to read as possible.

Have one or two images on the page—perhaps a full shot and a detail showing the material—with your name, title, medium, dimensions, date, location, client, and any other pertinent information. Also include a brief description of the work, especially if it has relevance to a specific site. Put a copyright symbol with the date of the work's completion and your name in a discrete spot near the image like this: © Artist's name 2008. Print it out on nice photo- or brochure-quality paper.

Here are examples of some tear sheet layouts on letter-size paper:

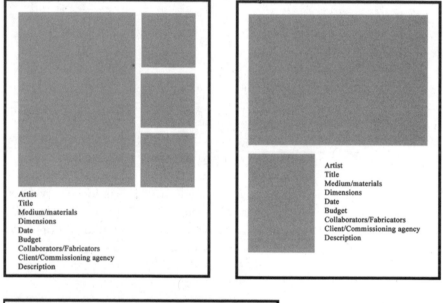

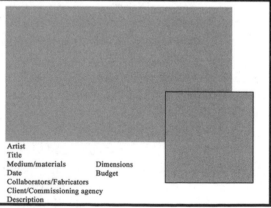

LETTER OF INTEREST

The letter of interest, sometimes also called the statement of qualifications, is important. It is not an artist's statement, although you can cannibalize some of it to use there. The letter of interest is specific to the project you're applying for. It's a chance for you to sell yourself to the selection committee, giving them a glimpse into your personality, professionalism, qualifications, and enthusiasm for a particular project. It will not make up for lousy images or work that is not a good fit for the project, but it can tip the decision in your favor when it's a close call between you and a handful of other artists. In some cases, if it's beguiling enough, it can even make up for a lack of experience evidenced in your portfolio.

Cath Brunner, 4Culture's director of public art, says that when writing a letter of interest,

> Artists without previous public art projects need to pay attention to the prospectus that describes the project—what will be the artist's job assignment ultimately if he or she is selected? If the prospectus says the project will require working with a community group—think about it. Have you ever led a neighborhood action committee? Have you ever organized a rally or served as a scout troop leader? Do you actually live in the neighborhood where the artwork will be located, and therefore have firsthand, in-depth knowledge of the site and the neighbors? Those are "qualifications" related directly to the job. If the public art project is in a hospital, I have seen first-time artists selected because they had worked as summer interns in a hospital or they had undergone extensive treatments as a patient and could understand the environment and the challenges that patients might face. The cover letter illustrates to the panel how well you communicate with others—use it to talk about why the panel should take a risk on you and your art and why you are interested in doing art for this particular project.[13]

Anatomy of a Letter of Interest

Most calls-for-artists ask that the letter of interest be kept to one page, so you need to make the most of it. While certain sections, such as your previous experience, can be more or less boilerplate, a letter of interest needs to be custom-made for each application because it is, essentially, a sales pitch.

First Paragraph Your first paragraph, starting with the very first sentence, should reflect the affinity you feel for the project that led you to apply in the first place. This is where you make your initial impression, so it needs to have some energy behind it. You want the panelists to keep reading. By the time it gets to the point where they're reviewing the letters of interest, it's been a long day of looking at images in the dark. It's most likely after a lunch of carbs and everyone is a little logy. Your first sentence needs to be peppy enough to snap them out of it. If you're not the perky type, that's okay. Just be the version of your best self that lets your personal style and enthusiasm show through. If you don't feel that way about a particular application then consider not applying for it. Calls-for-artists are like buses; another one will be along in no time. Save your effort for the ones that spark you, unless you want to do it for the practice.

The first paragraph is where a careful reading of all of the narrative sections of the call-for-artists is crucial. Dig deep and try to understand what is important to them. Highlight adjectives in sections that go over the site's history, goals, and physical description. Pretty soon you'll start getting a feel for the project. Here are key words I found in some recent calls-for-artists.

- Terre Haute, Indiana, *Gateway to the Arts Corridor* (Budget: $38,500)[14]:
 "highly visible"
 "accessible to the public"
 "Gateway to the Arts"
 "highlight the presence and vitality of the Arts"
 "distinct characteristics"
 "accessible to both pedestrians and motorists"
 "durable outdoor materials"
 "practicing artists"
 "demonstrated experience in outdoor sculpture"
 "appeal (to) all ages"
 "vandal resistant"

- Saint Cloud Public Library, *Request for Qualifications* (Budget: $175,000)[15]:
 "symbol of civic pride"
 "warm, friendly, inviting to public"
 "community anchor"
 "city landmark"
 "technically feasible"
 "within budget"
 "compatible with physical environment"
 "compatible with the use and nature of the library"
 "use of text of historical materials"
 "intimate discoveries"

"reward with repeated viewings"
"diverse cultural and ethnic populations"
"variety of ages"
"activate or enhance public space"
"raising curiosity"
"increasing the comfort level"

- Kansas City, Missouri, *Bridges Across I-670* (Budget: $860,000)[16]:
 "innovative concepts"
 "team with an architect and/or structural engineer"
 "schedule-aggressive competition"
 "safety and attractiveness"
 "to facilitate and encourage pedestrian use is imperative"
 "enhance the pedestrian experience"
 "ensure safe travel"
 "original and dramatic site-specific designs"
 "safely accommodate pedestrians and commuters"
 "aesthetically pleasing environment"
 "aggressive schedule"
 "no flexibility in the schedule"
 "artists with experience in urban design/public art"
 "large capital project"
 "able to work effectively within the project timeline"
 "collaborate with multiple government agencies"

As you can see, there is a treasure trove of information distinct to each project. You need to directly address the particular wishes and concerns of the committee in your letter of interest. Use the same words they used. This shows that you carefully read the call and that you understand what it requires. Another good source of background information, is to look at the agency's Web site. You'll find useful information, such as minutes from commission meetings pertaining to this project and the agency's public art master plan with their philosophy and mission statement, and you may get a chance to see what other kinds of projects have most recently been funded.

Second Paragraph What you focus on in the second paragraph depends on whether it's an RFQ or an RFP. If it's an RFP, which means the agency is looking for specific proposals, you'll need to go into preliminary ideas for the project. If you only know the site from the description given in the call, it'll be a little like playing darts blindfolded. You never know, though—you might hit a bulls-eye. Any agency that has issued an RFP doesn't have a firm idea of what it wants. Because the committee members are shopping, you might as well let your imagination loose. Again,

drawing on your careful reading of the narrative (and a call to the project manager for more information wouldn't be out of line at this stage), brainstorm a few options for them. Let them know you're flexible and interested in their input by saying something like, "Of course, I'm open to revisiting these initial ideas once I've had the opportunity to learn more about the project."

In an RFQ, where they're more interested in qualifications than specific ideas, use the second paragraph to refer to projects you've done that have some relevance. If in your word hunt you saw that they were emphasizing "community" and "diversity," for example, highlight that aspect of prior projects. If "education" is their focus, then show that side of your work. There are many facets to your practice. You can shine a light on whichever angles you want them to see. You might even discover a few yourself that you didn't realize were there before. (Note: If you're responding to an RFP, this will be your third paragraph.)

Third Paragraph This is a summing up in narrative form of your resume. It's where, in a matter-of-fact way, you describe your credentials, such as your education, professional organizations to which you belong, work and teaching experience, and awards. Even if your prior experience wasn't particularly relevant, you can use what I taught you for the second paragraph to find relevance in it. Say you paid your way through college working in a frame shop. Well, there you honed your attention to detail, your listening skills, and your ability to interpret each client's vision, and you learned the importance of art to people from all walks of life.

Conclusion This is where you say in your own words that you are excited about the project, think it's a great opportunity, and want to be chosen to do it. In business, it's called "asking for the sale." And don't forget to thank the selection committee for considering your application. If they've read this far, they deserve to be thanked.

The best way to illustrate these points is to show you examples of an actual RFQ[17] and the letter of interest from the artist who won the commission. As the project manager Jennifer Riddell told me, it's the "whole package," including the in-person presentation that won over the selection panel.[18]

PUBLIC ART OPPORTUNITY

REQUEST FOR QUALIFICATIONS NUMBER 450–03

ARLINGTON COUNTY, VIRGINIA

VIRGINIA DEPARTMENT OF TRANSPORTATION (VDOT)

ARLINGTON BOULEVARD (ROUTE 50)/COURTHOUSE ROAD AND 10TH STREET INTERCHANGES PROJECT

BACKGROUND

The Arlington County, Virginia, Public Art Program seeks an artist to work closely with a project team comprising engineers, planners, and landscape architects, to develop artwork/aesthetic treatments to be incorporated into a project to improve traffic flow at two major interchanges of interstate and local roadways in Arlington County, Virginia. Arlington is a 26-square-mile county within the Washington, DC metro area, and was originally part of the 10-mile square federal city surveyed in 1791. The area was retroceded to Virginia in 1846 and renamed Arlington County in 1920. Arlington is home to the National Airport, the Pentagon, Arlington Cemetery, and the Iwo Jima Memorial.

PROJECT INFORMATION

The purpose of the VDOT Arlington Boulevard (Route 50)/Courthouse Road and 10th Street Interchanges project is to improve the capacity and safety of two interchanges at Arlington Boulevard (Route 50). The current interchanges were originally constructed in 1954 under different design standards and for much lower traffic volume than exists presently (and is forecasted for the future). Thus, current vehicle turning movements and traffic entrances and exits from the two local roadways onto Arlington Boulevard are unconventional and can be confusing and even unsafe to motorists, pedestrians, and bicyclists unfamiliar with the conditions.

The interchange improvements will entail reconstruction of two bridges carrying Courthouse Road and 10th Street traffic over Arlington Boulevard, and the construction of a substantial amount of new retaining and barrier walls due to the elevation differences between the eastbound and westbound roadways of Arlington Boulevard.

ARLINGTON COUNTY PLANS FOR ARLINGTON BOULEVARD

Arlington Boulevard (Route 50) is a major gateway in and out of Arlington from Washington, D.C., on the east end and Fairfax County, Virginia, on the west end. Within Arlington, it traverses 5.25 miles and divides the county into its north and south sections. The experience of traveling the roadway forms many people's first experience of Arlington, and for many area residents, is a daily commuting route. Thus, it is the County's goal to beautify and make the roadway more distinctive through aesthetic enhancements that will be implemented as capital projects such as this one provide the opportunity.

CONTRACTOR'S SCOPE OF WORK

The project area encompasses an approximately 2/3 mile stretch of east- and westbound Arlington Boulevard between Courthouse Road and 10th Street, which intersect it. Opportunities for art/aesthetic treatments may include some or all of the following areas:

1) Expanses of concrete retaining/barrier walls;
2) Undersides of 10th Street and Courthouse Road bridges;
3) 10th Street and Courthouse Road bridge railings;
4) Bike trail areas;
5) Planned September 11 Memorial Grove areas not impeding the primary goals for the grove;
6) Other landscaped areas within project area.

The retaining walls are the priority area for treatment. Art/aesthetic treatments may include, but are not limited to, the following: surface texturing, embedding, coloring; lighting treatments; steel or ironwork enhancements to bridge railings; or functional elements such as seating or bike racks.

ELIGIBILITY/SELECTION CRITERIA

Professional artists are invited to apply. Each applicant must have collaborative, project team experience working with design professionals such as engineers, architects, urban planners, landscape architects, or other design specialists on architectural-scale projects in order to qualify for consideration, given the scale and complexity of the project.

BUDGET

Project budget, including artist design fee, materials, fabrication, installation, travel, and expenses, is $150,000. Cost of art treatments for areas already budgeted within the project may be incremental if art treatments are integrated into the project's construction.

SELECTION PROCESS

An art advisory panel will be convened to make the artist selection and recommendation for the award. Voting members of the panel will include a combination of the following: community members, artist/design professionals, VDOT representatives, A/E firm representatives, arts professionals, and other project team representatives. Nonvoting advisors may include members of the Arlington County Cultural Affairs Division or other relevant County staff. The Panel's proceedings are limited to panel members, voting and non-voting, in order to ensure confidentiality of the selection process and open discussion of the merits of applicants pursuant to county purchasing processes.

The panel will screen applicants' slides and materials, and short-list qualified applicants who will be invited for interviews. Project-specific proposals will not be required at the interview stage, although applicants should be prepared to discuss initial ideas and approaches to the project in broad conceptual terms.

HOW TO APPLY

You must register as a bidder to obtain the official solicitation documents via download from the Internet, or obtain a hard copy in person from the Purchasing Office or via U.S. mail. Documents are available free of charge by registering at the Purchasing Office Web site: *www.co.arlington.va.us/purchasing*.

Select Public Art Commodity Code #0305017 if prompted during the registration process.

A hard copy of the documents is available by contacting the Purchasing Office:

ARLINGTON COUNTY, VIRGINIA

OFFICE OF THE PURCHASING AGENT

2100 CLARENDON BOULEVARD, SUITE 500

ARLINGTON, VA 22201

(703) 228-3410

An advance nonrefundable fee of $5.00 is required for each hard copy set of solicitation documents issued by the County Purchasing Office. The Purchasing Office will only accept checks or money orders made payable to "Treasurer, Arlington County" or cash receipts processed through the County Treasurer's Office. The documents may be purchased in person or will be mailed after receipt of the fee by the Purchasing Office. APPLICATIONS WILL BE ACCEPTED ONLY FROM OFFERORS WHO DOWNLOADED THE ELECTRONIC DOCUMENTS FROM THE WEB SITE, OR WHO HAVE PAID THE HARD COPY FEE.

DEADLINE: OCTOBER 28, 2003, 2 P.M.

Complete applications are due at the Office of the Purchasing Agent (address above). Questions may be submitted in writing to Jennifer Riddell, public art projects curator, at jriddell@co.arlington.va.us or at fax number 703-228-3328. A copy of any questions submitted must be forwarded to the Office of the Purchasing Agent at rwarren@co.arlington.va.us or at fax number 703-228-3409.

Additional information about public art in Arlington County can be found at *www.arlingtonarts.org*.

Sample Letter of Interest

Long-time public artist Vicki Scuri allowed me to share this letter of interest she wrote for the Arlington, Virginia project that she subsequently won.

Arlington County, Virginia
Office of the Purchasing Agent

Re: VDOT Arlington Boulevard/Courthouse Road and 10th Street Interchanges

To the Selection Committee:

This is a perfect opportunity for public art-in-infrastructure! The possibility to create a Gateway to the City of Arlington through the enhancement of two bridges, retaining and barrier walls, and project landscaping including a memorial grove is a worthy and realizable goal. I am most excited to submit my qualifications for this project. I am an interdisciplinary public artist, specializing in public art and design team collaborations. I have been practicing since 1985. My experience is national, including large- and small-scale collaborations, with expertise in a variety of forms and methods. My experience includes art graphics, sculptural steel, lighting, concrete patterning, greening, public art planning, and enhancements for infrastructure with an emphasis on roads, bridges, trails, and pedestrian links. I create site-responsive projects that reflect local roots and expand awareness of place.

My design process includes research and dialogue to reveal community identity, city landmarks, destinations, and social history. I investigate economic, cultural, climatic, and environmental resources. I photograph the site—its environs and approach—to reveal its most innate (and latent) characteristics. Through this process, I distill a menu of opportunities. A community group, like Friends of Arlington Boulevard, could be an important resource, helping me to initiate my research and to firmly ground the project in Arlington. I am a resourceful player, networking to build consensus, expand vision, and raise the level of performance for all. I have done this repeatedly in my built works. The projects illustrated in this application reflect a high level of imagination, integration, collaboration, and coordination. All of the work is documented and bid through standard construction processes. It passes through all of the disciplines and it is supported throughout construction. To build on the scale of infrastructure is a cooperative, long-term venture that requires persistence of vision, patience, and fortitude. Many things happen along the way, and yet we succeed. I credit everyone who I work with for these successes.

I am most interested in the Arlington VDOT Project, as it is "my type of project." Recently, I worked in nearby Rockville, creating a public art menu of opportunities for Rock Creek Bridge. This menu includes railing and fencing designs, lighting, greening, and interpretation, based on the local water mill history and Victorian Romanticism. I would like to learn more about the specifics of the VDOT Arlington project to investigate its greatest potential positive impacts. I am well known for my work in concrete patterning, having received numerous merit awards for raising the level of performance on the following projects: **Dreamy Draw Pedestrian Bridge, Newport Way Retaining Wall**, and the **West Galer Flyover**. My recent sound wall project, **La Cholla North**, involves 48,000 square feet of patterned surface. According to Pima County, ADOT receives continuous positive comments from the community about this project. My work is not limited to concrete. Though it is one of the main ingredients of infrastructure, I am equally versed in sculptural steel forms and lighting, as demonstrated by the **Douglas Street Bridge**. I hope to have more opportunities to work on this scale and complexity, and to include greening and site design. Arlington seems like a perfect fit to me. I look forward to the possibility of interviewing with you for this challenging and dynamic project.

Sincerely,
Vicki Scuri,
Vicki Scuri | Site Works

TIPS FROM A PRO: Application Packets

After sitting on both sides of the community-based public art selection panel process; I've seen how artists can sharpen their competitiveness. Here are a few of my tips:

Make original, excellent art. Artists should make every effort to imbue their art with the highest aesthetic quality. The art should relate uniquely and authentically both to the artist and the site. When a panel is struggling to pick between handfuls of artists, the quality of the work sways them most.

Volunteer to serve on a selection panel in your community, or if appropriate, sit in on a panel. I remember the first panel I sat on as a young artist. I was amazed at the lack of knowledge of several of the panelists. One woman was hell-bent on believing that the colors of the art we selected had to match everything else. An older man was convinced that only figurative

bronzes qualify as "art." Experiencing the process from a panelist's perspective is perhaps the most enlightening (and humbling) experience an artist will have.

Present the best possible photographic images.* Competition is escalating in this field and decisions often come down to a razor's edge. After a panel views many strong images by a range of qualified artists, one or two poor photos might eliminate someone from the competition. Your photos are the primary example of your work, and a variety of people with a variety of experiences will be interpreting what they see.

Since this is public art, it's okay to include people in your photos, particularly for a sense of scale and to show human interaction. On the other hand, including cameo appearances by the artist (or his or her children, dog, cat, parrot, etc.) or staging photos with ballerinas or models is disadvantageous. Panels tend to see it as silly and amateurish. Also, make sure your annotated image list is accurate and that it matches the photos the panel is viewing. I'm amazed at how often submitted image lists are out of order.

Be specific and demonstrate confidence in your letter of interest. The artists who are creating unique, innovative work *and* who articulate their ideas earnestly and effectively are the most successful. Personally, I'm impressed by artists who show a developed body of work and who confidently explain how they will use their experience within the context (and challenges) of the public realm.

Regularly refine and improve your qualification packets. I encourage artists to host a gathering of their art and non-art friends (heck, grab a complete stranger) and run their materials past them. Seeking this type of honest critique is extremely helpful in gaining an outside perspective of how your work is perceived by others.

Be patient. Be smart. Keep trying. It's a marathon, not a sprint.

PORTER ARNEILL, Director/Public Art Administrator, Kansas City Municipal Art Commission

TIPS FROM A PRO: Letters of Interest

Assembling an application is fairly simple. If you can't assemble an organized and aesthetic portfolio, then I'd have trouble considering your work because it represents your working practices. Submit an organized application. Don't make the administrator organize it for you.

Artists need to do their own market research. Don't apply for projects that you can't do or ones for which your work isn't appropriate. The inverse is even more important: make certain your concept is actually buildable. Research your materials for conservation issues and document construction techniques. Compare your idea to the work of other artists who have completed similar projects. It'll be a great learning experience and give you more credibility. Given that your design is the best and that you can demonstrate professionalism and facility with technique and materials, I would definitely take the chance and commission the inexperienced artist.

The first questions asked of finalists are always: "How much do you think this would cost to build? Are there conservation issues with the materials? What will be needed to maintain the piece?" If you don't have reasonable answers to these questions, it makes me and the committee insecure. Inexperience is just one of the factors in the final selection process. A demonstrated lack of understanding of these issues will probably lead to your elimination. Often, when it comes to the final selection, a committee is looking for reasons to reduce the final group. Don't give them an easy one.[19]

JOEL T. STRAUS

TIPS FROM A PRO: Letters of Interest

I can say that what our selection committees appreciate are letters in which the artist restates the project parameters (the committee's desires) and proceeds to tell them exactly why he or she is the one they are looking for, giving good examples of how they have previously solved similar projects or describing how they might address this one.

It is also good to include concrete references instead of generalities. Don't say "I'm a team player" or "I complete projects on time," but "I worked with such-and-such a group on such-and-such a project to address these anomalies and resolve those unforeseen problems to bring their project in on time and within budget."

Artists may certainly speak to their own aesthetic philosophy and personal reasons for being in public art, but should do so in layman's language rather than foggy, esoteric jargon.

LEE MODICA, Arts Administrator, Art in State Buildings Program, Florida Division of Cultural Affairs

Tricks of the Trade

- **Never have to say you're sorry.**
 If there's anything in your portfolio you find yourself apologizing for, fix it before you show it again. You don't ever want to have to say, "Sorry I couldn't get a detail of this piece," "Sorry it's so blurry," "Sorry there are fingerprints on this," "Sorry, I don't know how that goat got in there. . . . "

- **Make sure you have all the information you need.**
 If there's information missing on the RFQ or RFP, as there almost always is, do not be shy about calling or e-mailing the project manager to ask him or her for details. Even little things such as whether or not they want the ten copies they requested collated and stapled or loose and three-hole-punched are important. Keep in mind that this is your chance to make a first impression. Your questions should be brief, intelligent, and pleasant. If it seems like the person wants to talk about the project more, use the opportunity to gain as much insight into it as you can by asking questions about the site, community, history, materials, what other work the committee members have seen that is like what they'd want to see there, etc. Treat it like a mini-interview that goes both ways.

- **Keep control of your presentation materials.**
 If they've only asked for one copy of each application item, but you've got a nice, colorful annotated image list with thumbnails, ask them if you can make a color copy for each committee member.

- **Make it easy for them to get in touch with you.**
 Have your name, address, and contact information on the front of every section of your application—resume, image list, and letter of interest included.

- **Make it easy for them to remember whose work they're looking at.**
 Have your name, the name of the project, and the page number on every secondary page of your resume, annotated slide list, and letter of interest (if more than one page). Example:

 Artist name
 San Francisco—artist registry
 Page 2 of 4

 (Don't forget to update if you recycle this information for another application! You don't want Kansas City to think you spaced out and sent them San Francisco's entry by mistake.)

- **Follow instructions.**

 If they didn't ask you for references, don't include references. If they ask you to fill out a form and get it notarized for their purchasing department, do it. If they ask for ten copies of your application materials, three-hole-punched, collated, and paper clipped . . . well, you know what to do.

 There are exceptions to the "follow instructions" advice. Every once in a while you'll encounter an application that will ask you to sign away your copyright if you get the commission or, incredibly, that you agree to abide by the contract even before you've seen it! Those are impossible requests that you'd have to be pretty desperate to agree to, not to mention that accepting those terms is a detriment to fellow artists as well as yourself. You'll need to ask the project manager if the agency has any flexibility on that, and if not, for the sake of solidarity with all artists, refuse to sign it.

You'll be glad that you've done all of this work because it ain't nothin' compared to what you're in for once you become a finalist.

End Notes

[1] Gabriel Akagawa, via e-mail, April 20, 2007.

[2] Michael Hale, graduate architect, Rowland Design, Indianapolis, Indiana, via e-mail, March 12, 2007.

[3] Palm Beach County. "Public Art Improves Our Community." Matching Grant Program Description and Application. *www.pbcgov.com/fdo/art/Downloads/010207%20APR%20extend%20deadline%20GRANT%20APPLICATION.pdf*, accessed February 21, 2007.

[4] City of Austin. "Austin Art in Public Places Artist Registry." *www.ci.austin.tx.us/aipp/downloads/SR%20Form-%20REVISED%206.23.06.pdf*, accessed February 26, 2007.

[5] Miami-Dade Art in Public Places. "North Corridor Metrorail Extension." *www.miamidade.gov/publicart/artist-calls.asp*, accessed February 26, 2007.

[6] Fort Worth Public Art. "Artist Registry Application Instructions." *www.fwpublicart.org/UserFiles/File/Artist%20Registry%20Instructions%20(3-21-05).pdf*, accessed February 21, 2007.

[7] Wisconsin Arts Board. "Image Guidelines." *www.arts.state.wi.us/static/percent/image-guidelines.htm*, accessed February 26, 2007.

[8] Kansas City Downtown Council. "Public Design/Art Opportunity: Bridges Across I-670, Kansas City, Missouri," *www.aiakc.org/I-670%20Bridges%20RFQ.pdf*, accessed February 26, 2007.

[9] New Mexico Arts, Art in Public Places Program. "Prospectus #185, New Mexico School for the Deaf." *www.nmarts.org/pdf/prospectus185.pdf*, accessed February 21, 2007.

[10] Kodak Slide Projectors. *http://slideprojector.kodak.com*, accessed April 7, 2007.

[11] Cara Thayer, via e-mail, April 7, 2007.

[12] Joel Straus, telephone interview, February 2, 2007.

[13] Cath Brunner, via e-mail, June 22, 2007.

[14] Terre Haute, Indiana. "Public Sculpture Opportunity, Request for Proposals." January 25, 2007.

[15] Forecast Public Artworks. "Saint Cloud Public Library, Request for Qualifications." *http://forecastart.org/St.Cloud_RFQ.pdf*, accessed February 26, 2007.

[16] Kansas City Downtown Council.

[17] Reprinted with permission by the Public Art Program, Arlington Cultural Affairs.

[18] Jennifer L. Riddell, via e-mail, January 19, 2006.

[19] Joel Straus, via e-mail, April 9, 2007.

Chapter 5:

Congratulations! You're a Finalist! (Now What?)

You've just been notified that you're one of three (or perhaps four, five, or more) artists selected to be pitted against each other for a commission. You now need to make an all-out effort to win the confidence and imagination of the selection panel. While a few public art agencies simply invite finalists for an interview before choosing one to put through the hoops of coming up with a detailed plan for artwork, the majority ask for specific proposals before meeting each artist. In the first approach, they're putting the emphasis on finding an artist they think they can work with to develop a concept; in the second, it's more about the concept itself.

You will be given a proposal fee of $500–$2,500 or more, depending on the size of the project budget. Like the odious RFP, this is another bit of procedural cognitive dissonance in the way public art is chosen. Because your art ideas comprise the bulk of the value of your work, that means you're essentially getting paid a few hundred bucks for your most important effort—sometimes without the benefit of having full access to the decision-makers and end users as you will once you are under contract. And that money isn't going into your pocket to compensate for all of that brainwork. It'll be spent on hard costs such as printouts, models, material samples, and perhaps a site visit and consults with architects or engineers as you pull out all the stops to win the thing. I have a colleague who was short-listed for a half-million-dollar project for which he was given a $10,000 proposal fee. He spent every dime of it on models and 3-D renderings, and he still lost. He doesn't regret it because he knows he gave it his best shot.

The finalist proposal needs to be as complete and accurate as you can make it, even though you have not yet been selected and put under contract. All agencies are different, but in general, if you win, you'll have some flexibility with your concept because they'll understand that your response to the site will change once you get more of a chance to investigate it. Don't expect a lot of flexibility though. After the selection panel makes its decision and goes home, after the full commission, city or county council, or other governing body puts its official stamp on it, it's not that easy to decide that you want the work to go in another direction. In addition, your initial numbers and schedule may end up as an attachment to the legally binding commission contract, so don't assume there's anything preliminary about your finalist proposal.

Questions to Ask Yourself

Ask yourself these questions as you lay out your finalist proposal:

1. Is your idea buildable?

Can you, given where you are in your experience, actually make (or find others to make) what you are proposing?

2. Is it feasible given the timeline?

Can you deliver what you're promising within the allotted time frame?

3. Is it worth it?

This is a more complicated question than weighing whether you will make money because there are intangible benefits to take into consideration, especially when you're first starting out. Financial advisor Nancy Herring recommends asking yourself these questions to decide if there are other reasons besides income to invest your efforts:

- Will it build my career by raising my profile and adding to my portfolio?
- Will it give me the opportunity to make work I love?
- Will it help me gain real-life experience and lay the groundwork for me to be more competitive the next time around?

Questions to Ask the Project Manager[1]

- *Budget.* Find out exactly what the budget will cover and the proposed payment schedule. Ask if there are any other sources of funds that could help with "leveraging" the construction budget. This is where there might be an overlap in construction and art funds allocated for the same site. For example, if your site is a sidewalk and your idea is to create an artwork using pigmented concrete, ask if your budget will only need to cover the cost of the pigment and design, and if the construction budget will pay for cement and installation.

 Ask if the budget you submit with your finalist proposal is going to be the one attached to your contract, or ask if you can refine it after your attorney has a chance to go over the contract, after you find out more about the details of the site, and after you get the final estimates from your subcontractors.

- *Contract.* Be sure to get a copy of the contract you would be expected to sign if you won. Go through it with a fine-toothed comb to look for any requirements that will cost you time or money, such as special insurance, storage, meetings, travel, site prep—or attorney's fees that you'll incur to help you decipher the contract.

- *Timeline and schedule.* When does the agency expect certain work to take place? Are there any hard deadlines, such as a dedication, which must happen on a specific date? What is the schedule for the entire project for all contractors—design, construction, and installation included? At what point is the artist expected to be involved, and what work will you be expected to accomplish?

- *Proof of approval.* The book *Going Public* recommends that you get legal evidence that the site has been officially sanctioned for the proposed public art project. I would go further than that and be sure to ask if the project itself has been approved and that the planned funds are available. Legal documents or something in writing, such as an e-mail from the program administrator, could come in handy if the deal starts going sideways. Many an artist can tell you a tale of woe about a year's worth of work that went down the drain because the agency couldn't raise matching funds, the mayor changed her mind, or the economy took a dive.

- *Site plans and photographs.* Get every kind of visual that the project manager has available to give you about the site, especially if the project site does not yet exist or if you can't afford to visit it in person. Not only will you need these to develop your idea, but you can use elevations, photos, and architectural renderings to mock-up what your work would look like as a virtual in situ without having to duplicate the efforts of others. Look at the site on Google Earth to get a feel for what's going on around it. Is it bordered by parks, buildings, vacant lots, or freeways?

- *Building and zoning permits or other relevant regulations.* Are you or your fabricator going to be responsible for navigating the bureaucratic maze to get these approvals or will the agency have done all or some of that for you?

- *Statement of the site's substructure, if known.* In other words, has the agency done its due diligence and made sure it isn't asking you to install your mosaic over a painted wall that you need to sandblast to make it usable, or that the parking garage lid where your landscape installation is going is engineered to hold it?

- *Environmental regulations.* Increasingly, as municipalities become more sensitive to preserving or reversing damage to the natural environment, they're doing "environmental impact statements" (EIS) before under- taking improvements of any kind. Ask for the EIS or a summary of it to make sure there's nothing that will affect your concept or costs.

- *Preliminary preferences regarding the proposal's format and content.* This is the time for you to diplomatically find out if there is any flexibility on the budget, timeline, payment schedule, or anything else you discovered wasn't realistic about the initial proposal. Remember, whoever wrote the proposal and instructions for the finalists was seeing the project from a hypothetical perspective, not from the perspective of the artist who examines every practical detail with a magnifying glass. Most project managers will welcome any input from the finalists about gaps or inconsistencies you found in their process or budget—as long as you're not negative and accusing about it.

21 Tips for Writing a Proposal (for a public art commission, grant, or anything else)

1. Read the prospectus and any related material carefully.

2. Reread, underlining or highlighting the important parts.

3. If there is any element of this prospectus that you cannot fulfill, discard the prospectus before wasting any more time on it.

4. Consider the goals of this organization and decide whether you are willing to be associated with them.

5. Make a list of what is being requested; e.g., budget, drawings, photos, slides of previous work, one-page proposal, etc.

6. Note which of the above you have on hand, which you have yet to obtain, and which you have to create.

7. If a budget is involved, double-check it for accuracy, using a method different from that which you used to draw it up in the first place. Experts say that things often take two to three times as long and cost twice as much as you had planned.

8. Decide who your audience is (for the project and the proposal): that is, are they artists, tech people, architects, or a mix?

9. Decide what you are going to do.

10. Decide how you are going to do it.

11. List who else will be involved, if anyone.

12. List your materials and methods.

13. Make an outline of your proposal.

14. Following the outline, do the actual writing. Use clear, simple language. Don't worry too much about grammar and spelling at this point.

15. Separate its sections with appropriate headings and subheadings.

16. End with a paragraph that summarizes the proposal succinctly.

17. After you have finished the first draft, set it aside for a day, then reread and correct it. Make deletions and additions as necessary.

18. If using a word-processing program, run the proposal through spell-check, being careful with homonyms such as "their" and "there" and "its" and "it's." Unless you have an above-average grasp of grammar, don't use a grammar-checking program, as it will do more harm than good. The *Chicago Manual of Style* is available as a book, CD, or online through subscription. There is also free useful information from its staff at *www.chicagomanualofstyle.org/*. Other free resources include *grammar.ccc.commnet.edu/grammar/* and *www.grammarbook.com/*.

19. Read it aloud, preferably to a willing partner. This will help you (and your listener) catch grammar and logic mistakes that might slip by otherwise.

20. Rewrite as many times as necessary to ensure that it is clear to even the most harried reader.

21. Have someone new proofread it.

Reprinted with permission from *The Art Opportunities Book* by BENNY SHABOY, (*www.ArtOpportunitiesBook.com*, 2004).[2]

TIPS FROM THE PROS

I asked the project directors of six leading public art agencies what questions they advise artists ask when notified that they've been chosen as finalists.

- Because the artist is usually brought in at the end of a long planning dialogue, ask what issues and expectations have been discussed regarding the art.
- What is the physical-cultural-political history of the project? What does the project manager perceive to be the physical, intellectual, and aesthetic/sensory goals of the project?

- How did this project come to be? What other projects have been accepted? Try to get a sense of their "personality."
- How open and flexible is the community to new ideas? Are there any sensitive political issues or is there a history of controversy surrounding a past art project?
- Is the budget firm, or is it just a number to make all proposals more or less equal?
- Will the agency have any funding for regular maintenance of the artwork?
- Are the architects flexible and willing to embrace an artist as part of the team? Or do they represent a more traditional approach in terms of the relationship of the art to the architecture?
- What did the committee like about the artist's work in particular? Which previous work did they respond to? Get the contact information to call each committee member and architect to ask him or her these questions individually to incorporate them into the finalist proposal.
- When is the finalist proposal due? If awarded the commission, how soon after that can the artist expect a signed contract?
- What happens to any budgeted contingency fee that the artist doesn't spend? Does he or she get to keep it, or does it revert back to the agency?
- Who is/are the intended or expected audience(s) who will have significant and/or primary interaction with the work(s)?
- Does the agency have the sort of technology you need for your presentation? (For example, a DVD player, a digital projector that will connect to your laptop, etc.)
- The most intelligent thing artists can do is create the opportunity for a fairly regular dialogue with the public art administrator and then *listen carefully,* as opposed to asking leading questions based on their presumptions that might limit their opportunities.

Questions contributed by LEE MODICA, JANET KAGAN, JILL MANTON,
PORTER ARNEILL, JULIA MUNEY MOORE, KURT KIEFER

WHAT GOES INTO A FINALIST PROPOSAL?

There are three main components to a finalist proposal: concept, budget, and schedule. There's also an underlying subtext: credibility. You need to convince the selection committee members that you can pull off what you're proposing by giving them a thoroughly-researched idea and a realistic, detailed budget and schedule. The more you look like you've got a handle on

the entire process, the more confidence they will have that you can success-
fully execute your proposed artwork.

Concept

If your idea captures the hearts and minds of the selection committee, they
may be willing to overlook some inexperience and inconsistencies in your
budget and timeline—but don't count on it.

As for how many ideas to submit, public art advisor Joel Straus recom-
mends to "give 'em two." One of them should adhere to the preconceived
vision provided by the agency through its RFQ or RFP project description
plus what you can glean from your conversations with your agency contact
and others associated with the project. The second should be what you think
would be right for the site after all the information you gather has been put
through your artist filter. You'll probably have many more ideas, but stop
at three. I've gotten feedback from several public art managers that pre-
senting too many ideas muddies the waters for the selection committee and
forces them to do the editing that you should have done before submitting
your proposal. You can indicate in your cover letter that you have more ideas
and that the ones shown can be considered as starting points should the
committee want you to explore further possibilities.

With as much access as you're able to get as a finalist, investigate the site
through a variety of lenses:

- history and memory
- culture
- social
- natural environment
- economic
- ethnic
- aesthetic
- political
- built environment
- function

It may not always be possible to get much access. For every agency that
will give you a mandate to get out there and engage the community, there
will be others in which the closest you'll get to the people who will live with
your artwork is whatever you're able to research yourself on the Internet,
through interviews, and in person. Mine more deeply for meaning than what
you can find on Wikipedia or the chamber of commerce's Web site. Look to
see what is beyond the immediate clichés even though you may end up
coming back to them to use as themes in your work.

This is the time to call the project manager for all the facts, insights, and contacts you need to put together a complete proposal. Unless you were given an unusually detailed packet of information as a finalist, you'll need to know the answers to these questions if you are doing a site-specific artwork. Even if you're proposing a relatively straightforward piece—such as painting a mural on a panel in your studio and then installing it yourself— you'll still need to be informed about payments, sequencing with other construction, site preparation, storage, and security.

From the project manager, get the names and contact information for the key representatives of the communities that engage with the site where your work will be. Think critically about the power structures. Who has the official voice, and what are the messages it is trying to convey? Whose voices were left out of the process? What is their experience of the place, and what are their stories?

The artist Jack Mackie and the team of designers he worked with in Chattanooga created a riverfront park where landscape, water features, historical markers, benches, and other features were united to tell the stories of Chattanooga using the metaphorical power of art. Named Ross's Landing after the Cherokee tribal chief John Ross, a portion of the park is paved with quotes marking the Trail of Tears, the name given to the forced removal of the Cherokee People from eastern Tennessee and northern Georgia to Oklahoma in 1838. Along this journey, nearly a third of the 15,000 people died. It's the sort of history that the chamber of commerce usually wants to keep out of the tourist brochures but found the courage to include as the true stories of Chattanooga when creatively led by the design team.

Artist B.J. Krivanek developed his own set of "mandates" to guide him in addressing the many facets of a public art proposal:[3]

- Translate: Narratives and aesthetics
- Accommodate: Various constituencies
- Incorporate: Urban histories and centers
- Negotiate: Public review and permits
- Manage: Budget fabrication and installation
- Anticipate: Public experience and interpretation

Lucy Lippard observes that the most successful public art seems to be governed by a "place ethic" that embodies some of these criteria.

SPECIFIC enough to engage people on the level of their own lived experiences, to say something about the place as it is or was or could be.

GENEROUS and OPEN-ENDED enough to be accessible to a wide variety of people from different classes and cultures, and to different interpretations and tastes. (Titles and captions help a lot here; it seems like pure snobbery even if unintended—to withhold from the general public the kind of vital information that might be accessible to the cognoscenti.)

APPEALING enough either visually or emotionally to catch the eye and be memorable.

SIMPLE and FAMILIAR enough, at least on the surface, not to confuse or repel potential viewer-participants.

LAYERED, COMPLEX, and UNFAMILIAR enough to hold people's attention once they've been attracted, to make them wonder, and to offer ever deeper experiences and references to those who hang in.

EVOCATIVE enough to make people recall related moments, places, and emotions in their own lives.

PROVOCATIVE and CRITICAL enough to make people think about issues beyond the scope of the work, to call into question superficial assumptions about the place, its history, and its use.[4]

Budget

Chapter 6 will go into excruciating detail to help you figure out how much you need to charge in order to make a living wage and the budget items you'll encounter when putting together your finalist proposal. Here are a few general tips.

Start with how much you need to pay yourself. Take your fee off the top and whatever is left over is what you have for hard project costs. It's like what flight attendants say in the safety demonstration: secure your own oxygen mask first before assisting others.

You've heard that old adage: everything takes twice as long and costs twice as much as you thought. Don't take it literally, but keep it in mind and put in extra cushioning in every category for unforeseen circumstances. Ten percent is a commonly estimated figure.

Many project managers consider it part of their job to help artists make their numbers work. Keep in mind, though, that you'll be up against other artists who have a great concept *and* a competent grasp of the numbers, so don't go to the project manager as a first resort. Figure out as much as you can on your own, with the help of your fabricator and within your own support group of other artists. If you find something that doesn't add up in the numbers the agency gave you, then call the project manager. On a terrazzo floor I was commissioned to design, my flooring contractor discovered that the budget the agency had allocated only covered the base costs of a simple, two-color design.

They hadn't calculated putting in the art. When we pointed that out to the project manager, she found the extra money we needed to do something fabulous.

One of the most complete lists of budget items that I've come across is this one, prepared by Jeffrey J. York of the North Carolina Arts Council.[5] I've added my comments after the italics.

1. *Artist's fee—a value assigned to the idea and design.* A key calculation to make is for artist's time. Start with 15 percent of the total contract. So a $20,000 contract is $3,000. If you need to earn $50,000 a year or $25 an hour, then you can spend a *total* of eighty hours—about two full-time workweeks, on this project. This includes all site visits, vendor meetings, and design time—*all* of the artist's time. These numbers show how important quick, easy facility with a project is. It stands to reason that a beginner will take much longer to accomplish these tasks, while a seasoned artist can probably manage the project in less than eighty hours.

Use Table 6.1 in chapter 6 to figure out the base hourly wage you need to make to live on.

2. *Labor—artist's physical time (including research, travel, meetings, community involvement, fabrication, installation, educational programming, documentation, etc.).* This is where your profit can get eaten alive. It's the answer to the question "Why are artists poor?" It's because we don't anticipate how much time it actually takes to make art. Estimate as close as possible from the stated scope of the project, your discussions with the project manager, and the process you need to make the kind of work you want to figure out how many man-hours it will take you.

Using the base hourly wage calculator in Table 6.1, even if you come up with $25 an hour as what you need to bill, remember that not every hour in a forty-hour workweek will be billed to a specific project's budget, because many workdays are spent cleaning up your studio, running errands, applying for other projects, etc. If your contract asks you to specify an amount that you will track and bill for labor (meetings, supervising, travel, design, hands-on art-making, etc.), start at $100 an hour. That's comparable to what other artists write in on their budgets for an hourly labor fee.

- *Assistants and other labor for research, model making, fabrication, etc.* If the project is fairly small, you can probably handle making all of the presentation materials yourself, including models, mock-ups in Photoshop, and printouts. To be competitive in the larger commissions where the stakes are as high as the budget, however, you may want to consider outsourcing the fabrication of presentation materials, such as 3-D or animated renderings (unless you know how to

do those yourself), professional-grade models, printed and bound packets, full-color presentation boards, and material samples.

Finding pricing for outside help is, mercifully, much more straightforward than figuring out your own labor. An architectural model maker will have a set fee depending on the complexity of the design, as will a CAD technician and a service center such as Kinko's. Those are all a phone call away.

3. *Consultants and Other People-Related Costs.* You will rarely need all of the help listed below. Remember in your dealings with these professionals to seek long-term relationships with the best people you can find. Haggling doesn't always pay off in the long run.

- *Structural engineers or specialists like electrical engineers, lighting designers, or plumbers.*

- *Architects or landscape architects.*
 Your need for these professionals will increase proportionately with the complexity of your concept and installation. For insurance purposes, your contract may require you to have your design redrawn and stamped by a licensed architect or engineer no matter how detailed your own drawings are. That's because artists are not in a licensed profession and are not able to get professional liability insurance to protect them from being sued if anyone gets hurt as a result of bad design. This could cost you in the range of $1,200 to $3,500 and beyond for a particularly technically complex job.

- *Historians, sociologists, urban anthropologists, etc.* Each community usually has one or two history buffs who would be thrilled to help you research the site without charge. Local libraries and universities would be the place to start looking for other social scientists and archives. However, if any of these experts—amateur or pro—is going to add so much content to the work that they amount to being cocreators or collaborators, they deserve to be paid and credited.

- *Lawyer.* Until you're proficient in understanding a public art commission contract—some of which can be over sixty pages long—you should have an attorney look it over for you. Ask to see the contract before you submit your finalist proposal. You'd be surprised what sorts of hidden expenses you can find lurking in there. Expect to pay around $350 an hour. Also check to see if there's a Volunteer Lawyers for the Arts chapter in your area by going to *www.vlany.org*. This is the New York chapter's Web site, but if you look in its "Resources" section under "National Directory," it has an up-to-date list of its counterparts in other states.

I used to think I could skip hiring an attorney in order to save money, but after losing thousands of dollars because I didn't catch everything I should have in contracts, I've converted.

- *Photography*. It's an essential investment to document the process as well as the finished work for your Web site, portfolio, speaking engagements, press, and publications.

- *Fabricator*. Hiring an outside firm to realize your concept if it is in a material you are not tooled up to work with—terrazzo, plate glass, mosaic, water, or light, for example—will be the largest line item in your budget. Chapter 10 will go into more detail.

4. *Travel.*
- *Airfare or automobile mileage*
- *Car rental*
- *Hotels*

Travel expenses can mount. Use all the resources available to cut costs. The Web sites for Travelocity, Orbitz, and Priceline will give you enough information to estimate the cost of your travel. When it comes time to make your reservations, packages that bundle airfare, car rental, and hotel can save you hundreds of dollars. One well-traveled artist I know names his own price on Priceline for hotels and routinely stays in nice rooms that would normally cost $120 or more for $75 a night.

The Couch Surfing Project (*www.couchsurfing.com*) is a worldwide social network whose goal is to spread peace, love, and understanding through the exchange of free lodging at the homes of like-minded people. The Hospitality Club (*www.hospitalityclub.org*) is a similar free organization. One of my students, Sam Reicks, speaks highly of having spent a summer traveling throughout Europe this way.

(Note: In case you're thinking that you can put the cost of a hotel in your budget and then stay someplace for free while pocketing the difference, you'll have to think again. Some agencies will ask that you turn in an invoice backed up with receipts for all of your expenses before they'll reimburse you.)

- *Meals*. If you worked for a large company, you wouldn't have to collect all your meal receipts for a refund; you'd simply get paid what's called a per diem. Each city all over the world has an allowance calculated for meals and incidental expenses (M&IE). The U.S. General Services Administration Web site makes it easy to find this information to use

when estimating your travel costs. Go to *www.gsa.gov* and navigate to "Travel Resources" > "Per Diem Rates."

5. *Transportation.*
- *Shipping materials to fabrication site*
- *Shipping work to installation site*

If you're working with fabricators, these expenses will be included in what they're charging you. If not, you'll need to find out how much a shipper would charge to pack, send, and unload your work. Get several bids. Haggling may work better here than with professional consultants. Look into if it would be cheaper to rent a truck and drive the work out yourself. Be sure to include a charge for your time, lodging, and meals if you do this.

6. *Materials.* Again, if you've hired a fabricator, materials will be included in his or her costs. If you're doing the work yourself, base the materials cost on previous projects. Some artists add a margin of 10 percent so they won't get caught short.

The cost of materials can vary greatly. Search far and wide for the best possible prices if you are using expensive materials like metals, whose prices fluctuate with market rates. Work closely with your fabricator to avoid mistakes and miscommunication. Look into reusing material from the project site that the project manager might have been planning to pay the contractor to cart off, or use recycled materials. An increasing number of artists are working this way to lower costs, make a stronger connection between their work and the site, and go easier on the environment.

7. *Site preparation.*
- *Cleanup/removal*
- *Irrigation and plumbing preparation*
- *Testing*
- *Grading/landscaping*
- *Surface preparation*

It's rare that the artist would be asked to do any of this sort of raw site prep. What's not so rare is that you'll arrive ready to go to work and discover that there's a bunch of debris on the site, or that the wall has something on it that needs to be removed before you can start. In any case, it needs to be absolutely clear in your contract who is responsible for site prep. If it's going to be you, spell out what you're responsible for and how much of your budget you will spend on it. Don't forget that above the cost of hiring someone to do this work for you, you need to charge for the time you'll spend on coordination and supervision.

- *Electrical and lighting.* The artist's budget will often be expected to cover the cost of lighting the artwork and any other electrical work or fixtures that were special requirements of the artwork; i.e., not part of the basic construction bid.

8. *Installation needs and equipment.*
- *Rental of lifts, scaffolding, special equipment/materials, etc.*
- *Truck rental*
- *Work lighting*

Your fabricator will take care of all of this as part of his or her subcontract with you. If you're doing it yourself, just as with site prep, be sure to charge for your labor, coordination, and supervision.

- *Storage rental.* This is an expense that can sneak up on you if you're not careful. If the client does not have the site ready by the time your work is ready, your contract will most likely say that you need to pay for storage even if you've kept your end of the bargain by getting the work done on time. I once did a project for a client that was two years behind in construction. I had to pay for the storage of my work for that entire time.

- *Traffic barriers/off-duty police.* Believe it or not, the artist is often expected to provide her own security and site control by hiring government and/or union workers. It's not realistic for reasons having to do with access, liability, and logistics. Try to change this requirement in your contract if at all possible.

- *Permits.* Unless it's a permit specific to work in your studio or one that your fabricator needs, try to get the commissioning agency to get any government permits related to the site. It's already part of the bureaucracy. It'll be easier for the agency.

9. *Office/Studio Expenses (aka "overhead").*
- *Rental, phone/fax, utilities, supplies*

Here's another place where you could leak money by not knowing how much overhead to write into your budget. Figure out how much it costs you per month to keep your place of business up and running, and allocate a portion of these expenses to the project. If your studio is in your home, measure what proportion of space it takes up versus your living space, and apportion your rent and utility expenses accordingly. It would be worth hiring an accountant to help you with this.

Overhead is deductible on your taxes, and fairly easy to log. Your automobile mileage and gas for business-related use is also tax deductible. You can buy little notebooks specially designed to keep in your car for tracking car-related expenses at office supply stores.

10. *Insurance.*
- *Loss/theft/damage coverage to protect the supplies and fabricated parts prior to shipping*
- *Loss/theft/damage coverage during shipping*
- *General liability for self and assistants*
- *Workers' compensation for assistants*
- *Any special insurance riders*
- *Performance bond*

See chapter 7 to learn how to deal with the myriad of insurance coverage required of public artists.

11. *Taxes.* It hurts, but ya gotta do it. The commissioning entity will almost certainly require you to sign a document that says you understand that you are responsible for any and all taxes. It probably will require a tax reporting number and will submit these documents to the I.R.S. This means you are on the hook. You cannot say, "Gosh, I just didn't understand." The documents make you swear that you understand.

Good record keeping and proper allocation of expenses will help reduce your tax bill. Many of the expenses in the sample budget are tax deductible or used to reduce your gross income for FICA purposes. See chapter 6 for a fuller discussion of taxes, but a good rule of thumb is 25 percent of your profit, not the gross contract revenue. Many artists do their own taxes and are good at it. If you're not, bite the bullet and hire an accountant.

12. *Contingency.* A contingency is a buffer of usually 10 percent of the total budget for unexpected problems and cost increases. The way most contracts are written, it will revert back to the agency's coffers if you don't use it. Not all contracts will require that you have a contingency. If they don't, don't put one in. Instead, put the 10 percent buffer in each of your other expense categories for your own protection. If the contract does require a contingency, make sure you don't have anything left over at the end of the project by charging enough for your labor, supervision, and overhead when you submit your invoices to the agency.

In summary, budgeting for public artwork is a lot like the hot potato game. The agency will try to make as many expenses as possible the responsibility of the artist. It's your job to root them out and try to toss them back.

Schedule

There are two important things to remember about scheduling:

1. Don't feel like you're stuck with the payment and work schedules in the initial contract.

No one knows better what it takes to make your work than you do. What is written in the contract is a one-size-fits-all best guess that a bureaucrat came up with. Yes, it may be tied to a very real construction schedule, but those are subject to change too. You need to design in flexibility so that you're not put in the position of having to front large amounts of your own money for materials or fabricators. If you need 50 percent up front to buy materials and get a fabricator started but the contract is written to pay out in percentages of 5-20-20-20-20-15, make your case for why that won't work for this project.

2. Tie your schedule to benchmarks, not dates.

This is discussed elsewhere in the book, but it bears repeating: don't agree to have a specific phase of work done by a specific date. Make it contingent on whatever you need the client to do first. For example, rewrite the contract to say, "Materials will be ordered, contingent on receipt of second payment of $X," or "Fabrication will commence contingent on receipt of third payment of $X."

It doesn't have to be about money. You could stipulate that "installation will commence upon preparation of site by client as specified in Attachment C." Try to think of every possible hitch you could encounter along the way and make a contingency plan for it.

To illustrate this point, here's a teaching moment courtesy of Ken vonRoenn, an artist who has had ample opportunities to learn things the hard way after more than thirty-seven years and 500 projects as an artist:

Lesson: *Get the majority of payment from a client before a work is installed.*
Story: *Early in my career, I designed a large project for a church and conceded to their demand that they would pay 90 percent of the cost only* after *the windows were installed. After installation, they kept finding small changes they wanted made, even though the window was exactly like the design. We made innumerable changes over six months in hopes we would be paid. Ultimately, after we made all the changes they requested, they offered to pay us only 50 percent of what was owed because they had "run out of money." I learned that all the requests for changes were just a ploy to delay paying us and our only option was to sue, which would have meant we would not have received any money for*

at least a year, which would have been far less than the partial payment they offered.

Net result: *I lost more than $50,000, but I now include a clause that provides for 90 percent of payment before a work is installed. I have not had a problem with this since.*

Glenn Weiss of *glennweiss.com* developed this outline to help artists organize their final proposals:

1. GENERAL DESCRIPTION OF ARTWORK: Text with attached drawings, images, and/or samples (include important dimensions, materials, colors, fabrication method, etc.)

2. GENERAL DESCRIPTION OF HOW THE ARTWORK SATISFIES THE PROJECT CRITERIA AND SCOPE OF WORK. (Please note any issues that have arisen during your research.)

3. BUDGET. *[For a complete list of expenses, see the section on "Budget" starting on page 79 of this chapter.]*

4. DESIGN COORDINATION REQUIREMENTS. (Concepts, designs, materials, lighting, and utilities recommended or required in the design of the facility.)

5. CONSTRUCTION COORDINATION REQUIREMENTS. (Sequencing and requirements of artist regarding on-site construction or installation. If there are subcontractors, please name them.)

6. MAINTENANCE PLAN.
 a) Ongoing maintenance of artwork. (Activity and frequency.)
 b) If applicable, cost of anticipated replacement parts and average lifetime.
 c) Date and type of anticipated major maintenance such as re-painting.

7. MAINTENANCE PLAN FOR THE SITE. (How is the artwork or artwork base designed for typical site maintenance such as lawn mowers, weed whackers, window washers, or vacuum cleaners? Do the site maintenance crews need to use any special methods—or avoid any typical methods—in order to not damage the artwork?)

8. REQUIREMENTS REGARDING THE SITE. (Examples include how much clear space is needed around the work and what kind of landscaping, lighting, furniture placement, tree trimming, openness, air movement for mobiles, etc. is required. Include drawings if helpful. What things should *not* happen at the site?)

9. EXTENT OF SITE THAT IS PART OF THE ARTWORK. (Some artwork has elements of the building or site that are part of the artwork

concept. In other words, if this aspect of the building or site is changed, then the artwork will be damaged. At this stage, the artist will require the removal of his or her name from the work. If a future change in the site attribute would not require the removal of your name from the artwork, please include in "requirements of site" in #8 above.)

The Five Work Phases of a Public Art Commission[6]
Contributed by Janet Kagan, Principal, Percent for Art Collaborative

As a public artist, you will be expected to develop and refine ideas and content for the work of art through interaction with your client and the site, in public meetings, and from your perceptions of project goals and desires. The following phases of work frequently define the payment schedule of a public art contract, although it is important to draft a scope of work that reflects your public art process.

1. Background Research and Conceptual Design
 a) Meet with project representatives; tour the site(s) and the community; learn about the project's goals and listen to multiple constituencies; review all relevant drawings.
 b) Development of preliminary ideas for the work(s).
2. Preliminary Design, Budget, and Proposed Schedule
 a) Identification of any necessary consultants to the project.
 b) Presentation of initial ideas concerning form, material, location, response to climate, and written project description.
 c) Proposed budget for each element.
 d) Schedule that reflects the integration of the project with the overall construction site.
3. Final Design
 a) Detailed drawings showing material selections and specifications for the artwork(s) and interface of the work(s) with building architecture, landscape, mechanical/electrical/plumbing, or other construction elements.
 b) Final cost estimate (design, fabrication/construction, transportation to the site, installation, and post-installation maintenance).
4. Fabrication and Construction
 a) Inform the client of any changes to the work (materials, color, form, size, design, texture, finish, location, etc.).
 b) Presentation of work-in-progress at approximately 50 percent and 75 percent completion.

5. Delivery, Installation, and Dedication
 a) Identification of all equipment and site preparation necessary
 to deliver and install the work(s).
 b) Arrange for off-site storage, should that be necessary.
 c) Prepare remarks for dedication ceremony, and celebrate!

An important dimension to the process of design, fabrication/construction, and installation is keeping in contact with your client. These communications may be written and formal, or informal telephone conversations that are followed up in writing. Public clients cannot afford any surprises because there are financial and political repercussions to misunderstandings that will extend beyond the reach of your specific project. As your client helps advance your artistic career, you and your work will forever change their program and the community.

PRESENTATION

Your aim is twofold: to make them see your work in the site so clearly that panelists feel like it was always meant to be there, and to assure them that you can get the job done. Help the panel place your idea in a context that goes beyond this project. Tie it into other work you've done, and show how it relates to larger themes you've been exploring. You can also cite outside influences, whether they are other artists, microbiology, the cosmos, or political and social concerns.

1. Visuals: Show as clearly as possible what your work will look like in the site: be visually literal. Even though you can see in your head what the project is going to look like when it's finished, any extra trouble you go to on your visual aids will not be wasted. Remember that there will be nonartists on the selection committee who won't have the same capacity to extrapolate from a rough sketch and description that a trained artist or design professional will. Your visual materials must spell out every little thing for them. They won't buy it if they can't visualize it. Keep in mind that the bar is raised higher all the time as more artists come in with realistic looking 3-D renderings and animations.

- Presentation boards with renderings or composite images of how the completed work will look through Photoshop, including where it fits on the elevation, the material and color samples, traffic flow, and any other pertinent graphics that can help the selection panel visualize how your idea would work in that place.
- An alternative to boards is to put all of this information in a PowerPoint presentation with material samples and a presentation summary to hand out after the lights go back on.

2. Handouts: Some artists put together a small booklet for each panelist that contains sections such as photos and findings from their research of the site, a summary of their concept and how it ties into the understanding of the site that they gained from their research, and descriptions of the material along with information about the fabricators and subcontractors they work with, as well as a detailed budget and timeline. It's the sort of thing you can print yourself and then have bound at a service center such as Kinko's. These books can become works of art themselves, incorporating found objects such as leaves from the site, small paint or material samples, and articles and photos displayed scrapbook-style.

3. Attire: It wouldn't have occurred to me to mention what to wear to the presentation, except the question comes up often enough with my students that I thought I should. So much depends on individual personality. Some artists can get away with showing up rumpled and charm everyone on the committee, while others who try the same thing will look disorganized and disreputable. I'll never forget one artist who gave a presentation to a committee I was on in black fishnet stockings (complete with a seam up the back), a miniskirt, and spike-heeled shoes. I don't know what she thought she was selling, but it seemed uncomfortably inappropriate in that small, beige, fluorescently-lit conference room among company dressed in business suits and lab coats in the middle of a workday.

In general, dress as a cleaned-up version of yourself. If you don't own a business suit and aren't used to wearing one, don't go out and buy one for the meeting. Artists can get away with dressing more creatively than the typical workaday panelist, but draw the line at party clothes, beachwear, or anything that you picked up off your bedroom floor that morning.

What to wear will be the least of your problems if you lose money every time you do a project. In the next chapter, you'll get the big picture on running a small business profitably.

End Notes

[1] Adapted by Jeffrey L. Cruikshank and Pan Korza. *Going Public: A Field Guide to Developments in Art in Public Places*. (Amherst, MA: Arts Extension Service, University of Massachusetts, 1988, 1976.) Comments in italics are the author's.

[2] © Art Opportunities Monthly, 2004.

[3] B.J. Krivanek, in a presentation to the author's course, Public Art Professional Practices, at the School of the Art Institute of Chicago, March 7, 2006.

[4] Lucy Lippard, *The Lure of the Local: Senses of Place in a Multicentered Society*. (New York: The New Press, 1997), pp. 286–7.

[5] North Carolina Arts Council. "Public Art Commissions: An Artist Handbook" Addenda IV. Office of Public Art and Community Design, 2005.

[6] Janet Kagan, Percent for Art Collaborative, 2005.

Chapter 6:

Budgeting for Public Art Projects and Other Financial Survival Strategies

With Nancy Herring, financial consultant

We live in a time of unprecedented wealth—for some people. The money is out there, but we artists have to be smart about getting it by overcoming a poverty mentality; we can stop selling ourselves short and learn a few timeworn business skills. The starving artist brainwashing is so intense that many of us believe we can't be serious artists if we earn any more than a subsistence-level income from our work. We can tell ourselves that our work isn't valued, or we can put on different goggles and look around to see that many artists are making a living without being superstars.

None of us went into this for the money. With the same investment in our educations that most of us made, we could have picked more lucrative professions. Instead, artists seem to be motivated by a strong drive to leave our mark on the world by making visible our internal creative dialogues. But that doesn't mean we need to work for free.

According to Hans Abbing in *Why Artists are Poor*,[1] a large portion of the art economy has been built on the assumption that artists will work for substandard wages in exchange for being free to pursue our muses. Society's subtext—often swallowed hook, line, and sinker by artists themselves—is "Hey, we'd all like to be artists, but we have to put aside those childish dreams and work for a living." The expectation that artists should work for less than other highly trained professionals is so pervasive that those of us who can least afford it end up in the ironic position of subsidizing the gigantic budgets of our government and corporate clients by undervaluing our labor and creative output or by agreeing to contracts that don't factor in a living wage.

It's up to you whether or not to give yourself away, but remember that when you do, you're not just undercutting the worth of your fellow artists; you're ultimately devaluing art.

The first way to stop this cycle is to know how to budget for projects so that you don't shortchange yourself. I've invited financial advisor Nancy Herring to answer some basic questions. Because our personal finances are so closely tied to our business success, she addresses them jointly and puts public art into the larger context of commerce.

BUSINESS PRACTICES FOR THE PUBLIC ARTIST
By Nancy Herring, M.B.A.

What should artists charge for their work?

In business, the art market is known as a highly fragmented industry—no one entity has a competitive advantage or accounts for much of the revenue. There are numerous buyers and sellers; it is relatively easy to enter the business and exit. (Other fragmented industries are real estate and landscaping. By contrast, the lightbulb industry is extremely concentrated, with only three companies controlling over 80 percent of $250 billion of *global* revenue.) The challenge for artists is to find a strategy for success in the face of what can seem chaotic, impenetrable, and overwhelming.

In dealing with a highly fragmented industry, it makes sense to focus narrowly on the doable and the incremental. A necessary first step is to build a solid financial foundation, which will enable you to achieve a sustainable living as an artist. These are skills you need to succeed whether you are in public art or other artistic endeavors. This section will give you some tools in personal finance, budgeting, and troubleshooting.

Money = Freedom

An artist is self-employed—there's a lot of freedom in that but also many challenges. You are responsible for paying taxes, organizing time effectively, making enough money, saving money, obtaining insurance, and so on. You can manage your life so that if you want to spend six months in Europe, you don't have to ask a boss for the time or quit your job. If you do your best work between midnight and 6 AM, then you are free to do it. You have the wonderful and rare opportunity to do what you love for as long as you can. Picasso worked as an artist for over seventy years! Louise Bourgeois is still working well into her nineties.

This section will try to give you tools so that you can plan your career on the basis of your needs and goals, and in terms of what you can target and control. If you have a firm idea of what your goals are, what you need to do, and your time frame, then projects that add to your goals become easier to identify, and those that detract become easier to reject.

Plugging away at what you can control helps maintain sanity and keeps the self-doubt at bay. Public art commissions can and should play a role in establishing your reputation as an artist, as well as help achieve your income goals. It won't really matter if you are as famous as Maya Lin. Go for it if you want it, but an artist's career isn't an either/or proposition. Art is a multibillion-dollar business in this country, and there are multiple gradients and entry points of opportunity.

Here are three easy-to-remember (but harder to do) maxims for achieving your financial goals, which will enable you to work as an artist, not as a lawyer with an art hobby.

Earn Enough Money

Never give your work away; don't undervalue your efforts. Remember that they need you. You may trade work, but be sure you get a good value. Sometimes it's useful to barter—just don't use your cash. Know what you're worth. Know how much you need. When someone asks you to do it for free "for the children," walk away. By and large, commissioners of public art are professionals; they may not necessarily know a lot about art, but they work with contracts and budgets all the time. Their proposals may not be perfect, but they can be flexible and practical; in short, they are able to understand that an artist must be paid, too. But you won't get paid unless you ask for what you're worth.

Step One: Know What You Need to Live On. You need to earn enough to pay your bills and save. The amount needs to grow over time in order to keep up with inflation. To get a handle on what you need, get three to six months of bank statements. Find out what your monthly expenses are that you've got to pay no matter what. These should include housing, transportation, health insurance, utilities (communications, electricity, gas, water, and garbage), and food. Some expenses are quarterly or semiannual—this is often the case with auto insurance. Don't underestimate these expenses. Recognize that you're unlikely to succeed at saving on heat by keeping the temperature in your home at fifty degrees. Also, you probably need a fast Internet connection and a cell phone, but maybe you can do without the text messaging service.

Step Two: Figure Out What You Need to Make a Living Wage. Table 6.1 breaks down how much you need per hour to achieve your income goals. This should be your benchmark for allocating your time and efforts. Ask yourself if you're achieving your target income. If your target is $50,000 a year, then a forty-hour workweek at fifty weeks a year comes out to $25 an hour. That may sound like a lot, but architects bill at between $100 and $125 an hour, and attorneys from $350 to well over $1,000 an hour. It's difficult to keep body and soul together while living in a city for much less than $30,000—and that's with a roommate.

Table 6.1

Annual Target Income (before taxes)	Hourly Wage[*] (before taxes)
$30,000	$15
$50,000	$25
$75,000	$37.50

[*]Assumes a forty-hour workweek, fifty weeks to the year (i.e., two weeks of vacation).

Taxes Don't forget to estimate taxes in your living expenses. You must pay federal, state, and local income taxes, as well as FICA, also known as Social Security. An easy rule of thumb is to estimate a total tax rate of 25 percent. The IRS requires that the self-employed estimate and pay quarterly income taxes.

Over time your income needs to grow sufficiently to keep pace with inflation, which has run about 2.5 percent a year in recent years. Over ten years, that means $50,000 today must grow to $64,000.

Never Spend More than You Earn

This is probably the single hardest thing for an American to control. Many think their spending is under control if they can meet their monthly expenses, don't overdraw their bank account, and make the minimum payment on their credit card. WRONG!!

Typical overspending rationales include: "My time is so crazy, eating out actually saves me money." "Really, having the newest sneakers out there ups my game." "I believe I need a high-end car in my business—it's important that people think I'm successful—first impressions matter." All of this is completely false. In restaurants, for example, you are actually paying not just for the cooking that others are doing but also the restaurant's rent, use of equipment, taxes, salaries, utilities, and so on. Even an income of $75,000 doesn't work out to an hourly wage that covers all this. Besides, you already incur many of these costs in your home. Don't pay twice.

Step Three: Find Where to Cut Down. A necessary exercise is to find out where all the money goes. Track out-of-pocket spending for a week or two. The results may shock you. Pull all those receipts out of your pockets and it turns out you've spent $10 on lattes, $20 on cigarettes, $20 on beer. Don't forget gas and parking. This can really get crazy. If you find you eat lunch out four times a week, try to cut it to twice a week. See if you can't make your own coffee. My husband used to average about six lattes a week, and it cost him about $72 month (about $800 a year). That could buy a lot of art supplies. Repeat this exercise once a year or so; it helps keep you on the straight and narrow.[2] There are some new Web sites that might help you easily track spending and join communities that have lots of specific money-saving ideas. Try *www.wesabe.com* or *www.geezeo.com*. These are free, robust, easy to use, and actually rather fun.

Never Spend More than You Need To

While there are many variations between lifestyles, there are some crossover areas where we can each save money.

Banking Services A brief primer on financial services: banking services should be cheap. Many banks look cheap, but pile on fees and expenses. For one, the cost of bounced checks is at least $50 and likely to rise. A few more quick tips:

- Use the Internet aggressively to find the best rates on all your banking needs, including checking accounts, savings and CD rates, discount brokers, mortgage rates, and credit card interest.
- Banks favor customers with more, rather than less, money, so you will get fee reductions the more business you do with a bank. (This may seem unfair, but big accounts are more profitable than small accounts.)
- Deposit checks the day you get them. If your bank charges for online banking, you should change banks.
- Try to use automatic deposit and automatic payments as much as possible; this will greatly ease your record keeping burden. (You should know that there is no advantage to using paper checks. In fact, some banks now charge extra for their use. There is no float left for checks versus debit cards; i.e., checks clear at your bank the same day, just like your debit card. At the time of this printing [2007], the cost of a first-class stamp is forty-one cents—it's just too expensive not to use electronic banking. A year of snail mail for your bills costs about $40—equal to about a tank of gas.)

Credit Cards You need one, and only one, credit card. This will help earn you a good credit score. No credit history at all is only one step up from a bad credit history. You need to keep a credit line open, if only for this reason.

- Credit cards can also be useful for tracking expenses.
- Seek to pay off the balance every month.
- Watch your interest rate like a hawk. If your credit card company won't keep the interest rate they charge competitive with others, change providers. Demand to be rewarded for being a good customer; banking is a highly competitive industry; you'll get results. Ask that your credit card company meet the interest rate of competitors. Literally say, "I have been a good client of yours for _____ years. I just received an offer from Cheap Credit Corp. I'd like you to meet their offer of _____%. Will you do that for me?"
- You should look for a credit card that doesn't have an annual membership fee, but if you have one that does, ask them to waive it for you. If they don't, switch cards.

Communications Watch communications costs—services proliferate, and costs rise inexorably. The Internet is revolutionizing how artists do business, and it is a necessary (and tax deductible) expense. Still, it's easy to spend $200 a month before you realize what's happened. Premium cable, multiple TVs, and bells and whistles on your mobile phone all drive your costs up—way up. Focus on what you must have and try to eliminate what you don't need. Often, you can get your monthly rate reduced simply by calling your phone or cable company and requesting it.

Credit Score Your credit score should be 720 or higher. When you're chronically late on payments, you'll get dinged; if you default, you'll get hammered. Automatic payment on your regular bills will really help, but don't do it if you can't keep a cash cushion of one month's expenses in your checking account, because bounced checks will cost you, too. Instead, ferret out where you can cut expenses so you can live within your means.

There are three credit score companies through which you can check your rating for free once a year. Otherwise, it costs around $15.

- Experian: *www.experian.com*
- Equifax: *www.equifax.com*
- TransUnion: *www.transunion.com*

Cars Never, ever, ever buy a new car. If Grandma offers you one, try getting a portion as a used car and the rest as a contribution to your savings. A new car are a huge waste of money, and an even bigger one if you finance it. At a 4 percent interest rate over five years, a $17,000 car costs $23,000. Think of what you can do with that. The minute you drive your car off the lot, it has lost as much as half its value. That's right—if you have a $20,000 car, $10,000 just went up in smoke. It is much better that the $10,000 goes into savings, where it will work almost as hard as you do.

Housing Housing will almost always be your biggest single expense, outpaced only by raising children. Artists have the great luxury of living pretty much wherever they want. This can be a huge advantage in saving money and sustaining yourself as an artist. Home prices vary greatly across the country. Often, wages are low where housing prices are low, but an artist can earn a fair amount of income outside the community through public art commissions and gallery sales, which are priced closer to national averages. Here's a reality check: a home in Los Angeles on average cost $550,000 in 2007; the average in Chicago is $250,000. Average income, however, is the same. For those of you with roommates, there is a new Web site, *www.buxfer.com*, that will help the household track shared expenses.

Health Care Another service that offers price reductions upon request is healthcare. When you get your doctor's bill, call the doctor's finance office and ask if it will reduce the amount. It usually will.[3]

Save and Never Stop Saving
Build a cash cushion.
This is as important as earning enough money and not spending it. Aim to save 10 percent of your income year in and year out. Your first goal is to build a cash cushion, which will be extremely important to you. Let's dwell for a bit on how useful this cash cushion can be. Target at least six months of living expenses for your cash cushion. If you need $50,000 a year, then, $25,000 should do it. This won't happen overnight, but you will get there. You will be able to weather periods with no commissions or art sales, you can travel or take some art classes—and maybe expand the media you work in or you can put a full-court press into expanding your gallery representation. Most of these activities are part of sustaining your life as an artist. If you're able to save $5,000 a year and earn a 6 percent return on it, then you will achieve your goal in just four and a half years. And I bet you thought it would take ten years.

The Magic of Compounding This wonderful outcome described in the last paragraph is known as compounding. It is one of the most powerful wealth generators known to man. Conceptually, it is quite simple—it means that savings earn a return on the original amount and on all the profits thereafter, as well. By way of illustration, if you invested $10,000 at 10 percent, at the end of the first year, you would have $11,000. At the end of the second year, your $10,000 would grow to $12,100. After twenty years the original $10,000 would grow to $67,000 without any additional work or contribution from you. Compounding is also extremely flexible; money can be invested in lump sums, contributions can be made over the years, or the rate of return can change. Again, by way of illustration, if you invest, say, $4,500 annually for twenty years in the U.S. stock market and that money earned the long-term historical return of 12 percent, that investment would be worth $280,000. If you continued to hold that $280,000 in the stock market for another twenty years but invested no more money, you would have $2.3 million. Note that these results required neither genius nor Herculean effort; they merely are the result of investing your money so that it works as hard as you do. Terrible things can happen in the world which may interrupt this process, but in the last one hundred years, only during the Great Depression did we experience a significant period of negative compounding.

Earn a Return on Your Cash Cushion Your cash cushion can go to work for you. Certificates of Deposit, commonly abbreviated as CDs, are a safe way to

earn some money on your money, or as it's described more formally, to earn a return on your investment. There are many Web sites that can help with this, such as *www.bankrate.com*. Over time, this will enable your cash cushion to keep up with inflation and probably earn a little more, besides.

Future Goals Don't stop saving; always target saving 10 percent of your income. Your savings will help you achieve additional goals you may have as an artist, such as better studio space or living overseas. After you've built up that cash cushion, you will need longer-term investments for your savings. While establishing such a portfolio really isn't that hard, the financial industry seems to have done everything it can to make investing highly fraught, maybe even panic inducing. A reliable source for an introduction to investing can be found at *www.vanguard.com*, the Web site of the Vanguard Group. Jonathan Clements, who writes the "Getting Going" column for the *Wall Street Journal*, consistently offers clear, reliable, actionable advice. The articles are free on the *Wall Street Journal* Web site.

There is an alphabet soup of tax-deferred investment programs that will help you achieve longer-term financial goals. As an artist, you can take advantage of Individual Retirement Accounts, known as IRAs—either the traditional IRA or a Roth IRA and SEP 401k plans. As off-putting as these appear, they are actually highly effective, valuable savings vehicles. Any investment section of a bookstore will have an abundance of informative books on these topics.

Debt A main goal of all this saving is to keep you out of debt. It is easy to come by, but becomes a monkey on your back that can force you to leave the art world. Don't imagine that bankruptcy will help. It is virtually impossible to eliminate your debts in this manner. The best that will happen is that the debt will stretch out for years, even decades.

Not all debt is bad. In general, you want to pay down the highest interest rate debt first, and as fast as you can. Low-interest rate debt—often, at least part of student loan debt is low-interest rate—comes last. If you have debt that is lower than the inflation rate or what you are earning on your savings, you can pay this debt off more slowly. Credit card debt is the likeliest to carry a high interest rate. Often, these rates are in excess of 20 percent. You should use your cash cushion to help you get this under control. At 20 percent, you are paying $200 per year on $1,000 of debt. Remember, this is mostly profit to the bank that gave you that credit card with those sweet, teaser rates.

Maximizing the Value of Public Art Commissions

From the standpoint of an individual artist seeking to make $50,000 a year, at $150 million in contracts annually, the public art market is large. One-half percent of that market is $750,000, which could keep about fifteen artists in

clover each year. Perhaps public art will be your only venue, but more likely it will be one of several income streams. Additional sources of income may include galleries, private commissions, and work that receives a royalty, like printed materials, teaching, or fellowships.

There are many appealing characteristics of public art, not the least of which is a substantial number of opportunities to submit proposals. In most cases, the tastes and expertise of the selection panelists is varied and ever changing. Typically, public art proposals are open to anyone, thus helping to level the playing field among new and more experienced artists. Remember Maya Lin, who beat out thousands of proposals for the Vietnam Veterans Memorial in Washington, D.C., while still an undergraduate. Under these conditions, the sensible strategy is to apply for as many public art commissions as possible.

Turn this into a numbers game, not a beauty contest: the more proposals you submit, the likelier you are to win at least one. Try to have several proposals out at any one time; inevitably, you will lose some, but there will always be one or two more to come. It will help the hurt of rejection.

An early focus on public art with a strategy that maximizes the chances of winning commissions will help build your artist's resume. This, in turn, will help you gain gallery representation, as well as attention from art advisors and private collectors. All of these help add new income streams, bringing you closer to achieving your financial goals and, much more importantly, your objectives as an artist.

The time between submitting a proposal and having money in the bank can be very long; therefore, one needs to plan carefully. It is important to explicitly identify additional sources of income while managing the public art commission from beginning to end. It would be useful to produce a spreadsheet that estimates these revenues, like the one below. This will help schedule your time reveal gaps in your income, and will point out opportunities to pick up more income.

Table 6.2 Sample

Annual Gross Revenue

	Jan.	Feb.	March	April	May	June	July	August	Sept.	Oct.	Nov.	Dec.	TOTAL
Public art													
Finalist fee	$300					$250				$400			$950
Contract payment				4,000								8,000	12,000
Gallery					8,000	500	500	500	500	500	500	500	11,500
Multiples		300		200		1,000							1,500
Freelance										5,000			5,000
Part-time						1,200	1,200	1,200	1,200	1,200	1,200	1,200	8,400
Full-time													
Monthly													
Total	$300	$300	—	$4,200	$8,000	$2,950	$1,700	$1,700	$1,700	$7,100	$1,700	$9,700	**$39,350**

Will the commission require out-of-pocket expenses for things like maquettes, photography, and travel? If so, it may be necessary to have other sources of income to fund these. If you dip into savings, do you have a replacement plan? It is dangerous and expensive to use credit cards to fund these up-front expenses, because commissions frequently meet lengthy delays requiring the artist to pay interest on any credit card debt.

Budgeting

Below is a spreadsheet for working up a project budget. This should be used as a negotiating tool and a planning tool, as well as the nexus of your record keeping for the project. There are numerous spreadsheet programs available, including Microsoft Excel, Quicken and QuickBooks. You will have to decide which is best for you.

A major goal of applying for many public art commissions is becoming adept at reading and understanding calls-for-artists and contracts. You should be able to read a call and decide whether it's a good fit for your capacity and goals. You should be able to estimate a budget and determine whether it is profitable for you. A budget can also give you the tools you need to negotiate a better contract with the commissioning agency. The first proposal will be very difficult; by the fifth proposal, you will be surprised at how skilled you've become. By keeping track of how much your budgeted amount varied from your actual amount (budget − actual = variance), you'll have a much better idea how to calculate expenses the next time.

Refer to the detailed list of budget items in chapter 5 and the spreadsheet on calculating an hourly fee in Table 6.1 to develop as detailed a budget as possible for the project. Keep track of your budget in the following spreadsheet format:

Table 6.3

Income/*Expense*	Budget	Minus	Actual	Equals	Variance
Gross Revenue	Total value of contract	−	Actual proceeds*	=	Budget – Actual
Costs	Cost *estimates*	−	Final costs	=	Budget – Actual

Gross Revenue Gross revenue is simply the total amount of the contract. If the call-for-artists says there is $50,000 available for the artwork in a public parking structure, then that's the gross revenue. After carefully estimating a budget, refer back to the gross revenue amount. Of course, the gross revenue should be sufficient to cover all the costs of the project, especially your payment. Don't hesitate to speak with the project manager on these questions and ask if he anticipates any future monies from fund-raising or leveraging the construction budget. Being armed with a detailed budget that clearly specifies costs will make negotiating easier and more productive. Be prepared to back

up various estimates like insurance fees or art transportation costs with solid data. Remember, everyone can use the Internet to check what you tell them, so be accurate and fair. It is highly unlikely, however, that any project manager will question your right to earn a living. A detailed budget will help expose any possible inadequacies in the agency's proposal.

Costs The core of the budgeting process is accurately estimating costs. Ideally, you should use various research tools to pinpoint costs and avoid the temptation to pad every line item, instead of doing the work of finding out the true cost. Over time, experience will accrue, and you will develop a network of vendors, be they fabricators or insurance agents, whom you trust and who work efficiently with you. Fill in the line items and determine if there is sufficient profit for you to pursue the contract. *Remember that you want enough money left over after all the expenses to earn the rate indicated by your target income.*

Poorly estimated contracts are the bane of many, and have destroyed the profitability of extremely sophisticated corporations. Typically, individuals overestimate their own efficiency at coming up with a design and the number of re-dos the commissioning agent wants. Whenever possible, seek control of the latter; too many do-overs, and all your profit and income will evaporate. Charge for repeated design changes; this will be easier done if you can get it written into the contract. Home renovation contractors charge for such changes, as do architects, interior designers, sound engineers, and wedding video editors. It is common and professional to do so.

Variance As shown earlier, variance is the difference between the budgeted amount and the actual amount spent. This number will show you whether you stayed within budget or not. Variance is a useful planning tool. By identifying variance, you can more effectively plan your next budget.

To the extent that a project comes in under budget, those sums can be added back into the artist's fee, which, at the project's conclusion, is the same as profit—for instance, if you under-spend for your travel budget, then add that amount back into your artist's fees. Don't worry if that puts you over the 15 percent mark for your artist's fee. Fifteen percent is the minimum you should charge. As you'll read in the "Voices of Experience" section at the end of the book, artists charge fees from 15 percent on up.

Productivity Is Key Undertake enough of these proposals to get good at them. Being able to complete a request for a proposal quickly and accurately estimate your budget will boost productivity. This is one of the surest paths to achieving your income goals. Any economist will tell you that real wealth comes from increasing productivity. Be brave enough to decline projects that turn out to be suboptimal. Don't be afraid to recycle ideas, if appropriate.

Try to reuse as much of your written material as possible. You want to focus as much as possible on the actual artwork.

Keep a Project Diary Keep diaries or logs, and analyze them after each project so you can see where you spent the most time and money, and what you should cut or concentrate on more in the future. Think in terms of strengths, weaknesses, opportunities, and threats.

Strengths: What works really well?

- Is your application process streamlined?
- Did you get the information you needed for your proposal from the project manager, the community, and other stakeholders?
- Did you have a smooth working relationship with the project manager and others involved with the project?
- Was your budgeting and timeline on target?
- Did you find all the hidden costs in the contract in time to budget for them?
- Are you happy with the finished work? Are your clients?

Weaknesses: What could you improve?

- Was your application as good as it could have been?
- Did you unnecessarily spend too much time or money on certain tasks?
- Are there things you don't like doing or aren't good at that you could have delegated or avoided without harming your prospects?
- Did your fabricator come through for you on time and on budget?

Opportunities: Can you leverage this project for more work?

- Are there any other projects this client may know about for you?
- Did you meet anyone through the project (architect, fabricator, contractor, selection panel member) who seemed to be impressed enough with your work to refer jobs to you?
- To whom can you send an announcement about this project that may lead to more work?
- Will a press release be sent out about the project?
- Will the project manager submit it to the Public Art Network's *Year in Review* and the *Public Art Review* commission section?
- What improvements will have the biggest impact on income, costs, or artistic development?
- Can you be certain to return favors done for you?

Threats: Is there danger on the horizon?

- Is there a mismatch between the media or style in which you work and what current calls-for-artists are seeking?
- Is the competition increasing or are the budgets of the work you're qualified for decreasing?
- Is the work you're doing starting to feel like a grind?

When to Hire Help The short answer is, only hire help when it will increase your income stream.

Help could come in the form of an intern, a bookkeeper, studio assistants, a personal assistant, or a housecleaner, or through outsourcing production to a fabricator. It's time to hire help when doing so will allow you to increase your profit past the amount you pay them.

Here are some tasks artists commonly delegate to assistants:

- Find and apply to calls-for-artists
- Track and follow up on applications
- Coordinate meetings
- Book travel arrangements
- Keep the account book
- Maintain and update Web site
- Mail marketing material to art consultants, gallerists, commissioners, architects, designers, and landscape architects
- Maintain and update portfolio
- Research fabricators
- Answer phone and respond to business e-mails

How much should you pay? Well, here we are in the world of aphorisms: you don't want to pay any more than you have to but, then again, you get what you pay for. Ask around; see what others pay. Look at the job listings in the classifieds and on Craigslist, and go to the "Salary Center" at *www.monster.com* and use their wizard to see what these jobs pay in your area. For example, an entry-level administrative assistant is worth on average $39K in Chicago and just under $31K in Charleston. Divide that by the average number of work hours in a year (2,000) and you'll get hourly wages, respectively, of $19.50 and $15.50. Remember that $19.50 an hour for a great person is a far better way to spend money than $10 for the wrong person whom you'll probably have to replace.

Knowing When It's Time to Get a Day Job The way you'll know it's time to dust off the resume and look for outside work is when your savings are

dwindling to the point where you have less than three months of living expenses. This is even more dangerous if you have no new projects in sight. It takes some serious time to land a job and it costs money, so you need to evaluate your financial position in time to remedy the problem. You should be able to avoid a really big crisis like eviction or repossession if you act before your cash cushion gets lower than three months of expenses. *It is crucially important to avoid using debt (i.e. living off of your credit card) to finance living expenses.*

You might want to look for part-time or freelance work if you have some project payments due you but they've been delayed and your savings are getting dangerously low. Look for jobs that use and improve your skills. You can draw upon your network to help you here. There are freelance Web sites that seek to match buyers and sellers, such as *www.elance.com*.

Perhaps some really awful event, like a fire in your studio, has caused a setback that you're having difficulty recovering from. These things happen: panic for a day or two, then make a plan to get back on the horse. Remember that the more savings you have, the more time there is to reverse a bad financial situation without having to leave your field.

Nancy Herring *earned her M.B.A. from Columbia Graduate School of Business and has worked in financial services throughout her career. She has worked as a portfolio manager for Dean Witter Asset Management (now Morgan Stanley). While living in Moscow, Russia, she ran the asset management division of Troika Dialog Bank, and later was Director of Research at Regent Securities. She currently consults with a variety of clients on portfolio construction.*

End Notes

[1] Hans Abbing. *Why Are Artists Poor? The Exceptional Economy of the Arts.* Amsterdam: Amsterdam University Press, 2002.

[2] Note from Lynn: A fun (or sad, depending on your perspective) game I play with myself when looking where to cut costs is asking how I would feel if I found that amount of money laying on the sidewalk. Cutting out cable TV saved our household $840 a year. I'll never trip over a wad of cash like that, but I found it for myself.

[3] Another note from Lynn: I had a $1,800 emergency room visit for a squirrel bite reduced to $1,200. So, that was like finding $600 on the ground!

Chapter 7:
Insurance: The Lowdown

When you win a public art commission, you will enter a world of insurance requirements heretofore unimaginable as a simple studio artist: professional liability, workers' compensation, commercial general liability, business auto, performance bonds. . . . And as long as we're on the subject of insurance, we may as well cover what you need and don't need as far as personal insurance because, as with finances, the fortunes of small business owners are intertwined with our private lives.

Insurance agents are salespeople. They may seem like they have only the best intentions for you and your interests, but their prime directive is to sell you insurance whether you need it or not. Like Diogenes with his torch looking for an honest man, I found an insurance agent who was willing to go on the record and talk straight to artists about which insurance we absolutely must have and which we can go without.

INTERVIEW WITH KRISTIN ENZOR
I interviewed Kristin Enzor, an account executive for Pillar Group Risk Management, which advised the Indianapolis Airport Authority on the insurance aspects of its contracts with artists.

HOW SHOULD ONE GO ABOUT FINDING A REPUTABLE AGENT?
There is no consumer report for insurance agents. You need to find them by word of mouth or letting your fingers do the walking. It's true, insurance agents are salespeople; however, they are held under professional obligation to recommend coverages that they deem to be necessary. Otherwise, if you had a claim and it wasn't covered, you could sue them for not pointing that coverage out. Each state has an insurance department that regulates agencies and insurance companies. The state will also cover claims if the insurance company goes belly-up.

Look for a "full-service agency" because it can provide coverage for all your needs: personal lines of insurance (personal auto, homeowners, renters, and personal liability), life and health insurance (medical insurance and disability), and commercial insurance (workers' compensation, business auto, commercial property, commercial general liability, professional liability/errors and omissions, and performance bonds).

Every agency can obtain out-of-state licenses. However, this is only necessary when the named insured is domiciled in or operating out of state.

Most commercial coverages provide coverage for anywhere in the country, as well as U.S. possessions and territories, and Canada. Commercial property is tied to the location listed on the policy; however, for property that goes off premises (welding equipment, tools) there is coverage called inland marine insurance that can be purchased.

WHAT KIND OF PERSONAL INSURANCE IS ESSENTIAL?

- *Auto.* If the vehicle title is in your name, you must have personal auto insurance. All states let you get away with just liability insurance. So if you drive a junker, don't worry about getting comprehensive and collision coverage.

- *Any Homeowner's Product*—whether you own a house, a condo, or rent. It's not just for people who pay a mortgage every month. That policy includes personal liability and personal property combined in the "package." Homeowners insurance is important not just because it covers your home and personal belongings but also because if someone trips and hurts himself in your home studio or your dog bites him, he won't be able to sue you for every asset you own. Your insurance will cover it.

 Fine art would typically be covered within your personal property limit. The problem is that a claim would be settled on a replacement cost basis. This is great for replacing a television, but an antique chair would be replaced by a new chair, a painting could be replaced— technically—with new blank canvas stretched on stretcher boards. Also, a mysterious disappearance would not be covered. So, the best way of insuring fine art is scheduling (i.e., separately listing) each piece on the policy. There should be a list of items. Each item should have a brief description and a value, which should be a market value or an appraised value. That scheduled property will then be covered for the value shown on the list. Also, scheduled items are covered for mysterious disappearance. This is also true for jewelry.

- *Commercial Policy.* I'll go into this more in the section on business insurance, but you should know that if you have a home studio/office and the work you do there is your principal source of income, it needs to be insured under a commercial policy. If you're just starting out or you are right out of school, don't get commercial insurance unless you've established a market value for your work. It also depends on what you're doing with your taxes. When you begin deducting your studio space and art supplies on your tax forms, it's a good time to get commercial insurance.

If you rent a studio space, you'll need to have renters insurance, even if you're just starting out. Again, if you run your studio as a business, then your commercial insurance will cover it.

- *Health*. Everyone absolutely needs medical insurance. Generally, the higher the deductible, the lower the monthly premium, which is true on all kinds of insurance policies. If you're young and healthy, get a policy with a very high deductible and pay for the occasional doctor visit out of pocket. Your policy will cover emergency care.

- *Health Savings Accounts (HSAs)*. A new option for coverage is a Health Savings Account. This is a way to fund your health insurance. You put non-tax dollars into a qualified bank account that is used specifically for the payment of the health care plan. They require more effort (shopping physicians to get the best price) and a different mindset, in that you agree to pay more when visiting the doctor for a routine visit (no more co-pays).

- *Disability Insurance*. People between the ages of twenty-five and fifty-four are three times more likely to be disabled than to die. For artists, being physically disabled could have an enormous impact on their livelihoods. For this reason, disability insurance is really more important than life insurance.

- *Life Insurance*. You don't need to buy it unless you have children or a spouse, or have a fair amount of debt. There are two kinds of life insurance: permanent and term. When buying term, you're buying life insurance for a specified number of years. If you don't die in that time, then the policy expires. If you know you're near the end of your life, you might consider this option. Term insurance is less expensive. It is a good option if you need to buy life insurance but do not have money out of the gate.

 Permanent insurance renews until endowment age (usually one hundred years old) or until you die. The premium can be guaranteed or flexible. There are different permanent options, including whole life, universal life, and variable life. Permanent life can be an investment vehicle.

WHEN IT COMES TO WORKING ON PUBLIC ART COMMISSIONS, WHAT INSURANCE DO ARTISTS NEED, WHICH PLANS DO THEY NOT NEED AT ALL, AND WHICH CAN BE BOUGHT PER PROJECT?

1. Workers' compensation coverage. Each state has different requirements. For instance, in Indiana, if you are a sole proprietor with no employees,

you can waive your right to purchase workers' comp by submitting a form to the state industrial board. If you're a corporation, you have to have it even if you're the only person employed by your company. If you have employees, you must have it. This protects you from being sued by your employee if they get hurt while working for you. In fact, whichever state your project is in will come down on you hard if this happens and you don't have workmans' comp. An employee is anyone for whom you're turning in a W-2 form to the I.R.S. A 1099—the form the I.R.S. requires for subcontractors—does not count.

The moral of this story is that if you have employees, you want them to be subcontractors. If you hire subcontractors (i.e., fabricators), you should be sure to ask them for a current certificate of insurance, which outlines the coverage they have in place, because if they don't have coverage for a particular incident (for example, workers' comp), then if one of *their* employees got hurt, he could sue *you*. Your homeowners or commercial liability would not cover that.

On public art contracts, you will be asked for proof of insurance that your subcontractor has added an "endorsement" on his or her policy, which just means they are naming you as an additional insured. You will be asked to name the client agency in an endorsement on all of your commercial insurance. Endorsements are simply amendments to the policy—any insurance policy. They can restrict coverage or they can broaden coverage. They are used to tailor the coverage.

By the way, limited liability companies (LLCs) are not considered corporations in some states. You'll need to rely on your agent to find out what the rules are in your particular state. If you live in one state and your project is in a different state, you may or may not need to comply with that state's laws. Again, because each state has its own regulatory board, the requirements vary. In general, on short-term projects—say, under sixty days—you do not need to abide by that state's requirements.

What should you expect to pay for workmans' comp? It's based on payroll.

2. Commercial general liability insurance (formerly called "comprehensive general liability") protects you from third-party suits that are attributed to your work. Within this coverage, there are premises/operations liability and products/completed operations liability. The difference is premises/operations is for when the work is being done. Products/completed operations is for after you're done with the job, like if someone slips and falls. Most of the risk exposure occurs while it's being created on site, as if someone hurts himself during construction.

Commercial liability is divided into two different categories—bodily injury and property damage—and only protects if there has been physical injury or damage to property. Third-party loss of income is not covered.

(It also includes other coverage thrown in, like personal and advertising injury liability, which protects you from claims of misrepresentation. For example, if you did a caricature of someone, and they were offended and sued you, you'd be covered.)

Say you hired a big terrazzo company to install a floor you designed, and someone slipped on the shiny surface of the terrazzo and sued everyone—the client agency, the city, the contractor, your fabricator, and you. What would happen is, the terrazzo fabricator's insurance company would probably claim that its client installed the floor correctly—assuming the installation was per spec. *That means if it's not a design or installation issue, then it becomes one of negligence.* Attorneys will always go after as many pockets as possible. Your commercial general liability will protect you. The other part of that is how your contract is written with the owner and the one you have with your subcontractor. Everyone is pushing off the liability to the next level (see "endorsements"). To make a long story short, you need to have your own attorney look at the contract you get from the client, write one specific to your needs, and have your subcontractor sign it in order to protect you.

There is a standard subcontractor agreement. The American Institute of Architects has one because their members run into this sort of thing all the time. All attorneys with clients in the building industry have access to them.

You can buy commercial general liability in a package policy that combines property and general liability. It's cheaper when you buy it that way. If necessary, you can also customize it.

Expect to pay: a property premium is based on value, while commercial liability is based on payroll, under the "sales and service organization" classification.

3. Business auto. You really don't need this, and you should try to avoid it because it is more expensive than personal auto. The only time you absolutely have to have it is when you have the title of your car in your business name. Sometimes the client agency will require it. You can use your personal vehicle for business purposes as long as you aren't using your car in the course of your daily business operation. For example, if you have a courier service company, you need a business auto policy. If you use your car to drive to the art supply store, or even if you haul tile to the job site, you don't need it. So tell your client that you don't need business auto if it is requested in the contract. If the client forces you to get it anyway, then get it and cancel it as soon as the job is done.

There's a big difference between personal auto and business auto. With personal, the basic intent is to cover the *driver*, no matter what vehicle you're driving. Business auto is designed to cover the *vehicle*. That means you have no coverage for any other vehicle you drive if you carry business auto.

So when renting a car, be sure to check the box for liability coverage if you only have a business auto policy, and be sure not to drive your friend's cars. You can get "drive other car" coverage for around $100 extra to get covered for driving other cars. If your partner or spouse routinely drives the car that's insured on a business auto policy, then the insurance company will want to run a motor vehicle records (MVR) check on them.

It will cost about 25 percent more than personal auto partially because of the increased liability limits.

4. Inland marine insurance is for property that moves. Property insurance only covers so many feet in and around a given location; anything taken off of your property isn't covered. For example, if the site isn't ready and your artwork has to sit in storage or it's being trucked to the site, then you need to get inland marine insurance. The good thing is you only need to buy this case by case.

The price of this coverage depends on value and how the work, object, or material is being shipped. You can expect to pay somewhere between $.75 and $2 per $100 in value.

5. Professional Liability Insurance (PLI). PLI covers losses for claims arising from errors or omissions in the course of business activities for specific licensed professions.[1] Always try to negotiate this requirement out of your contract. Artists are not professionally licensed, like architects, engineers, doctors, and certified public accountants (CPAs). Professional liability is not necessary unless required by contract. If required, miscellaneous professional liability policies can be purchased. There will be a minimum premium of $1,000 to $2,500. The policy should be cancelled as soon as the job requiring the coverage is complete. Request an occurrence form, not a claims-made form.

Kristin Enzor has been a commercial insurance agent for eight years and has been in the insurance industry off and on for twenty years. She has a B.F.A. in painting and photography from Indiana University at Bloomington.

Once again, artist Ken vonRoenn has a cautionary tale to share:

Lesson: Always read the insurance policy.

Story: I had a very large project that took a year to produce, and I asked my insurance agent to add an endorsement to my policy to cover the value of the project for this period of time. Two months before installation, with 90 percent of the project complete and crated in my studio, my studio and the project were destroyed in a fire. When I called the insurance agent the day after the fire, he said there was no endorsement for the project. When I asked him why he didn't

add it after our phone conversation, he said he "didn't remember" my requests. Soon after my attorney called the insurance company, I received a notice that my entire claim was denied and that I was being sued for filing a falsified claim. To honor my contract, I had to redesign the whole project (the designs were also destroyed) and pay to have it reproduced (I couldn't get another year off from grad school). Moreover, the legal fight with the insurance company continued for two years, after which they offered 25 percent of my claim the day of the trial, which I ultimately accepted because my attorney advised me they would tie up the settlement for at least another three years with appeals.

Net result: I lost more than $250,000.

PERFORMANCE BONDS

David Santarossa, the owner of the terrazzo company installing a floor I designed at the Indianapolis International Airport, asked me for a performance bond. Because of the way my contract with the airport is written, all the money goes through me before it gets to him even though he's the one taking all the risk with labor and materials. This is not an unusual arrangement (even though it would make more sense for the client agency to have a separate contract with the fabricator on large projects like this). He was worried about asking me because he thought it might sound like he didn't trust me, but I agreed with him. What if something happens to me and I'm out of commission for a long time? Or what if the client can't pay me for ninety days, meaning Santarossa can't make his payroll? Or what if the client decides to reject my artwork after it is installed? The way these uncertainties are handled in the construction world is through performance bonds. It's a way of creating a buffer or putting some elasticity into the flow of payments.

A performance bond is issued by an insurance company to cover one party against loss if the terms of a contract are not fulfilled by another party it's doing business with. It's usually part of a construction contract or supply agreement.

According to Fred Eickoff,[2] bond manager for J.W. Flynn's, it's difficult for artists to get a performance bond because to get one, you need:

1. A CPA statement that lists all of your liabilities and assets
2. Financial references
3. $150K in cash or liquid assets that they can attach if worse comes to worse
4. A high credit rating for your business

Another reason bond companies are reluctant to do business with small businesses is that their "bread and butter" is large contractors. They make money

from the premiums of contractors who are required by law to put up performance bonds and who might buy several a year. A public art contract, even if it seems to us like we've hit pay dirt with one for half a mil, is small potatoes to the Fred Eickoff's of the world.

What Eickoff suggests instead is a kind of poor man's performance bond in the form of an "irrevocable letter of credit." Using your home or other equity, you establish a line of credit that your subcontractor has permission to draw on if your client is late in paying you or if anything happens to you to cause you to default on the job. You can specify the terms, such as the draw date and amount.

The happy ending in my case is that the public art project manager for the Airport intervened and convinced Santarossa that they would get paid no matter what.

HEALTH INSURANCE
Health Care for Artists by Daniel Grant[3]

It is no news to anyone that obtaining adequate and affordable health care and health insurance has become a major problem for a sizeable portion of the population. And artists of all media and disciplines are among the groups most likely not to have any health insurance coverage. According to a survey sponsored by the National Endowment for the Arts, less than 75 percent of the composers, filmmakers, photographers, and video artists questioned have any form of coverage. Of all artists in larger cities, the survey found that 30 percent lacked health insurance. One of the reasons for this is the fact that most artists earn too little money to afford insurance; 68 percent of the artists in the survey had household incomes of $30,000 or less.

Perhaps the ongoing debate in the United States on how to provide coverage for the millions of people without health insurance will result in significant improvements. Perhaps the increasing prevalence of health maintenance organizations (or HMOs) may put out of business many of the arts service organizations that currently offer group-rate plans to their members, as artists may believe that they have less of a need to join such organizations. In this latter scenario, a lot of the career services that only certain organizations provide will be lost to artists, as well.

Until the health care situation is improved to include all citizens of the United States, regardless of their ability to pay, artists will continue to rely on their own sources of help and coverage. A number of literary, media, performing, visual arts, and crafts organizations provide group-rate health insurance plans for their members. Membership in the health insurance plan of some of these organizations is confined to artists residing permanently within a particular city or state, while they extend nationwide in others. For

example, the Chicago Artists' Coalition's health insurance program is available throughout Illinois and in some of the peripheral states, such as Michigan and Wisconsin. Iowa, however, is not eligible unless there are enough coalition members seeking health insurance to warrant creating a group-rate program there. On the other hand, seven organizations—Artists Talk on Art, Editorial Freelancers Association, National Association of Teachers of Singing, National Sculpture Society, New York Artists Equity, New York Circle of Translators, and the Organization of Independent Artists—all use the same health maintenance organization, limited to the states of Florida, New Jersey, and New York. "That's where our network is," says Phyllis Goodwin, sales representative for RBA Insurance Strategies, which negotiated the health insurance policy. Participants in this plan are billed quarterly, paying $583.95 for an individual, $1,392 for a family consisting of a single parent with children, and $2,262 for a two-parent family with children.

The Kansas City, Missouri-based Forrest T. Jones & Company, which administers group health insurance policies for fifty-nine associations, including the National Art Education Association, offers coverage for members in thirty-eight states but not in twelve others (Idaho, Kentucky, Maine, Massachusetts, Minnesota, New Hampshire, New Jersey, New York, Oregon, South Dakota, Washington, and Vermont). These excluded states require policy deductibles to be no higher than $500 (Forrest T. Jones & Company has a $1,000 deductible) or that dental and vision care be included (Jones & Company does not require this coverage).

The insurance industry is regulated by each state, and rates are higher in some states than in others. Massachusetts and New York, for instance, are "guaranteed insured" states, meaning that those wanting insurance coverage cannot be denied policies because of their health (preexisting condition), age, or sex. Some insurance carriers refuse to provide policies in these states because of their inability to weed out potentially higher-cost customers; insurance programs are likely to be more costly in these states than in others as a result of the presumed pool of expensive-to-care-for group members. Medical care and services in New York are also more expensive than in most other states. Those higher costs and mandated coverage are factored into the prices of policies; as a result, New York policyholders are likely to pay more than their counterparts in Illinois or California. The states themselves make analyses of the medical costs in their counties, determining rate areas (by zip code) that are used by insurance carriers when establishing premiums.

Other factors that drive up or down the cost of health insurance are:

- Age: Health insurance becomes more expensive as one becomes older.

- Sex: Men are generally less expensive to insure, because they do not have babies (prenatal and maternity costs are high), nor do they

require mammograms and pap smears. As a group, men also use medical services more sparingly than women. Even after their child-bearing years, women remain more expensive to insure. In life insurance, on the other hand, the policies for women are less expensive because they live longer.

- Group or individual policies: "Group-rate" sometimes means less expensive, but many group policies include families and offer extensive prenatal and maternity benefits, which increase the costs. A single male may get a better rate with an individual plan, but if he plans to marry and have children, the group plan is likely to offer the types of coverage that are more expensive to purchase individually.

- City or suburb: Cities tend to have more elaborate medical care facilities and equipment, raising the costs for insurance carriers, and their policies to urban-dwelling individuals, couples, and families reflect that increase. To a lesser extent, the degree to which there is a higher incidence of crime in a city may also be factored in.

- Deductible: The deductible, or the amount that the policyholder agrees to pay before the insurance carrier steps in, ranges widely from $0 to $5,000, and sometimes more. Lower deductibles increase the annual, monthly, or quarterly costs of a policy.

- Number of dependents: The more children one has, the higher the premiums. Insurance carriers generally cut off coverage for children over the age of nineteen, although some will continue coverage up to age twenty-three (finishing college) and even twenty-five (graduate school); however, lengthened terms of coverage increase the costs.

- Add-ons: The more options one attaches to a policy, the more expensive it becomes. Insurance coverage for experimental treatments, cosmetic surgery, optometry, dentistry, foot care, organ transplants, drugs not included in the insurance carrier's formulary, assistance with daily living, ambulance service, mental health, and a variety of other concerns is frequently not included in basic and group plans.

Many of the larger performing arts unions offer insurance packages for their members, but the coverage plans tend to differ widely from one local chapter to the next, and local chapters are spread around the country geographically. Here and there, a local chapter may have no health insurance program to offer. On the other hand, the Denver Musical Association, Local 20-623 of the American Federation of Musicians, offers members' insurance on their instruments—coverage that musicians frequently claim is next to impossible to find and exclusive to this union chapter—along with dental,

health, and life insurance. Many of the organizations offering health insurance programs rarely ask detailed questions about what prospective members do in the arts or otherwise, and it is unlikely that, say, a musician would be denied a medical insurance claim for belonging to a primarily visual artist group. The American Craft Association, an arm of the American Crafts Council, wants its members to be involved in "the crafts or some related profession," and the Maine Writers and Publishers Alliance requires members to be self-employed.

Membership itself is usually not free, and annual dues range from $25 to $50, sometimes more. The costs of individual or group insurance coverage range widely, depending upon the particular plan and its benefits, the insurance carrier, state laws, and the number of people enrolled in the plan. Artists generally have been a more difficult group to insure because of industry concerns that they do not earn enough money to pay their premiums, as well as that they do not generally take adequate preventive care—a result of their poverty—and require more expensive treatments. A number of insurance carriers also believe that artists as a whole are more likely to contract acquired immunodeficiency syndrome, or AIDS, than other occupational groups, which has led to companies greatly raising premiums for, or completely dropping, plans that cover artists of all media and disciplines. There is no factual basis for this belief, but the subject of AIDS and negative ideas about artists in our society generally tend to exist well outside rational discussion.

Becoming a member does not immediately enroll an artist in an organization's health care program, and insurance carriers are permitted to deny coverage to any individual. Insurance carriers usually require new members to complete a questionnaire or take a physical, and enrollment on a health plan sometimes takes months. The reason for this is that over the years, insurance companies have seen people join a group's insurance program so that someone else pays for a needed operation, and then drop the health plan after they have recovered. Artists need to look at health insurance as a long-term commitment, and they also should shop around for the most suitable membership groups that they are eligible to join.

A reason to buy insurance through an arts organization is that the coverage plans may be tailored to a particular group. Lenore Janacek, an insurance agent who has crafted insurance plans for artists' groups, notes that she looks for "companies that are sympathetic to artists. Artists, for instance, are users of mental health care, so that should be part of the area of coverage. Artists are also interested in alternative forms of health care, so I look for companies that provide coverage in that area." Because artists may not have a lot of money, she notes that some are offered the choice of a basic Blue Cross plan, with premiums as low as $35 per month.

Various types of health insurance plans are available, all with their own rules and enrollment requirements and procedures. Beyond the fee-for-service

and HMO possibilities are hospitalization (base plan, medical, surgical) and major medical insurance plans. Hospitalization insurance generally pays for bed and board (usually in semiprivate rooms), nursing care, and hospital staff physicians' services for a period of between one month and one year. Some hospitalization plans also cover:

- The use of operating and recovery rooms and equipment
- Intensive care rooms and equipment
- X-rays, laboratory, and pathological examinations
- Drugs, medicines, and dressings
- Blood, blood transfusion equipment, and the cost of a hospital employee administering the transfusion
- Oxygen, vaccines, sera, and intravenous fluids
- Cardiographic and endoscopic equipment and supplies
- Anesthesia supplies and equipment
- Physical and occupational therapy
- Radiation and nuclear therapy
- Any additional medical services customarily provided by the hospital

Most hospitalization plans, however, tend to be limited in terms of the services covered, requiring individuals to purchase major medical or "catastrophic" insurance. This type of plan picks up 80 percent of the costs that the basic hospitalization does not cover, less a deductible (the first $500, for instance), up to $1 million or more.

Among the questions to keep in mind when shopping for insurance coverage are: Who in your family is covered (someone with a preexisting condition, dependents at what age)? What services are covered? Is there a waiting period (and if so, what is it?) before coverage begins for someone with (or without) a preexisting condition? Are there limitations on the choice of health care providers or where health care may be obtained? Is the policy renewable (guaranteed renewable: the company cannot cancel a policy as long as premiums are paid on time; optionally renewable: the company may terminate the policy on specified dates; or conditionally renewable: the company may refuse to renew a policy for specified reasons)? What are the family and individual deductibles or co-payments? What is the average annual premium increase for the plan, and how high, and under what conditions, will premiums increase?

A valuable source of information on health care options for the arts community is the Artists' Health Insurance Resource Center (*www.actorsfund. org*), which was established by the Actors' Fund of America with support from the National Endowment for the Arts. Among the databases are

individual and group insurance plans available by state, to selecting an appropriate plan, and links to other sources of information.

PLUS: This is a great list of resources:[4] *www.sculpture.org/members/WebSpecial/aprilresource.shtml*.

(You need to be an International Sculpture Center member to access this site.)

Daniel Grant *is the author of* The Business of Being an Artist, The Fine Artist's Career Guide *and* Selling Art Without Galleries*, among other books published by Allworth Press.*

End Notes

[1] A good article detailing how the definition of a "professional" has been expanded to include a number of other occupations when it comes to PLI can be found at The Insurance and Planning Research Center in an article called "Miscellaneous Professional Liability Insurance" (*www.coverageglossary.com/pages/profliab.htm*).

[2] Fred Eickoff, via telephone interview, March 27, 2007.

[3] "Web Special" on *Sculpture* magazine. *www.sculpture.org/members/WebSpecial/April.shtml*, April 2007, accessed March 26, 2007.

[4] A resource not included in Grant's article is *www.ehealthinsurance.com*. It helps you compare plans, get quotes, and apply. Keep in mind that it's a licensed insurance agency, not a consumer help organization, even though it has useful consumer information. I found that if I applied as a business instead of as an individual, I got better insurance coverage and paid almost $200 less in premiums a month.

Chapter 8:

Ask the Expert: Contracts Q&A

By Barbara T. Hoffman, Esq.*

Barbara Hoffman is a preeminent art lawyer who has represented many of the most well-known public artists for more than twenty-five years. The questions posed in this interview are representative of concerns compiled by artists experienced in working in the public arena as well as those just starting out.—LB

As a preliminary matter and to facilitate discussion, let me define the scope of this chapter on public art contracts and some basic concepts. The goal of this chapter is to give the artist confidence in negotiating a public art contract by giving him or her an awareness of rights and to help the artist know when it is necessary or advisable to seek legal counsel. By public art, I refer to original art commissioned by a private corporation or individual, a foundation, or a governmental entity for exhibition or installation in a space accessible to the general public. Although the author of this book tends to favor the term "agency," I prefer to use the term "client" or "commissioning entity."

A contract has been defined in many ways. Perhaps the simplest is "a promise or set of promises enforceable by law," or "a statement of agreement creating legally enforceable obligations between two or more competent, consenting parties." Generally, every contract must have an offer, acceptance, and consideration, which is usually money but sometimes something else of value.

A contract does not have to be in writing under most state laws unless it is a (1) contract for the sale of goods over $500 or (2) a contract for services which cannot be completed in one year. Any assignment of copyright as a matter of federal law must also be in writing.

W. C. Fields once said, however, that "an oral contract is not worth the paper it's written on." That is primarily because even between those dealing in good faith, memories fail or the parties negotiating may not have interpreted their discussion in the same manner. Then, too, in the event of a dispute, proving an oral agreement may be quite difficult.

Most commission agreements will take the form of a formal written agreement. While there are certain clauses, which we attorneys refer to as "boilerplates" (one of my clients calls them "potboilers") in every contract, each contract should be tailored to the particular project. As a lawyer, my first question to a client who consults me about a public art project is, "What are you going to be doing?"

* ©Barbara T. Hoffman, 2007. This chapter and the following are dedicated to my clients who work in the public realm. I am grateful for their teachings in commitment, courage, and vision.

NEGOTIATING THE CONTRACT

• Can I negotiate the contract the agency gives me? Could that jeopardize my getting the commission?

In an article entitled "The Art of Negotiation,"[12] St. Louis Volunteer Lawyers and Accountants for the Arts describes negotiation as the give-and-take process of bargaining to reach a mutually acceptable agreement." It is an act that combines communication skills, psychology, sociology, and conflict management. It is an important tool in a lawyer's arsenal; however, others should not be intimidated by the process. Negotiation is a part of daily life. Roger Fischer, coauthor of *Getting to Yes*, offers the following suggestions for enhancing negotiating power:

> • *The power of skill.* A skilled negotiator is better able to exert influence than an unskilled negotiator. Skills, which can be acquired, include the ability to listen, to become aware of emotions, to empathize, and to become fully integrated so your words and non-verbal behavior reinforce each other.
> • *The power of knowledge.* The more information negotiators gather about their counterparts and the issues at hand, the more powerful they'll be at the table. Preparation is crucial—a repertoire of examples and precedents enhances a negotiator's persuasive abilities.
> • *The power of a good relationship.* Generally, negotiations are not onetime events. Instead, they establish or foster ongoing relationships. Trust and the ability to communicate are the two most critical elements in a working relationship. If, over time, you have established a well-deserved reputation for candor, honesty, integrity, and commitment to promises made, your ability to exert influence will be greatly enhanced.

Perhaps the most important point in negotiating a contract is to know what you want—what points are negotiable and what points are deal breakers. If you have a lawyer, it is important that he or she understand what you are doing and your objectives.

Lawyers frequently say, "There is no harm in asking." Some things, of course, are difficult to negotiate. For example, a request for proposals, which is sent out to a select list of competitors, normally cannot be easily negotiated. The artist must carefully consider whether the terms, the project, and the initial monetary offering make it worthwhile to submit his or her work. Notwithstanding, several artists recently invited to submit to a municipal RFP declined because of the anti-artist boilerplate requirement of surrendering of artist's rights and a low proposal fee. Faced with an empty slate, the

administrator belatedly offered to change the contract terms. Even if a government body presents a printed form which appears to be set in stone, more likely than not, certain clauses can be negotiated. Most obvious are those clauses that deal with the particular scope of service to be provided by the artist, and the benchmarks and amount of payment at each of those benchmarks. More difficult to negotiate, particularly with governmental bodies, will be those clauses that have been preapproved by a local governing body. Such clauses may include indemnification, insurance, and, often, sections of artist's rights. Most importantly, negotiating a contract often gives you a preview of what the rest of the project will be like. If it is very rough going during the negotiations, it is only likely to get harder, not easier, if the same people are involved.

• **What if the agency doesn't give me a contract? Should I work without one? Should I provide one of my own? If so, where can I find a model agreement to use?**

It is very unusual that an agency or a client with enough money to hire an artist to do a commission does not have a written contract. The usual scenario is that there is a contract ready, but that the artist must perform before negotiating and signing the contract. The more the artist invests time and possibly money in a project without a contract, the harder it becomes to negotiate a contract and leave the project if he or she is not able to secure favorable terms. My advice is, all things being equal, do not begin to work without a contract, and if time pressure prevents entering into a full contract, a letter of intent and a phase one payment should be negotiated.

With respect to the other questions, there may be situations where an agency or client does not have an appropriate contract. Often, too, lawyers representing the client will be real estate lawyers or city attorneys unfamiliar with art law or copyright. The Model Agreement for Commissioning a Work of Public Art ("Model Agreement") developed by the Association of the Bar of the City of New York in 1983 is a good starting place in that situation. The Model Agreement can be obtained by contacting Lynn Basa at *lynnbasa@lynnbasa.com* or me at *artlaw@hoffmanlaw.org*.

• **Should I hire an attorney to negotiate my contract from the beginning? How much will it cost for an attorney to review my contract? What should I do if I can't afford one?**

It is always better to have an attorney involved in negotiating a contract for several reasons, including the fact that it enables the artist to keep out of the negotiation process if it is not going well. Often, an attorney is involved once the preliminary concept or invitation has been extended to the artist and the artist has discussed the basic artistic features of the project. This is an appropriate time.

Attorneys have different rates, but experienced attorneys in this area will charge from $300 to $500 an hour. However, for artists who meet the income requirements and are unable to afford an attorney, most states have a branch of the organization called Volunteer Lawyers for the Arts, which provides free legal assistance to artists without sufficient resources. I founded the Washington Lawyers for the Arts, which is still active throughout the state of Washington and recently celebrated its thirtieth anniversary.

• **As a finalist, is there a way I can keep the agency from asking me for more and more work? (Here's a common example of this unfortunate situation as told to me by an artist: First the agency asks for a drawing, then a material sample, then more drawings, then a model, and all the while, the artist is traveling back and forth for meetings. In the end, after a year of this, the mayor decides she doesn't like the artwork, overrides the commission, and rejects the selected artist. All this for a $1,000 design fee.)**

The artist should know at the time she enters into a competition exactly what is required and not get involved in providing more. Also, unless artists collectively object to this practice by refusing to undertake all of this work for a $1,000 fee, the situation will not change or improve.

In the case mentioned, there certainly should have been reimbursement for travel expenses and required attendance at no more than one meeting. To my knowledge, a model is rarely requested as part of an initial proposal, if at all. Again, artists are prone to accept a certain amount of risk in investing their time and money in submitting a proposal. The question is: is the reward worth it and can the artist afford to say no? Of course, not knowing all the facts, it is difficult to render an opinion, but the artist in your example may have a legal claim for damages.

• **It seems like a good idea to have a budget estimate before I sign a commission contract, but how do I protect myself from unanticipated demands from the client or agency? (This is a classic catch-22 for inexperienced artists: they're asked to commit contractually to a budget and then asked to do extra work and/or commit more time as the project progresses to such things as engineering stamps, shop drawings, material samples, extra meetings, etc.)**

You are right. This is a situation in which many inexperienced artists find themselves. More experienced artists with greater knowledge and/or bargaining power do not commit contractually to these kinds of activities. For artists with less bargaining power, it is sometimes a question of making sure that only preliminary estimates are required at the outset and that there are adequate progress payments for design development and structural review.

• If I'm handed a sixty-page contract full of irrelevant or anti-artist "boiler-plate," instead of trying to negotiate it point by point, can I simply add an addendum to the contract that addresses my real concerns and protections for such things as a workable payment schedule, insurance, and realistic time schedules?

This is not a bad suggestion if the client's lawyer agrees, but you had better have a lawyer assist you in the negotiations. You had better know what is in the contract and make sure that the addendum deals with the issues that are important to you and modifies the clauses that don't work for you in the main contract.

• Can I simply draw big Xs across sections of the contract that I don't agree with, sign it, and send it in like that?

A physical contract is not an artwork and its form is not inviolate. You can, of course, draw an X or some other mark to indicate clauses or provisions with which you don't agree. Each of those changes should be initialed in addition to signing the contract on the signature page. Of course, a contract is based on mutual understanding and agreement. If the client or agency does not agree with your Xs, there may be no deal. On the other hand, if the client does not object and sends you a check so that you can begin performance, you have entered into a valid contract.

• Is it legal to ask artists applying for RFQs (in other words at the open-call, competition stage) to sign an "assurance of acceptance" of the forthcoming contract should they be selected? (Guy Kemper says this is becoming more commonplace, and "of course, it is impossible to say that whatever they put in the contract about your specific contract you'll accept. They want you to agree to the "boilerplate"—which usually includes signing away VARA rights discussed later in this book—in advance of considering you for the RFQ.")

It may be unfair, but I can't think on what grounds it would be illegal. The reality is that despite such clauses, negotiation of the contract once an artist is selected may occur, particularly if the artist has "bargaining power." However, technically, and certainly it has happened, the artist may be required to accept the contract that was proposed to her. The artist, however, is unlikely to be forced to do the project. I am not aware of any specific case where an artist refused to accept a contract after being selected, and then was sued for walking away from it. The unfortunate part of all this is that artists with bargaining power who enter into competitions where the restrictions are not so onerous will not enter competitions that pay little money and require surrender of artist's rights. In the end, it is the public that loses. Clients must recognize that it is the artist who creates the work, and without respect for the artist and his or her artistic vision, we will end up with mediocre monuments in public spaces.

• When do you go from being a compliant team player to a doormat? How do you keep from crossing that line while also making sure you get what you deserve? When is it time to walk away or get an attorney? If you feel like you are being unfairly burdened with an expense or work that is outside of your agreed-upon scope of service, what steps can you take before you pound your fist on the table and threaten to walk away from the project?

Questions like these are very difficult to answer without a frame of reference or context. Basically, every contract, particularly those with an agency or a corporate client, should have one contact person named in the contract to act as an interface between the artist and the agency/client. Hopefully, the initial problems referred to in this question can first be discussed with that person. If the project is a collaboration, there is also usually one person who will be designated as the team coordinator or point person. It is also quite typical now to have alternative dispute resolution mechanisms such as informal discussion, mediation, or arbitration built into public art contracts with any complexity or of a significant monetary amount. Particularly recommended would be a clause requiring mediation in the event of any dispute. This means that any disagreement arising during the course of the project would be brought before a neutral party who will help them resolve their differences. Mediation is consensual and is nonbinding unless all parties agree to be bound by the mediator's recommendations. Mediation can be used for disputes between a client and an artist or between an artist and other team members.

TYPES OF CONTRACTS

What are the different contractual arrangements an artist may encounter? Have public arts contracts changed over the years?

Most of the federal, state, and local public art commissions of the late '60s and early '70s involved the making of objects "plopped" in public plazas. Such commissions reflected the past government philosophy of creating outdoor museums filled with objects. This paradigm in most instances is based on the artists receiving a fixed fee to "design, fabricate, transport, and install the artwork" at a designated site. The artist must then hire fabricators and other subcontractors. This type of contract, which has multiple variations, is still fairly typical for government art programs. Nevertheless, beginning at least in the 1980s and continuing through the present, the notion of sculpture has gone through a radical redefinition. Sculpture has come off its pedestal and linked to the environment, context, and site.

Today there is an increasing recognition of a greater role for artists and their contribution to the public sphere. Artists are now engaged as designers of site-specific landscape installations and environmental works, parks,

urban master plans, museums, and housing projects. The artist may be the sole designer, the leader of a design team, a member of a collaborative team, or a partner in a joint venture with architects or landscape architects. The artist functions in a similar fashion to an architect: the contract is primarily one for services for the organization, and the artist provides drawings, models, and technical information. In this paradigm, a general contractor produces the final product, subject to the artist's oversight and approval. Such contracts may become complex, for the contract is a road map of how these various entities will interact. Issues not only of aesthetic control but also of sharing liability, copyright, and coordination become more complicated.

• **Is there a typical artist fee for the public art commission? Is the fee included as part of a lump sum or fixed amount, or is there an artist fee which is identified separate and apart from the total project cost which has its own payment schedule?**

It should come as no surprise that fees vary with the nature and scope of a project. Another factor of a contract is whether the artist is functioning as an "artist," "designer" or "pseudo-architect." Usually an artist should charge 20 percent of the project cost for a fixed-fee contract, although in the public art arena, every rule has an exception.

• **I've been given a purchase order by the client agency instead of a contract. What is a purchase order? Does having a purchase order instead of a contract increase my risks for liability, not getting paid, or . . . ?**

No. A purchase order can be seen as an offer to enter into a contract. The problem is not that it is not a binding contract, but that the purchase order may not have the negotiated terms and provisions necessary to decrease risks. Often a purchase order is the basis for a contract between an artist and a subcontractor or fabricator. The purchase order usually will have several amendments added to it by the artist which cover the benchmarks for payment, issues of liability, an assumption of risk, warranties, and other provisions that protect the artist and ensure that there is a parallel structure between the artist subcontract and prime contract. It is very unusual that the commissioning body itself will issue a purchase order. In the event that it does, the same issues apply: the purchase order does not usually include sufficient terms to define the artist's rights and rewards.

• **My contract is written so that I am a sub to the general contractor. I fabricate the artwork myself. What risks should I be aware of, and how can I protect myself in the event that the general contractor does not finish the work on time or absconds with my money?**

The General Services Administration has in many instances tried to adopt a policy of having the architect as the prime contractor and the artist

as the sub. The same issues arose in these projects as in those described in your question. It is always better for the artist to try to contract directly with the client for two reasons: (1) When the artist is the sub, particularly to the architect, it sets up a negative hierarchical relationship and (2) The risks that the question anticipates are always present. As in any contract situation, the artist can try to protect himself or herself with contract language providing for prompt payment and a payment schedule which reflects compensation for work already performed. However, at the end of the day, there is no better protection than knowing who you are dealing with and (hopefully) working with reliable people. Moreover, the particular risk you speak of is not an insurable risk. This example is the mirror image of the general contractor-artist subcontractor question discussed in the first paragraph. The message, again, is: know the people with whom you are dealing, check references, and talk to other artists. One artist provided the following comment on this subject:

> I made the mistake once of giving a job to a fairly young subcon-
> tractor who sounded like he would do a great job, but he didn't
> have an established business with a staff, office, et cetera, *and* I
> gave him up-front money! What a huge mistake that was. He per-
> formed a small part of the work and asked for more money, and
> when I wouldn't give it to him, he left town. And my $30,000 went
> down the drain. I eventually hired a lawyer, found the guy, and got
> a judgment against him, and only recently am I receiving a small
> portion of my judgment in small monthly payments (five years
> later). Never pay a subcontractor anything until the job is complete
> and accepted. If they're too small to handle that, then they're too
> small to take on the job.

SPECIFIC CONTRACT CLAUSES

In 1985, as noted above, the Association of the Bar of the City of New York adopted a Model Agreement. Although the contract was based on a fixed-fee commission agreement with the work fabricated off site, almost all of the provisions remain timely and represent a fair and balanced approach to the resolution of many difficult and complex issues. The Model Agreement answers, in much greater depth, many of the questions posed by the artists who contributed to this chapter, and my answers can be seen as supple-menting the annotations to the Model Agreement. The philosophy that supports the Model Agreement is still appropriate: client and artist are on the same side. A balanced contract that addresses the reasonable needs and concerns of all parties fosters the greatest creativity and quality.

Scope of Services/Scope of Work

• **What is the difference between "scope of services" and "scope of work"? Are they the same thing?**

For all practical purposes, it is a question of semantics. I personally prefer to use "scope of services," but there is no important legal difference. Often, "work" is a defined contract term.

• **What are the components of a "scope of work" or "scope of services"?**

This is the most unique aspect of the contract. The "scope of work" or "scope of services" describes in detail the work to be performed by the artist and his or her responsibilities. For example, it covers whether the artist is responsible for providing designs only, or for providing designs, materials, fabrication, and transporting and installing the work at the site. It is very important that the artist clearly states his or her responsibility and defines rough points, such as whether or not he or she is responsible for site preparation, installation, and other transportation—all of which may not be clearly expressed by the client or agency.

Storage

• **I've noticed that contracts will have a penalty for artists if we don't have the artwork ready by the installation date, but if the site isn't ready when it's supposed to be, the artist gets stuck with the storage costs. How can I protect myself against asymmetrical contract provisions like this?**

This is a clause that is often negotiated, and it is one for which it is not difficult to achieve symmetry. The artist that ends up getting stuck with storage costs has improperly negotiated the contract.

Quality Control

• **As an artist and member of a design team, my role in inspecting the work in progress during construction is minimized as the client hires on-site inspectors. How can I get my rights of approval respected in reviewing the work during construction on large infrastructure projects?**

Again, this is a negotiating issue. I always try to insert a clause which gives the artist the right to inform the client of any unfair action taken by a contractor and has the client agree that he or she will reject any work not approved by the artist. The client must understand that an artist's vision is in the subtle details and that payment of an artist's fee is wasted if the artist does not have the opportunity to reject work that does not conform to his or her aesthetic vision as expressed in the artist's plans and drawings.

Payment Schedule

• **Often the payments in schedules set by agencies are weighted toward the end of the project. Because I need to pay for materials and subcontractors up**

front, I need the preponderance of my payment at the beginning. Can I specify my own benchmarks and payment schedules in a contract that are favorable to me? If so, what payment schedule do you suggest?

Payment schedules are often easily negotiable, particularly if the artist can present evidence to support a front-loaded payment schedule. It really all depends on the nature of the artist's work and what the artist is doing. Some artists will require a lot of time up front, whereas others doing large-scale site installations will do most of the work at the end. On the other hand, if the artist is acting as a designer only, preparing documents and then supervising, then the payment schedule should be front-loaded.

• **What is a change order? How can I make sure that I get paid for extra work that is asked of me beyond the scope of work specified in the contract? What and how should I charge for extra work? By the hour?**

A change order is nothing more than a contract modification agreed to by the involved parties. It should be in writing. Usually the contract provides adjustments, which require additional work. It really depends on each individual case and what the main contract provides to answer whether one should be paid by the hour or paid based on a percentage of the increased costs of materials or the increased scope of work. Architects usually specify that for work exceeding basic services, they will charge an hourly fee. But again, this varies. Whatever the adjustment and method of compensation, it should be provided for in the contract.

• **I signed a contract where the final size of the artwork wasn't determined because construction was not yet complete. There was a clause in the contract that said my wage would go down if the dimensions of the site decreased. They did, but the cost deducted was based on the cost per square foot of all expenses (labor, travel, artist fee, etc.), not just the cost of the materials that would have been used. How can I prevent this from happening on future projects?**

Don't sign a contract with a similar provision. Very often, reducing the size of a project entails more work than if the project were built as originally specified. In this particular case, and in future cases, the artist should negotiate for an additional fee to reduce the scope of work. Of course, if there is no additional design work required, then simply reduce the fee based on the cost of materials.

• **I submit my invoices on time, but the agency is taking longer than the sixty days specified in the contract to pay me. This makes me unable to pay for materials and fabrication, which is putting me behind schedule. Will I be in default of my contract if I slow the project down to match the agency's**

payments, or should I go into debt to keep the project moving forward? And can I charge them interest for late payments?

This is not an uncommon situation, unfortunately. There is a limit to what one can do, but certainly try to have a clause in the contract which specifically provides for an interest of 1.5 percent on payments not made within the time period specified. This question also suggests that the original payment schedule agreed to did not adequately take into account how the payments should be allocated to prevent the artist from having to subsidize the project with his or her own money. There are also clauses that one can write into a contract which, in the event of failure to pay in a timely manner, allow the artist to stop work. The problem is that often there will be other people involved who are working for the artist, so slowing down the project is really not a viable alternative. I am afraid the only solution is to anticipate this problem in future contracts with frontloaded payment schedules and a hefty interest charge if payments are not made in a timely fashion.

Contingency

• **What is a budget contingency? How much should it be? Can the artist set it? What if the artist comes in under budget? Does he or she get to keep that money? What if the budget is so small that there's no room for a contingency?**

A budget contingency is based on the fact that over time, the cost of labor and materials may vary, usually upward. When the artist is asked to prepare a budget and there is some leeway, I recommend a 10 to 15 percent contingency. There is no one answer to whether or not the artist gets to keep the contingency; it depends on so many different factors and practices.

Timelines

• **What can I do to cover myself in the case that I fall behind the contracted schedule waiting for an agency that continually misses deadlines?**

This is a fairly easy question. First, the contract should always provide for the readjustment of timelines in the event that one party is prevented from meeting his or her deadlines by the delay of another party. As a matter of law, one party cannot be held in breach of a contract obligation if his or her performance was held up by another party. The contract should always provide that all parties can in good faith mutually adjust the time schedule, which is certainly a legitimate request in many situations. Timelines and performance benchmarks should be very carefully thought out, and the provisions governing them should be negotiated with careful attention to the variety of contingencies that may arise.

Documentation

• The contract stipulates that the artist should pay for a plaque and photography included in the project. Shouldn't the agency pay for these things?

There is simply a matter of bargaining power and the agency's budget. There is no magic answer to this one. Another important aspect of this is to consider the artist's ability to select the photographs used to represent his or her work, because many people will learn of the work exclusively through photographic documentation.

Insurance

Insurance can be both easy and complex. The easy part is calling your lawyer or broker. The hard part is not having insurance if something goes wrong. Insurance is negotiable, and there are many ways to skin the cat. Chapter 7 of this book goes into depth on the types of insurance coverage artists need.

• What are "performance," "labor and materials," "maintenance," and "bid" bonds for? On what types of projects are they required? Are they the same as professional liability insurance?

Various bonds are provided by bondsmen to guarantee payment in the event of a contractor default. It is a type of insurance with a premium paid whereby the bondsman guarantees to pay for or complete the performance in the event that the contractor defaults. In the late seventies, I wrote a position paper for the King County Arts Commission advising them to remove performance bonds from artists' contracts because the premium, which was high, could be better applied to the artist's fee. In most instances, public art contracts now do not include the requirement that artists obtain performance bonds. They may occur from time to time in large-scale projects involving large payments to the artist, and where the artist is required to perform services much like a general contractor.

• Why can't the commission contract simply be with the licensed professional who is used to meeting requirements for indemnification, PLI, workmans' comp, performance bonds, et cetera, such as the general contractor, my fabricator, or the architect? Why are we required to have professional liability insurance if we're having a subcontractor do the installation? My subs have all the liability insurance needed.

Sometimes, these types of insurance are with the licensed professional. My own preference is that the artist holds the prime contract and passes on the liability to the subs, who have the required insurance. Yes, you didn't necessarily have to spend $3,000 a year. It is usually possible, with careful contract negotiation, to obtain the maximum benefit and control for the artist at the same time that issues of indemnification, insurance, et cetera are properly

allocated where they belong. Like anything else, you have to know what you are doing or hire someone who does.

These are difficult questions, and it may not always be possible to fix things. But certainly, a well-drafted contract can allocate liability and risk to those most capable of paying for it without "pure nonsense and a huge waste of money."

• **What do "risk of loss" and "risk transfer" mean? How is the cost of the risk determined? What should artists be aware of when encountering this section in a contract?**

Risk of loss simply defines who is going to be responsible for replacing an object or an installation if it is damaged. The uniform commercial code, which is the law that governs sales of goods in most states, has specific rules for allocating risk of loss if the contract does not otherwise provide. My own preference is to write out clearly in the contract which of the parties have the risk of loss at any given time. The insurance coverage period obtained by the artist should be coextensive with the artist's risk of loss.

Indemnity

• **What is an indemnity clause? What are the implications for artists? (Lajos Heder, an artist with many years of experience as a public artist, writes: "Most contracts include a nasty indemnity clause that says something like 'indemnify, hold harmless, and defend the city—or 'client'—against any and all claims.' I have argued against this with varying levels of success, particularly against the 'defend' part that implies that the artist actually has to hire an attorney to defend himself or herself against the city in a lawsuit that could be quite frivolous.")**

An indemnity clause is a provision in a contract which provides that the entity indemnified will be protected from third-party claims arising out of certain contractually defined circumstances. Generally, each party to a contract can sue the other part for a breach. Breach of contract claims are not available against individuals who are not contract parties. Similarly, without an indemnification or hold harmless clause, one party to a contract sued by a third party has no right to be compensated by the second party for damages and attorney's fees. Indemnification clauses are usually "boilerplate." That is to say, they are clauses which have been, in the case of government commissions, approved by the city council or some other governing body. It is therefore difficult to negotiate them. If there is some room to negotiate, artists should try to narrow indemnification to those situations arising from the artist's "sole negligence." The Model Agreement referred to earlier in this chapter recommends that the client or commissioning agency indemnify the artist for final acceptance.

As a result of lobbying by design professionals, various states have leveled the playing field slightly by limiting the ability of public entities allowed

to impose broad indemnification provisions on design professionals. In this respect, California's new legislation, AB 753, signed September 25, 2006, by Governor Schwarzenegger, makes indemnity agreements requiring designers to compensate public entities for more than their share of negligence unenforceable for contracts entered into after January 1, 2007. The drawback is that the law defines design professionals as licensed architects, registered engineers, land surveyors, and landscape architects; thus, artists are not included in the legislation. Hopefully, however, in many of these large-scale public projects where artists form a part of a collaborative team with these other design professionals, they will benefit from contract language newly drafted by government attorneys to comply with the new law.

Apparently, one factor which led to the legislation is that most current professional liability insurance policies no longer provide for extra or contractual risks that may exceed professional liability for negligence. If design professionals are found liable at trial based on these broad indemnity provisions and are assessed damages beyond their own negligence, they may not be covered under their professional liability policies.

Warranty

• Is there anything I should look out for in the Warranties of Title section of a contract? It appears that all it is asking is that I vouch for the fact that I am the originator of the idea for the artwork and didn't steal it from anyone else. Is there more to it that I should be aware of?

No.

• Regarding warranties of workmanship, how much is a reasonable amount of time for the artist to be responsible for guaranteeing that the work be free of defects? I've seen contracts with periods ranging from one all the way to ten years. Is this negotiable? If so, is there an industry standard for how long this warranty should last?

Warranties of workmanship depend on what it is you are doing and the nature of the materials you are using. My advice is never give a warranty beyond a warranty that your subcontractor or material supplier is willing to provide. In short, the industry standard depends in large part on the nature of the materials that you are using and the warranties characteristically given in that industry. In general, these clauses are negotiable.

• After the warranty period was up, some tiles fell off of a mosaic mural I did. The city had their maintenance crew go out and patch it up with what looked like bathroom tiles. The artwork looks terrible now. What recourse do I have?

If you read the Model Agreement and signed it, you would have had contractual options available to you, as well as rights under the Visual Artists

Rights Act. Without knowing whether or not you waived these rights, it is difficult to provide you with any advice except to say to pay more attention to your contract and artist's rights the next time around.

INCORPORATION
• **Should I incorporate my business?**

The primary purpose for incorporation is to provide the individual with limited liability. Particularly if one has assets and/or many employees, it is desirable to incorporate. Currently, while it is difficult to provide general advice without knowing the various details involved, the best corporate form is the limited liability company (LLC). That is because it is a hybrid corporate structure which provides corporate protection toward personal liability but at the same time provides a pass-through on taxes. The LLC has replaced the subchapter "S" corporation as a preferred form for those who wish to protect their individual assets by use of the corporate form. This may also avoid some of the risks of double taxation involved. Regardless of whether the artist is a sole proprietorship, an "S corp," or an LLC, attention must be paid to avoid the situation where the artist may receive a large payment in one year for fabrication but not expense it until the following year. In both cases of the LLC and sole proprietorship, the artist will not be able to deduct the expenses from the income in that year; however, with the corporation, which is not an "S," the artist may have double tax action.

In the next chapter, I will discuss several of the most important aspects involved in the public art commission, including copyright, fair use, and the Visual Artist Rights Act.

Questions were contributed to this section by the following artists:
Alice Adams, Dale Enochs, Cliff Garten, Nicole Gordon, Brad Kaspari, Lajos Heder, Guy Kemper, Jack Mackie, Mike Mandel, Julia Muney Moore, Marilyn Ines Rodriguez, Koryn Rolstad, Vicki Scuri, Survilla M. Smith, Ginny Sykes, Stephanie Werner, and Chana Zelig.

End Notes
[1] Sue Greenberg. *Anatomy of a Contract*. (St. Louis: St. Louis Volunteer Lawyers and Accountants for the Arts, 2004.) A free download can be found at *vlaa.org/documents/Contracts-ID2.pdf*.

Chapter 9:

Ask the Expert: A Primer on Copyright and Artist's Rights

By Barbara T. Hoffman, Esq.

Because the collective questions posed to me in this chapter reflect some basic confusion about copyright and artist's rights, I believe a nutshell analysis of these two areas would be useful before responding to particular questions concerning copyright and artist's rights as they apply to public art commissions.

COPYRIGHT BASICS

"The source of Congress' power to enact copyright laws is Article I, cl. 8, of the Constitution the "Copyright Clause". According to this provision, 'Congress shall have Power . . . to promote the Progress of Science and useful Arts by securing for limited Times to Authors . . . the exclusive Right to their respective Writings.'"

To be protected under current U.S. copyright law, a work "must be an original work of authorship fixed in a tangible medium of expression." The Copyright Law imposes no requirement of aesthetic merit as a condition of protection. However, a work must have "at least some minimal degree of creativity." Works of visual art—a painting, a photograph, or a sculpture—are protected by copyright. Thus, the simple act of creating an original work in a "fixed" medium, including the electronic, gives the author copyright of the work.

Rights of the Copyright Owner

Under Section 106 of the 1976 Copyright Law (the "Copyright Law"), the copyright owner has the exclusive right to (1) reproduce the work in copies or phonorecords, (2) prepare derivative works based on the copyrighted work (which includes the right to recast, transform, or modify), (3) distribute copies by sale or other ownership transfer, or to rent, lease, or lend copies, (4) perform the work publicly, and (5) display the work publicly.

For certain one-of-a-kind visual works of art and numbered and limited signed editions of two hundred copies, authors (artists) have the right to claim authorship (attribution), prevent the use of their names in conjunction with certain modifications of the works, and to prevent alteration of their work (preserve its integrity) (Section 106A). The latter two rights are known as *droit moral*, or moral rights. Section 106A states that "the author of a work of visual art" shall have the right subject to the exceptions provided in 17 U.S.C.

113d, "to prevent any intentional distortion, mutilation, or other modification of the work which would be prejudicial to her honor or reputation." She has the right to prevent any destruction of a work of recognized stature and "any intentional or grossly negligent destruction of a work that is a violation of the right." However, 106A(c) (2) provides an exception: "The modification of a work of visual art which is the result of conservation, or of the public presentation, including lighting and placement, is not a destruction, distortion, or modification unless the modification is caused by gross negligence." Additionally, there is an exception in 113 (d) for works that are integral to a building, these artworks being deemed outside the scope of VARA.

Ownership of the bundle of intangible rights comprising copyright is separate and distinct from ownership in the work of art. Under current law, in the absence of a writing expressly conveying copyright, the sale, gift, or transfer of the original work of art does not transfer the copyright in the work of art. Under the Copyright Act, copyright interests can be transferred *inter vivos*, or at death, and in whole or in part. For example, a copyright owner can transfer all the rights or one or more of the rights, or create joint ownership of rights. A copyright owner may license or assign copyright in the work in a number of ways: (1) by the type of use and/or media, (2) by an exclusive or nonexclusive license, or (3) by territory or duration, to name only a few possibilities.

It is no longer the practice for most clients to request that the artist grant copyright of the work of art as a condition of the commission. To the extent that there is an assignment or "license" of a copyright interest, it is usually a nonexclusive license allowing the use of the artwork for noncommercial purposes. A nonexclusive license is not a transfer of copyright ownership, but a transfer of a contract right; thus, the artist should be aware that the client cannot rightfully file a copyright infringement action and that he or she (or the artist's heirs) must bring any action for copyright infringement. Both nonexclusive and exclusive licenses are usually negotiated. The commissioning entity usually requests that the artwork be unique, so the artist normally agrees to a limitation on his or her exclusive right to make exact reproductions of substantially similar size and materials.

Different language will be negotiated for artists who work in editions or in repetitive themes or styles. For those artists acting as "architects," the basic American Institute of Architects' Model Agreement is useful. That document protects the artist's drawings and entitles the client to reproduce them only as "instruments of service" for the project.

The Copyright Act vests initial ownership of copyright in the creator of the work, unless it is a "work for hire." In the case of a work for hire, it is the employer and not the employee who is considered the author. Section 101 defines work for hire as (1) work prepared by an employee within the scope

of his or her employment and (2) a work specially ordered or commissioned for use as a contribution in one of nine categories. The United States Supreme Court decision in *CCNV v. Reid* clarified that a public art commission cannot be a work for hire in category (2). Thus, a commission is only a work for hire if the artist is an actual employee of the client, with a W-2.

Duration of Copyright

The 1909 Copyright Law prescribed a twenty-eight-year term of copyright from the date of the work's first publication. Thus, until 1978, the effective date of the 1976 Act, the term of federal copyright was twenty-eight years from the date of publication. To maintain copyright protection during the second, or renewal, term, a copyright owner has to file a renewal application during the twenty-eighth year of the initial term. The 1976 Copyright Law, which became effective in 1978, provided that federal copyright protection of works created by "identified natural persons" run from the work's creation—rather than its publication—and that such protection would last until fifty years after the author's death. In 1998, Congress passed the Copyright Term Extension, which extended the duration of copyright to the life of the author plus seventy years, and which retroactively extended the term of copyrights in existence to the seventy-year term.

What Is Fair Use?

From the infancy of copyright protection, the fair use doctrine "has been thought necessary to fulfill copyright's very purpose, 'to promote the Progress of Science and useful Arts'" (*Campbell v. Acuff-Rose Music, Inc.,* 510 U.S. 569, 575). What is fair use? As the syllabus for a crash course in copyright of the University of Texas states, "We would all appreciate a crisp, clear answer, but far from clear and crisp, fair use is described as a shadowy terrain whose boundaries are disputed."

Recognized as common law, the doctrine is now codified in section 107 of the Copyright Law, 17 U.S.C. Sec. 107 (1994). It provides an affirmative defense to a claim of copyright infringement that a work was used without the copyright holder's authorization or permission. Section 107 provides in its first sentence an illustrative list of the purposes for which the doctrine may be invoked, including "comment" and "criticism.," Section 107 then lists four vague factors that courts consider in determining whether a use is "fair." These factors are (1) the purpose and character of the use, (2) the nature of the original copyrighted work, (3) the amount and substantiality of the original work taken, and (4) the effect of the use on the market for the original work. (For more about fair use, check the articles on my Web site at *www.hoffmanlawfirm.org*.) Artists have prevailed with the fair use defense in a number of recent cases involving parody, satire, and appropriation.

The Battle of U.S. Artists for "Moral Rights"

Under French law, every creator has a personal, perpetual, and inalienable right to respect of the artistic integrity of the creative work. The five components of *droit moral* are (1) the right of paternity: a work must be attributed to its creator and no one else; (2) the right of creation: no one except the creator may determine whether or when the work is put before the public; (3) the right of integrity: no one except the creator can change the work; (4) the right to protection from excessive criticism; and (5) the right to withdraw the work from the public. Legal protection of an artist's so-called "moral or personality right" was controversial in the United States because U.S. copyright law focused primarily on the protection of economic rights and interests. Prior to 1990, artists relied on theories of contract law, or defamations of a trademark as a "moral rights equivalent." As noted previously, in 1990, after years of debate, Congress enacted the Visual Artists Rights Act (VARA) as section 106A of the Copyright Law, a limited form of "moral rights" protection.

Legally, this vests in the artist a right of attribution and a right of integrity. VARA provides that the author of a work of visual art shall have the right to claim authorship of that work, and shall have the right to prevent any intentional distortion, mutilation, or other modification of that work which would be prejudicial to his or her honor or reputation, and to prevent any destruction of a work of recognized stature.

An artist who wishes to state a claim under VARA must first establish that the laws apply to his or her case by proving that the work meets the statutory definition of visual art. A work of visual art is defined by VARA in terms both positive and negative. VARA affords "protection only to authors of works of visual art—a narrow class of art defined to include paintings, drawings, prints, sculptures, or photographs produced for exhibition purposes, existing in a single copy or limited edition of 200 copies or fewer." VARA applies at the moment of creation. An artist's right of integrity enables the artist to protect his reputation and personality by protecting the physical integrity of his work.

Works of "recognized stature" within the terms of VARA are those works of artistic merit that have been recognized by members of the artistic community and/or the general public. To obtain this protection, an artist must prove not only the work's artistic merit on its own but must also show that it has been recognized in a community as having such merit. The stature of a work of art is generally established through expert testimony.

A Few Limited Victories

Can a sculptor of a permanent installation of forty metal Canadian geese on display at a shopping center prevent the mall operator from adding red

ribbons to decorate the sculpture at Christmas? Can a nonprofit organization that commissioned a sculptor to create an artwork hire the sculptor's assistant to complete the artwork in order to override the sculptor's objections? Does an artist have the right to prevent an owner who commissioned a work of site-specific art from removing it?

The preceding questions illustrate whether and when an artist has the right to control the integrity of his or her work after it has been sold or before it has been completed. VARA may or may not give the artist a right of action. The first example is based on a well-known Canadian case. The court approved the sculptor's request to take down the ribbons on the grounds that the modification of the work would harm the professional and artistic reputation of the artist and would, therefore, be in violation of the integrity of his work. (Canada has endorsed moral rights since 1931.)

The second example is based on the case of the distinguished sculptor Audrey Flack, which I litigated and which stands as one of the few precedents on the side of the artist under VARA.

The facts of *Flack v. Friends of Queen Catherine* are interesting because they provide insight into the risk of certain business models used to commission works of public art. In 1989, for the purpose of memorializing the life of Catherine of Braganza, Princess of Portugal, Queen of England in the mid-seventeenth century, and the namesake of the borough of Queens, New York, the Friends of Queen Catherine (FQC) undertook to create a monument for installation on donated public property facing Manhattan. On the basis of a model she created for the project, Flack was commissioned to further design and supervise the fabrication of a twenty-two-foot model, and then a thirty-five-foot clay model to be cast as a bronze sculpture and installed at the site. FQC entered into a contract with the foundry Tallix to fabricate the project based on Flack's designs under her supervision. Flack had no contract with the foundry. By the time Flack had completed preparatory work on the project and, in 1997, began the fourth phase to create the full-size statue, unfounded rumors that Catherine of Braganza was involved in the slave trade created public controversy around the project, resulting in the loss of the site. Flack, nevertheless, completed a full-size clay statue, which was presented to visitors and the press at Tallix.

Given the controversy, by 1998, Tallix sought assurances of FQC's ability to fund the project, which was not forthcoming. The foundry terminated the contract. Tallix and FQC finally settled their differences, permitting work on the thirty-five-foot bronze statue to begin one year later. However, Flack discovered that in the interim, the clay sculpture of the head had been placed outside in Tallix's garbage dump. In addition, the waxes and molds drawn from the thirty-five-foot clay sculpture had been damaged; thus, it was necessary to reconstruct the clay face to develop new molds. Flack

offered to resculpt the face but demanded an additional fee. Tallix, at the suggestion of FQC, hired one of Flack's assistants to resculpt the face. The result of the assistant's work was a "distorted, mutilated model," which Tallix and FQC were in the process of casting and shipping to Portugal. Flack came to see me to see whether she had any remedy against Tallix or FQC for the modification or destruction of the sculpture.

We began an action for infringement of Flack's rights under VARA and copyright laws based on the unauthorized creation of derivative works and other claims. We also asked the court for temporary emergency relief to maintain the status quo, which was granted.

Because the clay sculpture had been exhibited at Tallix and because we submitted expert affidavits testifying to the "recognized stature" of Flack's work and this work by her dealer, an art critic and curator, the work's "recognized stature" was acknowledged by the defendants. However, the court held that Tallix's placement of the head in the garbage did not constitute a willful destruction of the artwork, and its modification was caused by "time and the elements," both an exception to the rights granted under VARA.

Flack prevailed on her claim against Tallix and FQC for hiring her assistant. While Tallix and FQC argued that hiring Flack's assistant was a conservation measure—an exception to VARA protection—the court nevertheless decided that hiring the assistant to sculpt the clay head could be gross negligence and permitted a VARA claim, as well as a claim for copyright infringement based on the creation of an unauthorized derivative work.

Thus, while it is clear that a property owner, foundry, or commissioning entity does not have the right to complete the work without the artist's approval, contrary to the law in France, courts in the U.S. have been reluctant to compel a client to permit an artist to complete a work the artist was commissioned to create. Another case in which an artist was successful in bringing his VARA claim involved a suit against the City of Indianapolis, which demolished a work of art that was installed by agreement of the City on private property. The court awarded damages in the maximum amount allowed for non-willful VARA violation. On appeal, the artist argued that the violation was willful, and enhanced damages were warranted. The City argued that the evidence admitted to establish the "recognized stature" of the art was an inadmissible, out-of-court statement, or "hearsay." The court held that the evidence admitted was not hearsay and that the destruction of the art was not willful, but rather the result of bureaucratic failure.

Artists by and large have not been successful in their VARA claims either because the work falls within one of the exceptions in the statute or, even more troublesome, because the work is not of a "recognized stature," raising the likelihood that judges will make aesthetic value judgments.

Some major setbacks: Judges don't get VARA. Sculptors have lost their VARA claims because the artwork was work for hire, or had been "used for promotional or advertising purposes," another VARA exclusion. Most recently—and, in my opinion, incorrectly—the United States Court of Appeals for the First Circuit (Massachusetts) determined that VARA did not apply to site-specific work. The artist sued the defendant realty company arguing that removal of his work from a Boston municipal park would violate his rights under VARA because the removal of work that is site specific destroys it. The court's flawed reasoning disregards the purpose of Congress in enacting VARA and the careful balancing of interests between the rights of private property owners, artists, and the public it represents, and elevates the rights of property owners unnecessarily over the interests of the artist and the public in preserving art work of recognized stature for future generations.

Let's hope that the recent decision of the Honorary David H. Coar in *Kelley v. Chicago Park District* (U.S. District ct. N.D. Ill. 2007) represents a new and welcome judicial sensitivity to public art in nontraditional materials. Although the reasoning is somewhat stretched, the court's conclusion that the garden's "Wildflower Works" was copyrightable and fell within VARA is welcome.

Because of the difficulties in achieving VARA protections, many public and private commissions provide for artist's rights in contracts. The Model Agreement provides for artist's rights, including identification, maintenance, repairs, and restoration. In addition, the Model Agreement provides that the artwork shall not be intentionally altered or mutilated, and extends protection to the site for site-specific works.

Unfortunately, many commissioning works of art for public display seem to ignore that it is the public as well as the artists who lose when VARA rights are waived. For large-scale public commissions, I believe the compromise which I negotiated with Dale Lanzone, then head of the General Services Administration Art in Architecture program, is a good solution: "For the purposes of section 17 U.S.C. 101, 106A, the Artist will determine the significant characteristics of the Artwork which will be subject to the protection of sec. 101.106A et seq. against any intentional or grossly negligent destruction. . . . "

COPYRIGHT Q&A

How does copyright work with regard to public art? Do I automatically have a copyright once I create the artwork, or should I register with the U.S. Copyright Office? Do I still own a copyright even if I don't put a copyright symbol on the actual artwork?

There is no special category for public art in copyright law. The work will either be a pictorial, graphic, and sculptural work, or a work of architecture

or landscape architecture. Copyright of the work exists from the moment it is fixed by the artist in a tangible form. If you do a drawing or a clay model, a copyright exists of that particular image, and the resulting final artwork is a derivative work based on the original image. Registration is not necessary for copyright protection, but copyright law provides several incentives for registration, including (1) coverage of statutory damages and attorney's fees if the work is registered before an infringement occurs, and (2) *prima facie* evidence for the facts on the copyright registration certificate. Since United States joined the Berne Convention in 1989, it is no longer necessary to put the copyright symbol on the artwork or in any other place as a condition for copyright protection. Copyright notice still provides the useful service of informing people with interest in a given work that someone is claiming copyright to this artwork.

I've been asked to sign away my copyright. Should I do that?
Remember that as the "author" of the work, you own all rights to that work. When clients commission an artwork, they are paying you for the physical artwork and not necessarily for the intangible rights that accompany it. After negotiation, most clients today will not ask for a surrender of all rights, but will limit their request to only what they need or what they are willing to pay for in addition to the commission fee.

Who owns the design once it is submitted? Am I free to reuse it elsewhere if it isn't selected? If my design isn't chosen, can I get a guarantee that they won't use it (even in a modified form) down the road? And if they do choose my design as the winning one, does it become solely the property of the agency?
The answers to these questions turn on two principles. First, unless this is a work for hire, the artist owns all the intangible rights of the designs submitted. Second, did the artist assign or license any of the exclusive rights of copyright to the client when the designs were submitted? That is to say, the remaining answers are dependent on what the artist signed at the time of submitting the designs and what terms are specified in the contract. If the artist signed no agreement, then he or she is free to exercise all of the exclusive rights of the copyright owner. It is also important to distinguish between ownership of the drawings and ownership of the intangible rights. Often, the artist may not be able to negotiate to retain the drawings submitted; however, in my experience, this is not a foregone conclusion.

Regarding artist teams: At what point is an idea copyrightable? For example, if an artist team thinks up an idea, does sketches, and tells the client about it, but then one of the artists goes off on his own and executes the idea himself (i.e., puts it in tangible form), do the other members of the artist

team have any recourse? How can they protect themselves from this at the beginning, especially if the commission contract expressly requests that the contract only be with one artist team member who represents the whole group? Are there any sample contracts out there?

This is an excellent question, with many possible answers. First, unless there is a contract amongst the team members at the beginning, anyone is free to use an idea. An idea is only copyrightable when it is expressed in a tangible form (i.e., a sketch, drawing, or notes). It is really important, particularly in the scenario described above, to have a contract amongst all the team members outlining the scope of their services and how they will define their intellectual property rights, whether they are in ideas, concepts, or copyrighted materials. There is no model agreement for collaboration, but two areas do require discussion and agreement. First, is the work product to be a work of joint authorship as that is defined by the Copyright Law? Second, what happens if the collaboration terminates? If it is a work of joint authorship and the parties have not signed a written agreement about their rights, any one of the joint authors has a right to exploit the copyright but must account financially for any profits to the other joint authors based on the proportionate share. So, for example, if three authors create a work, the profits will be split into thirds absent a ruling to the contrary.

If I had others fabricate the artwork, am I the copyright holder of the final piece, or is my ownership limited to the plans for the artwork?
The fabricated artwork is more likely than not a derivative work of an original drawing. In order for the fabricator to claim copyright of the artwork, the fabricator would have to argue that this was an authorized derivative work. Depending on the complexity of the original underlying work, in my view, the relationship of the fabricator to the artist should always be clearly defined to prevent any disputes from arising in the future.

• May I sell multiples of smaller versions of one of my artworks that was commissioned—for example, a maquette of a sculpture?
It depends on what the contract stipulates. If you surrender all rights to the artwork, then you cannot sell multiples. If the contract provides that the work is unique, there is an issue as to whether or not you can sell a maquette of a smaller size. To avoid problems, this should be clarified in the contract.

Who owns the copyright to photographs of my work? Do I need to get permission from the photographer if I want to use images of my own work for promotion, publicity, or salable items? When a photo of my work is published, whose name goes after the copyright symbol, the photographer's or mine?

The photographer owns the copyright to the photographs of your work unless it is a work for hire. The photographer needs the artist's permission to reproduce images of his or her work, since the artist owns the copyright of the artwork. If the artist retains the photographer, the artist should have a simple letter of agreement with the photographer giving the artist a non-exclusive license to reproduce the photographs for certain specified purposes as part of the basic fee that the artist has paid the photographer.

Practices vary, but normally the copyright symbol is followed by the name of the photographer with the word photo credit, then by the name of the artwork and the artist. Alternatively, sometimes the photographer will not require a credit in his or her name, and the photograph will simply feature the copyright symbol, the name of the artist and the work, and the date. Particularly difficult situations may arise with respect to both credit and copyright for photography of performance art if written agreements are not entered into prior to the shoot.

Because my work is in the public domain, can others take pictures of it and then sell those images?
Your work is not in the public domain. The public domain is a term of legal art. It is in a public space. If your work is in the public domain, it means it is free of any copyright protection. Normally, if a photograph of the artwork is incidental to a photograph of the site as a whole, it may not infringe the copyright of the artist. However, a more substantial use of an artist's work may in fact infringe his or her copyright. There have been a number of lawsuits that involved artists suing movie studios for the use of their artwork that was located in a public space. In one lawsuit involving Andrew Leicester, Leicester failed to prevail because his sculpture was seen as an integral part of a building that was not protected by copyright.

Visual Artists Rights Act, Sec. 106A (VARA) Q&A
Do moral rights laws vary from state to state? If so, how can I find out what they are for a particular state?
Prior to 1990 and the enactment of VARA, a number of states, including California, New York, and Massachusetts, enacted artist rights laws. As part of the Copyright Law, VARA is a federal law and specifically states that it preempts (replaces) any state laws which provide equivalent rights. If there is an issue where the artist must rely on state, as opposed to federal, law, consult with an attorney.

I've been asked to sign away my VARA rights. Should I do that? What are the ramifications if I do? If I want to convince the agency's attorneys to let

me retain my VARA rights, what can I do to persuade them? Aren't VARA rights kind of like civil rights? Why should I sign them away? Can I negotiate extra compensation for signing them away?

The short answer to the first question is "No." More often than not, artists are explicitly asked to sign away their VARA rights. This is a problem, and, in my view, the client or administrator who seeks the waiver of VARA rights is not exercising the proper stewardship role of a public art collection. From the point of view of city attorneys, VARA conjures up lawsuits by unreasonable artists seeking to achieve fame and fortune. Usually, a compromise with a limited waiver is possible. Sometimes it is possible to protect an artwork's integrity via contract, although as I indicated, contractual protection is not as good as VARA protection. So, yes, in my view, VARA rights are like civil rights, and in principal, an artist should not be required to sign them away. Good luck, and congratulations on your skill as a negotiator if you succeed in getting paid for signing away your VARA rights.

Ownership

I'm confused about who owns the artwork. Is it the agency that commissioned it and contracted me or the owner of the building where the artwork is located? If ownership of the building is transferred, then do the provisions of my contract for the artwork transfer with it? (For example, if the city that commissioned my artwork sells a building to a private developer.)

There is no one answer to this question. If the commission is a percent-for-art commission or part of a redevelopment project, the ultimate owner of the artwork will not be the agency. If your contract is only with the agency, any contract rights you have as an artist will only be enforceable against the agency unless the agency is required to assign the contract rights to future purchasers. VARA rights do not depend on contract unless they are waived by contract. VARA rights exist independent of a client's ownership rights and independent of contract.

Duration of Responsibility

When does the artist's responsibility for maintenance and repairs end? What is a reasonable amount of time for the artist to be responsible for maintenance?

The answer to these questions depends on contract and ethical commitment. The artist is not responsible for maintenance beyond fulfilling the contractual obligation of the warranty of quality and providing maintenance instructions. Artists will often wish to include an obligation on the part of the client and the agency to maintain the work in accordance with reasonable conservation standards and with the artist's right of integrity.

If controversy about an artwork is still going on for some time after the artwork has been installed, how long can the artist reasonably be asked to attend community meetings about it without getting paid?

It's your artwork, and it is a question of how much time you want to spend defending it. If you can prove that the artwork is of recognized stature, the agency or client will not be able to destroy it unless there is some contractual provision giving the client the right to remove the artwork in the case of controversy, or if you have waived your VARA rights.

Chapter 10:
Working with Fabricators

Many public artists do not execute their own artwork. We outsource the production to fabricators. You don't need to know how to pour a terrazzo floor, fuse glaze to plate glass, or piece a mosaic. All you need to know is how to hire a reputable expert to do it for you. As long as you can render a reasonable facsimile of your idea as a drawing, painting, or model that can ultimately be translated into a digital format, an entire universe of materials opens up to you.

However, there's a trade-off. If you're able to do the work yourself, you'll pocket more of the budget, because you'll be receiving the artist's fee as well as the ability to charge for labor. But then, you're out the "opportunity cost." In other words, what other profitable opportunities did you miss during the months you spent on that one project? Could you have been applying for more six-figure commissions, some of which you might have received? Or, creating a body of studio work? Or, developing and supervising three or four more projects that you've outsourced? And do you really have the time to learn how to weld? Do you even need to learn how to weld?

Most public art agencies will require that you find your own fabricator to subcontract with directly. A few, such as the Regional Arts and Culture Council in Portland, Oregon, the Los Angeles County Arts Commission, and the Wisconsin Arts Board, have a list of local vendors who work with artists that they can point you to. Increasingly, some will have prescreened and contracted directly with the fabricators that they want artists to work with, as does the Los Angeles County Metro Transit Authority's public art program. The latter arrangement is particularly good for artists with no prior public art experience because it levels the playing field, so that you're competing based on the quality of your concept, not on your ability to find, contract with, and supervise a fabricator.

FINDING FABRICATORS
Fabricators fall roughly into two groups: those who specialize in working with artists on site-specific commissions, and those who work mainly with other trades. There is no centralized source of information on how to find these firms. Like many other aspects of public art, you'll need to rely on exchanging information with other artists and your own initiative.

Artist Fabricators

The emergence of public art as a viable market has brought a number of fabricators to the foreground who work exclusively with artists to translate their ideas to permanent materials. Some have spawned in response to recent demand, while others have been in business for generations using centuries-old techniques. Firms that are used to working with artists should be your first choice because they'll understand your concerns about having your work interpreted into a medium that you're not used to seeing it in. Nor will they treat you like an exotic creature who is liable to do something unpredictable at any moment.

Be sure not to overlook other artists whom you can commission to execute your ideas. You might be surprised at the number of artists who have come to the very practical realization that if they can't make a living solely from their own work, they'd rather stay in business for themselves by subcontracting with other artists than get a job doing something else.

Sculptors have the most established network of art fabrication specialists because of the contiguous history in their practice of creating work so large that they can't do it by themselves. Public sculpture today can involve light, video, earth, wind, fire, water, and state-of-the-art electronics, in addition to traditional stones and metals. It shows up in the form of gateways, signage, bike racks, historical markers, war memorials, bus shelters, and kiosks. Instead of being shaped with hammer and chisel or molded in a forge, it can also be cut by lasers, water jet, and plasma.

Painters and others working in two-dimensional mediums are limited only by the ability to envision their work in another material. Legions of fabricators are standing by who can turn your work into mosaic, terrazzo, glass, fiber, wallpaper, and shaped metal.

Look for full-service companies who will help you engineer your idea, go with you to the committee meetings to explain technical details, and install the finished work. It's up to you to be sure they have all the appropriate insurance, bonds, and permits that your client requires for them to work on site. (See chapter 7, on insurance, for more detail.)

Where to Find Fabricators

International Sculpture Center (*www.sculpture.org*). The ISC has ambitiously created a section on its Web site available for members to find fabricators in stone, metal, and fiber, as well as digital and material engineers who help artists figure out how to make their ideas work without falling over or falling apart. Each fabricator has its own searchable section that links to the full Web site. A spokesperson at the ISC told me the goal is to be the most valuable source of fabricators for artists on the Web.[1] The Basic/Student/Senior ($100/$65/$65) categories will buy you full access to

this information, along with ten issues of the magazine *Sculpture* and access to their comprehensive online public art opportunities listings.

Sculpture magazine (*www.sculpture.org*)
Some of the vendors listed on the ISC Web site advertise in the organization's magazine. For $55 a year, you'll get ten issues (but no access to the other online member benefits), or you can buy it of major newsstands throughout the country.

Public Art Review (*www.publicartreview.org*)
Ads from fabricators can be found in each of the biannual issues, which are available by subscription. But if you go to the Web site and click on "Advertising" in the main menu, you'll be taken to a page with a section called "Our Advertisers." There, you'll find a link to the Web site of every advertiser in the current issue.

Public Art Network Annual Conference (*www.artsusa.org/services/ public_ art_network/*)
There's an exhibitor room that's part of every annual PAN conference. Only a handful of fabricators go to the effort and expense of attending, but those who do are ready, willing, and able to work with artists. At the 2007 conference in Las Vegas, you would have found Botti Studio of Architectural Arts, Creative Edge (water jet), Derix Architectural Art Glass, Franz Mayer of Munich (architectural glass and mosaic), Mosaika Art and Design (mosaic), and Peter's Glass Studio. This is a good place to get some face time with a potential fabricator if you're seriously looking for one to establish a working relationship with. Think of it like speed dating.

Or, if you're really serious, instead of spending money to go to the conference, visit the fabricator's studio. Even if you don't have a specific project in mind, you'll get a crash course in how the materials look and feel, details on their process, and inspiration to burn for new work.

Industrial Fabricators
Thomas Register (*www.thomasnet.com*)
The *Thomas Register* is the most comprehensive source—nay, it is the bible—of industrial products and services. About as long as the Bible, with more than 65,000 directory categories, it's the closest thing to one-stopshopping for fabricators. The good news is that the Web site has a pinpoint search function, which allows you to find a specific service within any number of miles from a zip code. The bad news is that there's no flashing neon arrow pointing to companies that will work with individuals on small projects (although it lists 1,082 neon sign companies), let alone who will accommodate the outside-the-box requests of artists.

A way to improve your chances of finding a simpatico fabricator is to do a keyword search for "custom" once you're already in your desired category. For example, I looked up "laser cutting services," entered "custom" in the "search within results" box, and found a company in Minnesota that described its services as "Laser cutting services suitable for irregular shaped parts with full engineering services support for small and large productions. . . . " I went to the company's Web site and looked at its "Portfolio" section, and saw that among all the flanges and whatnot that it does for heavy industry, it also proudly includes some complex, arty lettering and naturalistic, free-form shapes. To complete this exercise, I called the company and asked if they ever work with artists on one-of-a-kind projects. I was told that yes, actually, it does.[2]

This is the same way I found companies to work with here in Chicago, such as G.E. Mathis, Farrodyne, and S&B Finishing. But you don't have to live in one of the industrial capitals of the world to find good fabricators; many midsized towns have machine shops, sheet metal companies, sandblasting, and powder-coating services. A better idea yet is to find materials and industries that are specific to the area where your commission is, and build your piece idea around what's already there. Are there carpet mills, the remains of a once-flourishing boat-making center, or a big recycling plant nearby? Did it use to be the bottle cap manufacturing capital of North America? Is there a plethora of goats?

If you find a fabricator who . . .

- Understands they are making a work of art and is excited about it
- Respects your vision
- Responds to you promptly so that you can get samples and information to your client on time
- Stays within budget
- Celebrates your victories with you and backs you up when the going gets tough . . .

. . . treat him like gold and never let him go.

WORKING WELL WITH FABRICATORS

Working with fabricators is one of the most straightforward relationships you'll have in the entire public art process: you need stuff made, they make stuff. Even if they're not used to working with artists, anyone who has successfully stayed in business for a while will know how to stay within deadlines and

finite budgets. Each of you will forge your own way of working with your respective subcontractors, but there are a few things that will smooth the path if you're aware of them early on.

Estimates

Fabricators need certain information before they can give you a meaningful estimate. You can't just call them up and get a square foot cost to plug into your budget. I mean, you could, but you'd be running a terrible risk of having that budget approved and then finding out that your concept will cost 50 percent more to make. Any shop with integrity will tell you it can't pull a number out of the air; they will need to know some basic specs, first.

Like most fabricators, Kori Smyth of Mosaika Art & Design says they can work from any starting point, including a drawing, painting, or digital image, but that dimensions, proposed timeline, and location are also needed. "Also, if we know the budget parameters, that will greatly speed up the estimate process because then, we will be able to show the artist what level of complexity he can afford."[3]

Erica Behrens, the U.S. associate rep for Franz Mayer of Munich, adds, "We get e-mails from artists all the time asking how much our glass or mosaics cost. They think there's a standard square foot price, and there really isn't. Size, proportions, complexity, whether the work is integrated into a building, loose, or abstract, type of mosaic materials used—all affect the price dramatically."[4]

Terrazzo fabricator Dave Santarossa, who is the third generation to run his family's mosaic and tile business in Indianapolis, sees himself as an enabler of each artist's vision. He says that at the beginning, the artist can provide a very basic design, illustrated as briefly and simply as he or she can to convey the intent and overall meaning of the piece. Santarossa is expert enough to give the artist some very general square foot pricing at that point.

"The difficulty," says Santarossa, "is trying to price something and put restraints on something that doesn't have an end. There's no final design until the end. Can we budget enough money to create the art and still stay within the parameters of our costs? That's the most difficult thing to do. That's why we try to avoid 'budget busters.' If you price it high enough to give the artist some latitude, some kind of creative real estate inside the time restraint, the piece will evolve by itself and become something that is within budget."[5]

Expectations

You, the artist, need to wrap your head around the fact that your work will look different in another material than what you're used to seeing it in. Prepare yourself for a certain amount of change to your original concept to

occur at the hands of the fabricator as he or she translates it into his or her medium. No matter how much you perfected the color on the painting, drawing, or printout, it will not look the same when it is turned into mosaic, terrazzo, glass, or fiber. Color will respond differently on these materials than it does on paper or canvas, depending on how light interacts with the particular substance you've chosen. You'll quickly learn that there are gaps in the pigments available for coloring various mediums, and that some of the colors are less fade resistant than others. Some of the gestural quality of your original rendering may be lost—although most good fabricators will struggle mightily to maintain that aspect of your design. Scale is a big thing, so to speak. What looked perfectly legible when viewed at arm's length could turn into an incoherent blob when enlarged three thousand times and put on the floor—unless viewed from a thirty-foot ladder.

"We hope that the artist will be very open and embracing of how their work becomes an artistic piece, but in a different format," says Behrens of Franz Mayer. "Communication and education about the techniques is key. If an artist is expecting something or doesn't understand the limitations of the material, they can be disappointed or, perhaps, even feel that they have been misled. They need to understand the materials; the piece is just as much their work as the work in their studio."[6]

Communication

When I asked the fabricators I interviewed for this chapter what the most important factor in a good working relationship was with artists, they all answered "Communication!" (exclamation point included).

"The most important factor in having a fabricator make an artist's work is a relationship based on trust," says Stephen Miotto of Miotto Mosaic Art Studios. "There should be enough communication between the artist and the fabricator before work begins that the fabricator has no questions about the spirit of the work, and the artist feels confident that the spirit of the work is understood. If the fabricator feels free, the work will be as fresh as the original; if work begins with uncertainty, the work will end up feeling stiff."

Underlying Miotto's advice is something artists would do well to remember about their fabricators: they're artists, too. Maybe not in the sense of having shown in galleries or even knowing how to talk about art, but in the sense that they have an intuitive feel for the material, a highly-developed command of their craft, and a genuine passion for making something elegantly functional and beautiful. If you treat them with the respect for their abilities that you expect to receive as an artist for yours, they'll be much more inspired to do good work for you.

At Franz Mayer, the fabricators encourage as much participation as is practical from artists. "We recommend the artist come to Munich and

experiment in the studio, particularly during the beginning part of the process, so that they engage in a back and forth dialogue with the craftspeople who are working on their piece," says Behrens. "If they are painters, they need to work with our painters so they can become comfortable with how their work is going to be interpreted. Our painters become the arm of the artist. The artist does not have the training to physically, for example, airbrush float glass, set mosaic, or prepare glass for fusing in the kiln. Our craftspeople are there to work collaboratively as an extension of their artistic process."

Barbara Derix of Derix Architectural Art Glass emphatically seconds this. "It's a collaboration! First and foremost, the artist needs to know what effect he or she wants to create! Everything else is a collaborative process!"

Flexibility

Santarossa understands that entrusting the making of their work to hands other than their own is a balancing act for artists. "They need to have a firm grasp on their design intent, the meaning of that particular piece, to really, truly know what they're after and not change their work in response to every suggestion. But they also need to be open to better or easier ways to do things. Some artists can't bend." The ideal balance, he says, is to work with the fabricator to explore other techniques that could get across the original design intent by modifying the methods and materials to the point where it's not physically impossible to do within the budget.

Says Miotto, "The nature of art is to push the envelope. A fabricator needs to say what is not possible, but not before trying to come up with a solution to the impossible."

Another area where artists need to be flexible is scheduling. "Not too many artists like to work on a timetable," says Santarossa. "We're all like that. If this were a perfect world, we would all have enough time to do all our projects; we would not be hurried at all to produce an artwork. But time constraints and other responsibilities require that we have some kind of a deadline and structure in working. It's a blending of a more structured industry (construction) with a less structured industry (art)."

Practical Matters

On the topic of what can go wrong on a public art project, the word "substrate" came up more than once. In simple terms, the substrate is the surface that will hold the artwork. It's also the not-so-metaphorical convergence point where, if all of the dominoes have fallen into place—payments, fabrication, site prep—the artwork installation schedule intercepts the construction schedule when it's supposed to. This is where communication and coordination between the fabricator, architect, general contractor, engineer, client

agency, and artist is crucial. The first domino, the foundation, is the contract you shrewdly negotiated at the beginning of your commission.

Schedule Coordination

There was a sign at the copy center in the hospital where I once worked that read: *Lack of planning on your part does not constitute an emergency on my account.* Do everything you can to avoid crunch time for yourself and others. Prioritize your projects and the tasks within them. Make sure your fabricators get the information they need in ample time to do what they need to. This includes not only information that needs to come directly from you, but also through you as the conduit from the client agency to the fabricator.

It is not unheard of for a simple bit of paperwork to sit on some bureaucrat's desk for weeks or even months when you and your fabricator should be using that time ordering materials and beginning production. Of course, your deadline doesn't change just because someone upstream took all the time he needed (and then some) to do his job. Fortunately, the solution to this is simple and twofold.

1. As discussed elsewhere in this book, be sure the timeline you submit as part of your contract includes benchmarks for receipt of necessary information, as well as approvals and payments from the client, fabricator, and anyone else who could be a bottleneck. Specify that your tasks are contingent on receipt of that. If not received within the specified time frame, tell them in writing that the deadline for installation will be adjusted accordingly.

2. Be a squeaky wheel. It's your responsibility to keep your part of the project moving. Remind, remind, remind. Keep an e-mail and/or paper trail of your reminding. Log your phone calls and what was said. This will come in handy when whoever held up the process is trying to cover his butt about why the artwork won't be installed in time for the dedication ceremony. His first line of defense will be, "Oh, you know how flakey artists are." If you don't nip this in the bud, the agency may try to withhold payment from you for noncompliance with the contract even if it wasn't directly your fault. If worse comes to worse, you'll need a paper trail for legal action.

Payments

Fabricators require payment up front because the vendors, along their supply chain expect payment before they'll deliver raw materials. That, and there's a contagion of employee mouths to feed and the mouths those employees have to feed. This gets a little tricky if your contract with the agency says you don't get paid until you come through with certain deliverables (drawings, models, or material samples), or until you meet certain benchmarks (engineering stamps, permits, or percent of production completed). Most agencies will

listen to reason and adapt their contracts accordingly, but it's up to you to catch the changes that need to be made and be assertive enough to negotiate for them.

Artist Alice Adams says the single most important piece of advice she can give is that "the artist should make every effort (and instruct their lawyer to make every effort) to tie the payment schedule of their contract with the commissioning agency to the contract with their fabricator. This way, the artist is not left hanging and having to make payments to a fabricator if, for whatever reason, their payment from the client agency is late or withheld."

Or, you could play hardball like Ken vonRoenn. Here he is again with another lesson he learned so that you don't have to.

Lesson: Imagine the worst-case scenarios and provide for them in a contract.

Story: I had a large project for a skylight, and subcontracted with a Japanese company to produce a printed laminated glass artwork with a complicated pattern. In writing the contract, I provided the provision that if the glass was incorrect or failed, they would be financially responsible for all costs associated with not only replacing the glass but also the expenses of removing and reinstalling it. I also set up the payment schedule so that 80 percent of the payment would be made only after the glass was installed. During the installation, I discovered they made a mistake in aligning the pattern, which meant all 4,000 pounds of the glass had to be lowered by crane from the roof, which was seventy-five feet above ground, be remade, delivered, and lifted back up to the top of the roof and reinstalled. All of this work ultimately cost more than 75 percent of the original contract, which I deducted from the final payment. They threatened to sue, but in the end, their lawyer told them they couldn't because of the clauses in the contract.

Net result: I saved more than $75,000.

End Notes

[1] Lauren Hallden-Abberton, via telephone, June 30, 2007.

[2] FedTech Laser & Waterjet Cutting Services. *www.fedtech.com/laser.htm*, accessed June 30, 2007.

[3] Kori Smyth, Saskia Siebrand, and Jennifer Hamilton of Mosaika Art & Design, via e-mail, June 28, 2007.

[4] Erica Behrens, Franz Mayer of Munich, via telephone interview June 30, 2007.

[5] Dave Santarossa, Santarossa Mosaic and Tile, via telephone interview June 28, 2007.

[6] Behrens, 2007.

Chapter 11:
Public Access and Private Money

Public art, as loosely defined for this book's purposes, is art found anywhere people go for reasons other than to have an art experience. So, aside from the art that's found on public property, the private sector commissions scads of art for hotels and hospitals, restaurants and resorts, casinos and cruise ships, and lobbies and lounges.

Once you submit an application for a publicly-funded art competition, you're on a government conveyor belt for processing. The agency will tell you what to turn in when, to whom, how much money you've got to work with, and how long you have to spend it. Everyone who applies will be treated the same way. This is not so with the private sector. You have to cut your own path to find customers among art consultants, corporate art curators, interior designers, architects, and real estate developers. The expenditure of taxpayer dollars requires some form of democratic process that is often quite layered, while the private sector can move more quickly and with more autonomy. That's not to say there's no accountability within a corporate structure, but that it often comes down to the decision of one person at the top.

It's not a level playing field, and that's precisely what makes it so rewarding—for the entrepreneurial personality, anyway. By relying on your wits and individual initiative, you can find markets that are a good fit for your work. And unlike public art agencies, which usually only commission one work by the same artist within a certain number of years in order to spread the wealth, private sector clients have no such limitations. If they like your work and they like working with you, you'll get repeat sales as well as word-of-mouth referrals.

PATHWAYS TO THE PRIVATE SECTOR
There are many access points for selling your work in the private sector, but for the most part, they don't go out looking for artists like public art agencies do. You need to find them.

Public Art Consultants
Sometimes, instead of using their own in-house public art department, if they have one, a government agency will subcontract with a consultant to put together a public art master plan, develop and manage large projects, draft a percent-for-art ordinance, or work on any number of other tasks normally associated with the administration of public art programs. Increasingly, cities

are requiring that real estate developers set aside a small percent for art in exchange for incentives, such as extra height or lot coverage. The developers usually have the option of putting the money generated by their project into the city's pooled public art fund in lieu of including artwork in their own building, hiring the city's public art agency to oversee the commissioning of art, or hiring their own consultant. This is where public art consultants come in.

Currently, nearly forty cities[1] in the country have dragged—er, persuaded—developers to set aside money for art. By passing new legislation, it is a requirement for them to do so for buildings over a certain size. This adds up. Jill Manton, director of public art for the San Francisco Arts Commission, says that publicly-funded building projects for fiscal year 2005–2006 generated $2 million for art purchases as a result of the city's 2 percent-for-art ordinance, while the 1 percent required of private development in a special district downtown generated approximately $10 million during the same period.[2]

One of the country's veteran public art consultants, Gail Goldman, helps private developers manage the money they have to spend on art. While she looks for artists through many of the same channels public art agencies do, she doesn't have the constraint of having to issue open calls unless it is required for a given project by the city. "In fact," says Goldman, "in private development, open competitions are rarely used. Instead, it's curated. In other words, it's up to the consultant. The consultant will talk to the developer (i.e., her "client") to get a sense of the site and of the developer's priorities. I'll think of five or ten artists whose work fits the site and present them to the client. The artist may not even know his or her work is being shown. With the developer, we scale it down to three or five finalists. It's a much more selective process than an open call. It's about inviting artists you know can do the work based on their reputation. Quality is absolutely key."

She says she sometimes finds artists by visiting galleries and museums, but the source she relies on most often is word-of-mouth recommendations by her colleagues. "We will often call one another and say we have a project we're working on, and ask if there are any artists they know that work in a particular medium or have experience working with design professionals. We often look for artists that have a reputation for being good to work with. It's not only about experience but also about discovering and inviting artists who have not been conditioned by the public process, who don't define themselves as public artists, and whose response to situations has not become formulaic. I'm looking for a quality in the work that's refreshing and specific to a place."

Marc Pally is an artist, curator, and art consultant based in Los Angeles. At the Community Redevelopment Agency of the City of Los Angeles in

1985, he was instrumental in drafting the first legislation requiring that developers set aside money for commissioning on-site art, as well as contributing to a cultural trust fund to encourage arts and culture in public sites. As a consultant working with private developers, his budgets for commissioning new work range from $100,000 to $2 million. He says that the biggest concern his developer clients have about incorporating art work into their projects is that "they want quality projects that fit their overall project goals and objectives, and they want to be able to work well with regulatory and/or oversight agencies."

Pally says he finds artists through the extensive database and connections he has built up over his years in the business. He stays current by "looking at art in galleries, nonprofit spaces, museums, public art projects, the art press, and Web sites," but doesn't encourage artists to send him their portfolios because of the burden it would put on his one-man operation. His advice to artists for bringing their work to the attention of public art consultants is "to get their work out however they can and hope it gets noticed and gets talked about. The competition for visibility is huge. Supply and demand are way out of kilter, and there are way too many artists for the number of available opportunities (in all aspects of art, not just public art)."

Even though Pally's last comment may seem counter to the encouragement I've given you throughout this book, take heart. Pally also says, "If a project is less than $150,000 or so, I make a big effort to bring new blood into the system, and I have a good track record of doing so. I don't believe public art should be considered a separate field (just a mild subdivision)."[3]

Where to Find Public Art Consultants
• City of San Diego Commission for Arts and Culture (*www.sandiego.gov/arts-culture/pdf/paconsultants.pdf*)
This is the most complete list of public art consultants that I know of. It contains over forty individuals or firms, along with their contact information. California, in particular, needs to keep up with who they are, because there are nearly thirty cities in the state that require private developers to set aside a percent for art on projects that meet certain criteria.

Art Advisors (or Art Consultants)

While art agents or artist reps work for specific artists to place their work in collections, art advisors work for the collectors. Mostly, these are businesses that buy art to enhance their work environments, such as law firms, financial institutions, medical centers, hotels, casinos, and restaurants. They also help individual collectors select art for their homes. Art advisors are distinguished

from corporate art curators, described below, in that they are freelance. They may buy for and manage several collections over the course of years or help clients with a onetime purchase.

As with any unlicensed, unregulated profession with a low entry threshold, you will need to guard yourself against dilettantes, incompetents, and crooks. Before extending yourself too far, qualify the art consultant. If one approaches you with a project, ask the questions on sales basics outlined in chapter 12. Check with one or two other artists she's worked with to find out if she follows through with what she says she's going to do—chiefly, pay artists within a reasonable amount of time. Look at her Web site to get a sense of whether she's running a going concern.

Patti Gilford, a respected Chicago-based art advisor, says that she finds work by going to galleries, art fairs, and B.F.A and M.F.A shows at art schools. She's "generally looking for very good quality work," whether it is by emerging or established artists. However, she also says that some of her clients prefer to collect artists with a pedigree.

Art advisors usually make their money in one of two ways: fees or sales commissions. They bill the client either by the job, by the hour, or on retainer, or they take a percentage of the retail cost of the artwork as a commission. If they are buying the work from a gallery, they'll get a commission of 10 to 25 percent. Sometimes the gallery will ask the artist to pay a portion of the advisor's commission. So if the artist normally gets 50 percent of the sale, then the artist might concede 5 to 12.5 percent to soften the bite of the dealer's cut. Your dealer should *always* ask your permission before truncating your part of the commission in this way. It can be done case-by-case or by having a standing agreement with the dealer at the outset of your working relationship.

Many art consultants refuse to work through galleries at all, preferring instead to buy directly from artists so they can get a full 50 percent commission on the sale. Of course, you can negotiate that and offer them less. Again, it can be situational. If it's work that you want to move, then 50 percent might be worth it to you. Alternatively, for work that is in demand, go ahead and name your own price.

If it's a site-specific commission, a finder's fee of 5 percent (of your artist fee, *not* the entire project budget) for the advisor may be more appropriate, depending on how involved and effective he or she is throughout the life of the project. If the advisor merely brought you the project but you have to do all the work of negotiating the contract, going to meetings, hiring engineers, subcontracting with fabricators and installers, and/or carrying the financial liability and insurance, then 5 percent of the artist fee is plenty for what amounts to a referral. Therefore, on a $100,000 project where you take an artist's fee of 15 percent, the art advisor would get $750. If they do more for you, negotiate upwards from there.

Dos and Don'ts When Working with Art Advisors

DON'T

The thing art advisors and corporate art curators hate the most is when artists don't take the time to find out what their focus is before contacting them. They don't mind a postcard, but they really don't want a portfolio packet to arrive on their desk with what is obviously a form letter sent out to 300 of their competitors—especially portfolios that don't contain return envelopes with postage. Even if it only takes ten minutes to look at the work, type a rejection letter, and send it back, multiply that by ten portfolios a week, and you can see why their irritation would start to build as quickly as the pile. As most art consultants will tell you, rarely do they ever find artists whose work they end up purchasing that has come in without any prior research on the part of the artist.

When asked what "don't" stood out for her after nearly thirty years as an art advisor, Patti Gilford quickly answered that it drives her "nuts" when artists tell her that their visuals aren't up to par, when the visual language is the basis for how we communicate in this business.

DO

Increase your odds of making a sale by making a connection with the art consultant first. Look at her firm's Web site to see what work she's collected in the past and if it fits with yours. If there aren't instructions on the site (or if there's no site at all) about submitting work, send a brief e-mail or give the advisor a polite call asking if she is reviewing work at this time and if you could send your portfolio. Gilford says your portfolio disc shouldn't have too many images on it. Be sure to include current work—the last two to three years will suffice—with a resume, pricing, and sizes. Include a SASE or a line saying the advisor can feel free to keep your materials to relieve her of the burden of returning them. Never send original artwork unless specifically requested by the consultant (whom, of course, you've prescreened to make sure she's on the up-and-up). You don't need to do an immediate follow-up call with art consultants because they're perfectly capable of knowing whether they're interested in your work. If they need more information, they'll call you—assuming you've made it easy for them to find you by having your contact information on every piece of paper and e-mail you send them. If you don't hear from the consultant after two weeks, call and ask if she's had a chance to look at your materials, and if not, ask when would be a good time for you to check back, mark your calendar, and then do it.

Corporate Art Curators

These are art buyers who are employees of a specific company. The glory days of the 1980s when corporate art buying was at its pinnacle, are gone. But large companies, specifically legal, medical, technology, and financial firms (think Deloitte & Touche, Bank of America, Safeco, Microsoft, Pfizer, Grubb & Ellis, and the Mayo Clinic), still collectively purchase many thousands of portable works (paintings, prints, photographs, and textiles) and sculpture each year. Because their in-house curators are already on salary with the company, they do not take commissions from artists. (Doing so is called a kickback and is illegal.)[4]

Where to Find Art Advisors and Corporate Art Curators

- International Association of Professional Art Advisors (*www.iapaa. org/memberlist.html*)

 The IAPAA is a good place to start because it requires high professional standards to qualify for membership, and best of all, there is a list of members on the Web site. You'll still need to do your homework, though, because the site only publishes member names and the names of their companies, not contact information or any details about what type of art work they specialize in. The organization also includes the curators of some major corporate collections. As busy as this could keep you following up on leads, it is by no means a complete list of all the top art advisors who are out there.

- International Directory of Corporate Art Collections (*www.humanities-exchange.org/corporateart/*)

 It's a bit of an investment, but for $75, you'll get the keys to the kingdom. The directory (on CD) comes in four editions: artist's, museum, gallery/art advisor, and combined. The artist's edition is the least expensive at $75. An annual subscription consists of lists of the 150 (out of 1400 total) most active corporate art collectors in the U.S. and around the world, as well as the 100 most active art advisors. The list of corporate collections provides detailed information on contacts, curatorial focus, and how to submit work. The art advisor list also contains complete contact information but nothing about the collections they work with or the type of art they buy, because that's usually not the sort of information their clients want bandied about. There are also a couple of free, lengthy articles on the Web site about why corporations collect and how to sell your work to them.

 What makes the CDs most worthwhile is that subscribers get a password to a place on the publisher's Web site granting access to new information that is updated every three months. The CDs are compatible with both PCs and Macs.

- The Corporate Art Brief (*www.humanities-exchange.org/artbrief/*)

 Under the same umbrella as the International Directory of Corporate Art Collections, the Corporate Art Brief offers synopses of articles regarding corporate art, such as companies that are selling their collections and new projects that will be commissioning artworks. Their "Focus: Collection of the Month" feature is particularly useful, containing tidbits such as this from June 2007: "The beginning art collection of CDP Capital (Montreal) consists of 151 artworks. It reflects the company's position and standing in the world of asset management, in that they have already adopted a mission statement for the emerging collection—the creation of a museum quality collection of the highest order. The selection of artworks is through a special committee that meets four times a year. This committee of eight people includes an art advisor and employees."

- The Artist Help Network (*www.artisthelpnetwork.com*)

 If you navigate to "Exhibitions, Commissions, and Sales" > "Corporate Art Market," you'll come upon a list of resources and consultants who procure art for movies and television (including the Set Decorators Society of America, at *www.setdecorators.org*), and lists for sale such as the art consultants list compiled by artist career coach Caroll Michels (*www.carollmichels.com*).

- *Art in America: Annual Guide to Galleries, Museums, Artists*

 Each August, *Art in America* publishes this densely-packed directory of nearly every visual arts-related venue in the U.S., along with detailed contact information. There's an index called "Corporate Consultants," but it doesn't differentiate between galleries that make themselves (and the artists they represent) available to corporate collectors and independent advisors. You'll have to sort that out yourself by cross-referencing the index with the listings by state. There are about 1,000 listings in the index, so pack a lunch.

Why Do Corporations Collect Art?

The answers that most often jump to mind (they do it for the tax break and investment) are not actually accurate. The tax breaks from collecting art are not significant enough to make an appreciable difference, and there are many other commodities that are more sound investments. In fact, most shareholders would rather the company didn't fritter away money on art but, instead, reinvest or pay it out in dividends.

The reasons for corporate collecting are actually more intangible and, in some cases, more laudable than you might think.

- To "humanize" the workplace; as decoration
- To cultivate art appreciation and, perhaps, future collecting among employees
- As a way of contributing to the cultural economy and being good corporate citizens
- Image and branding
- To show that they value creativity and forward thinking
- To attract prospective employees
- Relocation of headquarters
- Because the CEO has a personal interest in art

According to Chin-Tao Wu's *Privatising Culture*, the reason given most often for corporate collecting was a "relocation of firm," with over 79 percent reporting that it was a "fairly" or "very important" factor.[5] And 60.3 percent of the seventy-two companies surveyed had art collections because of the interest of a particular individual.[6]

Once you realize that the motivation behind what corporations collect is tied to the company's culture, you'll notice that advertising and technology firms take more risks with the type of art they buy, while banks and insurance companies are reassuringly staid. Law firms are all over the map, depending on their specialties, while hospitals (with some exceptions) tend toward the upbeat, the whimsical, and landscapes.

Lest my opinion be biased, having spent seventeen years as a corporate art curator, I offer these observations about corporate patronage from *Privatising Culture*.

> The significant inroads that the business sector has made into the cultural arena since the 1980s cannot simply be explained away by invoking the amorphous motive of "enlightened self-interest." Instead, business intervention in the arts has to be seen and understood in terms of political power within the modern state By virtue of their private wealth, corporations, like their chief executives at an individual level, command considerable power and influence in society.[7]

And then, taking away any remaining illusions we may have about the beneficence of corporate Medicis, Wu cites the late French sociologist Pierre Bourdieu, who said that the chairmen and chief executives who are the guiding force behind their companies' corporate collections have

been "able to appropriate the social status and value that come with being the head of a company that invests seriously in art," or what Bourdieu calls cultural capital. "Cultural capital is (not only) freely interchangeable with economic wealth, but also, the accumulation of cultural capital serves specifically to reproduce and consolidate the position of the dominant class."[8]

So there you go. According to Wu, the spending power and attendant status of private family fortunes (Rockefellers, Carnegies, Vanderbilts) has been replaced by institutional wealth.[9] This wealth, however, is oozing out in the form of second or third homes, yachts, expensive resorts, and other places where art is an integral trapping in the playgrounds of the rich. They have to get art from somewhere, so it might as well be from us.

Hotels

The demand for artwork in hotels is exploding along with a hotel building boom all over the world, even producing a subcategory of "art hotels." Art consultants and interior designers are doing everything from buying prints for the rooms to paintings above the concierge's desk, and are commissioning mosaic murals in restaurants. As *Artful Hotels* editor Shirley Howarth writes, "Unlike art displayed in offices, art in hotels is truly open to the public—anyone can walk into a hotel's public spaces and admire it, including the artists and their friends. This helps create 'local' roots for international hotel brands. And reflecting the local environment through art makes a greater connection with the community."[10] For the Gramercy Park Hotel, the legendary hotelier Ian Schrager collaborated with artist Julian Schnabel to create an environment entirely defined by art. Besides a collection that includes work by Warhol, Twombly, Basquiat, and Hirst, it includes carpets, chandeliers, tables, door handles, curtain rods, finials, and fireplaces designed by Schnabel.[11] Berlin developer and art collector Dirk Gadeke's "one artist, one hotel" approach for his Art'otels chain lets the design of each of his properties be driven by the aesthetic of artists such as Georg Baselitz, Donald Sultan, and Katharina Sieverding.

Don't let that list of art stars intimidate you. There's plenty of room at the inn for the rest of us. Sarah Hall, art resources director for the Atlanta based art advising firm Soho/Myriad, says there has been a "huge shift from designers/hotel owners and developers wanting decorative art to wanting more of a collection and art that, while still aesthetically pleasing to most, does not 'match the couch.' There has also been a huge shift in wanting to support the arts community and artists that are in the region of the property."[12]

She says that the work they collect is more contemporary than the straight, traditional landscapes of the past, and that the mediums vary from photography to works on paper, paintings on panel or canvas, sculpture, and some fiber. Hall says that she prefers an initial e-mail contact with a few images, pricing, and a link to the artist's Web site as the most efficient way of finding out whether the work is a good fit for her market. If she wants to move forward, she'll ask the artist to send a CD with JPEGs, a bio, and pricing.

Where to Find Hotels
Artful Hotels (www.artfulhotels.com)
Another publication by the people who brought us the International Directory of Corporate Art Collections, it contains many examples of how art is showcased in hotels all over the world. The site is divided into sections: South America and Africa, Europe and Britain, North America, and Asia and the Middle East. In its list of the "20 Best Artful Hotels," you'll find ones like the Hotel Siru in Brussels, which commissioned 130 painters, sculptors, and comic book artists to turn each of its rooms into paintings. Or, the Sonesta "collection" of twenty hotels located throughout the world, created by the famed art dealer Joan Sonnabend and her husband, which holds over 7,000 works of contemporary art. The site also includes a bibliography of articles about art hotels.

Because the hotels on this list are finished collecting, for the most part, the way to get your work into hotels that are just beginning to collect is to concentrate on finding the art advisors with whom they consult. It would be nice if there was a road map, but there isn't. You'll need to do your own detective work by:

- Reading design magazines to see which hotels have interesting art work, tracking down the art consultants they worked with, calling the corporate office, and asking.
- Going into hotels wherever you travel to see if they've used art and asking the concierge if he or she knows the name of the art consultant or has a brochure about the collection.
- Asking artists and dealers which art consultants they know of who work with hotels.
- Doing an Internet search of artists whose work you see in hotels. Many times, they'll list the art consultants they work with on their Web sites, or the consultant's Web site will pop up when you search for an artist's name.

You need not concern yourself with keeping up with whatever trade journals there are for hotel development to find out what projects are on the drawing board, because the art advisors are already trolling for those. Your

job is to position yourself downstream from them. And as always, establish and maintain a good relationship by following up and following through once you connect.

Hospitals

A few hospitals, such as the University of Washington Medical Center in Seattle, have a curator on staff, but most of them use outside consultants. The original artwork they buy tends to be for the public areas, not in the patient rooms where they put prints or posters. It's a big, booming (or should I say, "aging boomer") market both for portable works and site-specific commissions. Most of the major purchases are made as part of the capital budget during or soon after construction is complete. Besides buying artwork outright, hospitals often have bedside art and writing programs, musical performances, and rotating art exhibits. These are usually funded in part or in whole by donations and supplemented by volunteers.

Why Do Hospitals Collect Art?

Art is seen as a way of humanizing the increasingly high-tech environment surrounding patient care. To counteract what a stressful place it can be for most patients and visitors, hospital interior design tends to be more hospitable now than it was in the past, often adopting the aesthetics of a mid-priced hotel.

According to the Society for the Arts in Health Care survey of over 2,500 hospitals, 96 percent invest in the arts to serve their patients and 78 percent use the arts to help create a healing environment. Of those hospitals, 78 percent employ arts coordinators and 50 percent partner with outside community arts agencies.[13]

After I was hired as the founding director of the University of Washington Medical Center's art program, a good six months passed before I could convince myself that the money I was given to spend on art wouldn't be put to better use on patient care. Gradually, as we bought one piece, then another, it was the patients and their families who taught me the importance of art in hospitals. I'll never forget the time an older couple approached me as I was supervising the installation of art in the ICU and asked me if I was in charge of the art collection. When I said yes, they said that their son had just died of AIDS twenty minutes earlier, and they wanted me to know that one of the joys near the end of his life was to be taken around the hospital to look at the collection.

Having been the curator of a hospital's collection for twelve years, I hope you'll permit me this editorial comment: To me, art in hospitals is

putting it to its highest, best use. And because the practice of medicine isn't stuck in the nineteenth century, neither should the style of artwork hospitals collect. I agree that art shouldn't add to the stress of patients and caregivers by being disorientating, disturbing, or aggressive, but neither should it dumb itself down to the patronizing level of framed Muzak.

How to Find Hospitals that Collect Art
 • The Society for the Arts in Health Care (SAH) (*www.thesah.org*)
 There are so many hospital art programs that they now have their own professional organization, and you don't have to be one of their 1,600 individual members to access the list of member organizations on the Web site. It's a bit of a slog, but if you go to "Membership" > "About Our Members" > "Organizations," you'll find a list of over one hundred hospitals and nonprofits invested in the arts, along with some major hospital art advising firms such as Aesthetics, Inc., American Art Resources, and Wilkins Art Consulting. If you want to join (which gives you access to all of the contact information of its members), it costs $125 annually for individuals ($35 for students). SAH also has a national conference in a different city each year. I've found, however, that SAH consists more now of "healing arts" practitioners—those who are involved with art and craft activities for patients and writing and music therapy. When it was established in 1991, it was mostly for art buyers.

Architects and Interior Designers
Because my access to these design professionals has almost always been through art consultants, I asked Koryn Rolstad, an artist in Seattle who has primarily worked directly with architects and interior designers during her thirty-two-year career, what advice she has to offer to artists who want to land site-specific commissions.

 I only work directly with architects and interior designers. Art consultants are not usually involved, mainly because they would have to have a great deal of experience with code and legal aspects of capital construction contracts. This would change the nature of their business and require the same liability that the subcontractor (artist) would require. Usually the industry standard is to work directly with the artist on these larger commissioned projects, since the service contracts are initiated through the contractor, purchasing agent, or owner/end user. An art consultant would be better served to introduce the project and negotiate with the owner or the artist on a small percentage "finder's fee" for their efforts.

Artists may think that the large firms are where they should go first. Most large firms don't hire the artist—especially architects. Firms are broken down into engineering, architecture, interior design, graphic design, and landscape design. I have received many commissions through the graphic design part of the major firms. The most exciting work I've gotten has come from smaller firms (under twenty people). These firms have a much more intimate relationship with the client.

It is all about relationships. If artists are really wanting to work on capital projects, they have to figure out the kind of project that they want to do, and where. Public arts commissions use the same process, so why not artists? I find out who the clients are that the design firm is working with, and I jump in with my own ideas about the design and how I can fit with the "team."

There are many organizations where an artist can present his or her work. The business arm of interior design is the International Interior Design Association (IIDA), while the American Society of Interior Designers (ASID) is for professionals specializing in residential projects. The American Institute of Architects (AIA) is for architects, while landscape designers have the American Society of Landscape Architects (ASLA). All of these groups have local meetings and smaller regional conferences—up to the larger international conferences—all of which have vendor presentation opportunities.

It is all about marketing. In my early years, *Interior Design* magazine gave me a free half-page introduction as a "new company." I received over 2,000 requests for information. That's what started my national and international career, as a matter of fact. I have also designed ads for magazines and found out that the less expensive, black-and-white ads were just as effective as the color.

Lastly, go directly to the client. There are organizations that support different types of building and facility occupation, such as hospital and health care, shopping malls, and office and technology development. Example: Ewing and Clark has one of the largest portfolios of public office buildings—and with the economy changing, most are being remodeled now.

Presentations to design firms are set up by appointment. You prepare a PowerPoint with support material to show them, and bring lunch—usually box lunches. Find out how many people will be there and what they like to eat. Usually, this is organized through the head of the resource library of the firm.

The fact is, opportunities abound. I think that using traditional marketing concepts, like visual packaging presentations, targeting, goal setting, and consistency, are good guidelines. It is all who you know, so artists need to get familiar with the people who will potentially hire them and support their vision. Educate potential future clients on who you, the artist, are and what you want; make the client a stakeholder in your future. This is the win-win situation that will make you successful in business.[14]

Real Estate Developers

These are the elusive big game of the private sector for artists. Developers are hired by clients through a competitive process to put together the funding, select the architect and contractor, and oversee every aspect of the design and construction of major building projects from start to finish. Just like the rest of us, developers respond to RFQs for these gargantuan projects. Even without being forced by a city government to integrate artworks in their projects, many choose to do so on their own.

One thing you can say about real estate developers: they're not afraid to think big. *California Scenario*, a 1.5-acre sculpture environment, was commissioned by the Segerstrom family of Orange County to go between two office towers in Costa Mesa. Elsewhere, Nancy Nasher and her husband are carrying on the tradition of collecting begun by her father, Ray Nasher, at the NorthPark Center shopping mall in Dallas with the purchase of monumental works by Mark di Suvero, Claes Oldenburg and Coosje van Bruggen, and Joel Shapiro, to name a few.[15] Millennium Park in Chicago is one of the most spectacular examples of the private sector's gift to a city—and it wasn't because Mayor Daley made them do it.

According to Robert Wislow, the chairman of U.S. Equities Realty, which the firm responsible for managing the design and construction on behalf of the City of Chicago and the group of private donors that made Millennium Park possible: "Real estate development is a highly visual field, with projects realized in three dimensions. The process of sculpture follows a similar path, from concept to drawing to model to 'construction' of the finished product. . . . The built environment can, and should, support the culture of which it is a vital part because real estate, which has always refused to be reduced to the dry bones of profit and loss, is truly a fine art."[16]

Dawn Zancan, business development director for U.S. Equities Realty, advises that the best way for artists to find opportunities with real estate developers is to connect with the art consultants they hire, because trying to cold-call the development companies of the world isn't going to get you very far. Echoing the advice from the art consultants given elsewhere in this chapter, Zancan says artists should do everything they can to gain visibility

for their work by networking with other artists, researching art advisors' Web sites, and generally paying attention to where the new building growth is occurring.[17]

DIY

If you're not shy about making cold calls (or have an extroverted intern working for you), you can go even further off the beaten path by doing your own research and starting a list of prospects from scratch. Whenever you pick up a magazine or newspaper article about a planned new development—a big hospital, corporate headquarters, or library— do some detective work. Get every bit of information you can from the article. Call or e-mail the spokesperson quoted. Tell him you're an artist and ask if the project has a budget for art, and whom you can contact to find out how to present your work. Don't get discouraged. There may be several layers of people to go through. At the beginning of a large construction project, art is not at the forefront of anyone's mind, and you may get a hesitant reaction. Secondly, in large organizations, the spokesperson quoted in the article won't necessarily be in direct contact with the department ultimately in charge of commissioning artwork. If you can find the end of the thread and persist, you'll eventually be able to follow it to the correct department. Once you get there, you'll most likely be given some time period in the future when you should call back. It could be months from then, so be sure to write it in your calendar, and be sure to get the e-mail addresses of the people who answered your initial inquiries so you can send them a thank-you. This isn't just an empty etiquette exercise (not that good etiquette is ever wasted in business) but so a way of reinforcing the contact, your name, your interest in the project, and your professionalism, and it makes it easier for them to get back in touch with you once the project starts moving.

By the time the press release you saw in that magazine or newspaper article was issued, they have probably chosen an architect. Research that firm's portfolio and see what sort of artwork, if any, it has incorporated in past projects. Was the client in charge of selection in a separate process? Did the architect commission the artwork, or did the client hire an outside consultant? In any case, call or e-mail the "lead designer" and find out what you can about the project's timeline and selection process. Will artwork be included in the building or added on after construction is complete? Is there a budget to work with yet? Will a call-for-artists be sent out? If so, how can you get on the mailing list? If it seems like the person wants to chat, fine. If not, get the most basic information you can, find out when and with whom you should check back in the future, thank the person, and get off the phone. Remember, every contact you make with a potential client, however informal or fleeting, is part of the screening process.

MATERIALS TO SUBMIT

If you already did the work of putting together your presentation materials recommended in chapter 4, your promotional arsenal is ready for anything a prospective client asks of you.

What private sector clients are most likely to want is going to be quite similar to what their counterparts in public art agencies want.

- Digital images on a CD in three formats:
 - PowerPoint, so they can quickly transfer your presentation into theirs
 - JPEGs, to forward to clients as e-mail attachments
 - High-resolution (120–300 dpi) PDFs of tear sheets to print out themselves, plus hard copies that you've already printed
- Annotated image list with thumbnails, in order of numbered images on CD
- Price list: On your price list, indicate if the price is "retail" (i.e., what the client will pay before the art advisor's commission is taken out) or "artist's net" (the amount you need to receive after the art advisor's commission is taken out.)
- Resume
- Artist statement
- Business card
- Postcards (one of each of your most recent works)
- Recent articles featuring your work, if you have them

Now that you know how to find private sector clients, how do you get them to buy your work? As we'll discuss in the next chapter, it's all about sales.

End Notes

[1] To date, there is no formal data available on how many cities require percent for art for private developers. Janice Shaw, administrator at the Bainbridge Island, WA, Public Art Program, and members of the Public Art Network listserv culled this information from the 2005/2006 Public Art Program Directory (Americans for the Arts).

[2] Jill Manton, via telephone interview, January 22, 2007.

[3] Marc Pally, via e-mail, June 16, 2007.

[4] See *White Collar Crime: FYI. www.whitecollarcrimefyi.com*, accessed June 20, 2007.

[5] Chin-Tao Wu. *Privatizing Culture: Corporate Art Intervention Since the 1980s* (London: Verso, 2002), p. 245.

[6] Wu, p. 217.

[7] Wu, p. 16.

[8] Wu, pp. 244–245.

[9] Wu, p. 243.

[10] S.R. Howarth, ed. *Artful Hotels of the World. www.artfulhotels.com*, accessed June 16, 2007.

[11] Charles Gandee. *New York City: Gramercy Hotel Goes Bohemian*. Reprinted from *Travel + Leisure*. *http://travel.msn.com/Guides/article.aspx?cp-documentid = 362074*, accessed June 17, 2007.

[12] Sarah Hall, via e mail, June 19, 2007.

[13] Society for the Arts in Health Care press release, March 26, 2007.

[14] Koryn Rolstad, via e-mail, June 18, 2007. Rolstad is an internationally-recognized environmental artist and designer, residing in Seattle, WA who describes herself as "still standing after weathering the 'slings and arrows' of life and the business of art" and says her work has only gotten better for the effort.

[15] Thanks to Marc Pally for providing these examples.

[16] Robert A. Wislow. *The Art of Real Estate: Mixing Creative Juices with Bricks and Mortar*. (Special to *Midwest Real Estate News*, February, 2003).

[17] Dawn M. Zancan of U.S. Equities Realty, interviewed June 16, 2007, at the U.S. Equities office in Chicago.

Chapter 12:
Sales Basics

While being competitive for public art commissions requires some sales ability, particularly in the areas of follow-up and presentation, successfully selling your work to private clients is sales in its purest form. Fortunately, since it is the oldest profession, the tricks of the trade have been honed to a social science.[1] The business section of every bookstore has shelves loaded with advice on improving sales skills for products or services in much more competitive arenas than art.[2] While there are any number of businesses putting creative effort into differentiating their products in a market crowded with others that are so alike, each artist's "product" is already unique. Our competitive edge lies in our ability to find audiences that want our particular type of work and develop good working relationships and reputations with clients once we do get them. Then, we have to price our work to appeal to specific market niches while not losing money.

Alas, that's not enough. You need to know how to make sales happen. Here are some basic techniques distilled to their essence and tailored for artists.

QUALIFY

Qualifying means estimating how worthwhile it will be to pursue doing business with someone. It can save you much time, money, and stress down the road if it is done during the initial contact. Remember, you are a skilled professional offering unique services, so you need to know whether potential clients are prepared to hold up their end of the deal—you don't deserve to be on the receiving end of a one-way relationship! So, whether they call you up out of the blue for an impromptu meeting at a social event or a more formal initial interview, be ready to ask some version of these questions.

1. Need
- If they know your work, which previous pieces or projects stood out to them, and why?
- What work by other artists have they commissioned or seen that appeals to them?
- How did the commissioning process work for them?
- What experience have they had working on the "creative angle" with artists?
- Did it go well or badly, and why?
- Why are they commissioning or purchasing artwork?

- What purposes do they want it to serve?
- What are they looking for as far as medium, size, imagery, and theme?
- Do they envision you working in a collaborative process with architects, contractors, or other artists?

Avoid mind reading. Listen closely to the client's answers (particularly the adjectives), repeat and discuss those answers with the client, and write them down to ensure that you're in sync and so you can use them later in the project description in your letter of agreement. It reiterates their stated needs and establishes a record that you can use later when you're closing the sale. If time goes by and they're still not committing, you can check back in with them about their original need and ask if the situation has changed. Notice that none of these questions have to do with what *they* can do for *you*. As the old sales saying goes, "Telling isn't selling."

One of the richest opportunities for information is that first conversation, when the prospect is sharing his vision with you. Also, remember that you're getting a read on how he will be as a client—is this someone whom you would love to have as a repeat customer? Is this a simple, professional one-off? Or, is this someone you wouldn't (and shouldn't!) work with even if he paid triple your normal rate? If it looks like you're not the right artist for the job, don't be afraid to say so and facilitate an introduction to another artist who is. That way, instead of coming to a dead end, you've created two contacts for which you've done a favor.

2. Budget
- How much does the potential client want to spend?

This is where it is essential to know how much it costs to make your work—profit, living expenses, savings, and all. Art consultants and most other design professionals will have a good idea of what art should cost and what their budget is, but anyone not used to working with artists probably won't. Before you get too far along in your discussions—and especially before you start work or spend any money—you need to find out if you're even in the same ballpark.

It can turn into a bit of a dance.

Client: "How much will it cost?"

Artist: "How much have you got?"

You can break this stalemate by getting details about the scope of work the client had in mind and telling him the cost of similar projects of yours. If you work in a medium where you have a square foot cost that includes labor, overhead, and profit, you can use that as a starting point. It is always a source of great comfort to clients to know that your pricing is a reflection

of "market"—the price of other works comparable in size, complexity, materials, and artist's repute. If you have a page that shows pricing and size for similar projects you or other artists have done that can be e-mailed to the prospect, the negotiation will go far smoother than if she is always worried that she's being taken advantage of because she doesn't know how to properly price it.

Always tell prospects it's only an estimate and that you'll be able to give them a more accurate number once you get more information, "because every project is different." Even if you don't have many (or any) projects under your belt, you need to be able to answer the question of cost for yourself. If you haven't read it already, chapter 6 gives you practical tools to come up with a good estimate for how much time you will need and what your materials will cost.

When discussing cost, frame it in terms of the benefits you discovered were important to the clients through your conversation about their needs. These could be anything from reputation of the artist to creating a lasting legacy to pass on to their children, to the contact high of being around art and artists, to showing up their competitors, or to something as simple as a little more color in their life.

If all else fails, as my friend Betsy Eby advises, remember these words: "I don't know. Let me find out and get back to you." Those two sentences could save you from blurting out a number, any number, simply to give the client an answer you could come to regret. People have selective memories and will hold onto the lowest number they hear.

3. Schedule
- When do they want it?
- Is that a firm deadline?
- What has to happen with the rest of the design and construction before they're ready for your work to be installed?

Timing is the second thing potential clients want to know, after how much it will cost. If they ask this question, it's a signal they're interested in buying. Almost always, they'll want it sooner than you can deliver it, partly out of eagerness but also because anyone new to commissioning art doesn't have any idea of how long making art actually takes. You'll need to educate them by discussing how your work is made. Once they understand how much goes into it, they will have a more realistic sense of timing, as well as an increased appreciation of the inherent value of a one-of-a-kind artwork.

Experienced art consultants understand how long it takes to make art, but they are often at the mercy of a client who postponed deciding about art

until the last minute to see if there would be any money left over after construction and now wants it in time for the building's dedication ceremony. At the other extreme, especially when dealing with hotel clients, there's a tremendously long lead time.

4. Decision Makers
- Who needs to review your proposal, and who has the ultimate authority for signing off on it?
- Who are the official decision makers on paper, and who are the key influencers?

Don't assume that all the decision makers are in the room during your presentation. Try to find out if they are, and if not, try to get them there. In corporate settings, especially, lower-level management may be delegated to deal with the artist. Even though you may have them eating out of your hand, if the Big Guy hasn't gotten to know and love you, he won't be invested enough to give his go-ahead. You need to be diplomatic when asking who has the ultimate authority. You want to avoid seeming as if you see the managers as obstructing underlings. On the other hand, you don't want to come across like a barbarian at the CEO's gate. Sometimes, there's nothing you can do except make as good an impression as you can on the people available and wait for them to open the upstairs doors. Leapfrogging your way up the hierarchy is a *huge* no-no in Corporate World. One of the biggest fears the white shirts have about working with artists is that we're loose cannons who will wreak havoc on their carefully constructed system. You may make it all the way to the top, but you'll still end up having to work with the people you did end runs around if you succeed in getting a project. *Then,* you'll see obstructing underlings. The best thing to do is start at the top and have the boss delegate someone to deal with you. You may not get past the CEO's executive secretary, but that's not a bad thing. Secretaries can be your most valuable allies. Don't make the mistake of treating them like flunkies.

Not knowing who the key influencers are can make things go badly, too. I recently made two trips from Chicago to Orange County to meet with a client about a major commission for one of her homes. On both occasions, there was an ever-changing cast of characters rotating through the room (brother, friend from Oregon, personal assistant . . .). At the second meeting, where I was presenting the fruits of over one hundred hours of work, her interior designer wandered by, said he hated the colors I'd used, and that was that. It was the first I knew of his existence, let alone that he was the client's oracle for all things aesthetic.

In my excitement to do this project, I hadn't taken my own advice. First, I didn't find out the budget because knowing how wealthy the client was,

I assumed that money was no object. When I presented her with the cost after showing her my concept, she wasn't prepared for such a high number. (Note to self: Money is *always* an object.) Second, I didn't have all the information I needed to understand the site. My introductory meeting with the client took place in the home while it was still under construction. When I was there the second time and saw all of her furniture and artwork installed, only then did I have the full picture of her taste, but by then, it was too late because I had already come up with a proposal.

The moral is, qualify prospects before you do any real work. Scope out the relationship, the vision, the budget, and who decides or has real pull with the principal. Your life—and your client's life—will be much better for it!

CLOSING

Closing is a commonly used sales term for the process of getting clients to commit to a purchase. If you ever saw the film *Glengarry Glen Ross* ("ABC" = Always Be Closing), or bought a car from a dealer, you probably think closing is too desperate, pushy, or slimy to want any part of it. But in our business, all it means is indicating your interest in a project and letting clients know what the next steps would be if they want to work with you. It can happen in gradual stages; you don't need to hit them over the head with a 2 × 4.

For artists, the beginning stage of closing a sale could consist of any one of these lines:

"Would you like me to send you some images?"

"Should I call you next week to set up a time to brainstorm?"

"How about if I come up with some estimates and give you a call?"

"How about if I bring the painting by your home/office to try out for a few days?"

You may also have heard of the phrase "ask for the sale." It doesn't mean you should literally say to a prospective buyer, "Are you going to buy something, or not?" But it is one of multiple steps within the closing process. At some point, after you've qualified them and decided you're interested in the project, you need to say that you'd like to work with them and ask them if they think that's a possibility.

FOLLOW-UP

A crucial step after every contact with the prospective client is to following up. Do not think of it as hounding them. This is just another step you take so that they don't have to chase you. Amy Clayton, a friend of mine who works in sales all day, every day, says, "Follow-up is a two-way street. If you

tell them you're going to rock their world because you're that excited about their project, and then their world doesn't get rocked because you never call them back, what does that say about you?"

Take every opportunity to follow up.

- During the first encounter, give prospective clients your contact information. At some point during a face-to-face encounter, hand them your business card with a note written on the back that will trigger their memory about who you are when they find it while cleaning out their jacket pockets to take them to the dry cleaners. Be sure to get their card or write down their contact information because, unfortunately, there's no section in the personal ads for "missed business connections." If the initial meeting happens through a phone call or e-mail, give them your contact information and get theirs.

- Send them a follow-up e-mail or note in the mail saying you enjoyed talking with them and you're interested in speaking with them further about the project. Include a postcard or tear sheet of your work. If you have succeeded in setting up an appointment, mention in this note that you're looking forward to the meeting, reiterating the date and time.

- After you've mailed your portfolio or dropped off a piece, call up a few days or a week later and ask if they've had time to think it over and if they have any projects coming up that your work would be a good fit for. If they're not getting off the dime, get your work back. You're not running a charity that provides free art for the rich.

About Sending Work

If you send original artwork, make sure you get a receipt stating the value and name of the artwork signed by the client. You'll need this for insurance or legal purposes should something go awry. As for shipping, you can make any kind of deal you want, but it is customary for whomever requests the work to pay for the shipping. For example, if an art consultant wants to show your work to a client, he will pay to have it sent out. If you request that it be returned before the time you agreed to, let him have the work on loan, then pay for the return shipping.

- Always have a next step ready for them to take. If they want to commission a piece, set up a time to talk about it, assuming you're in the same geographical vicinity. If it's a large enough commission, go see the site. Ask them if they will cover your travel costs for this initial

visit and tell them that you'll apply it to the cost of the total project if they decide to commission you, with no obligation to go through with hiring you. If their budget isn't large enough to support a site visit, ask if they can send architectural plans and renderings of the site. Color boards by their interior designer, pictures they've cut out of magazines with the aesthetic that appeals to them, and any other visual clues that will help you get a sense of the client's taste are also useful—not just to help you come up with an idea, but to get them invested in the creative process.

- It's a rare person who doesn't cringe at the idea of telling someone "No," so make it comfortable for clients. Thank them nicely for considering your work, tell them they're welcome to keep your materials (but not your work), and ask them to keep you in mind for future projects. Then send them a thank-you note, once again including your card. As any seasoned salesperson (or someone in a dead-end relationship) will tell you, it's much better to get a definite "No" than to be led on. And how gracefully you take "No" for an answer will be a sign of how pleasant and professional you'd be to work with if they ever do have a project for you. Even after the big N-O, periodically send them an e-mail, postcard, or tear sheet of new work with words to the effect of, "I wanted to let you know about my latest project." Every time you overhaul your Web site, send out an announcement to people who have expressed an interest in your work.

The objective is to get your name and work in front of prospects regularly. I can't tell you how many times I've been called by an art consultant and made a sale right after one of my postcard mailings went out, because it happened to land on her desk just as she was casting about for new work to show to a client. I've also gotten calls seven years after a mailing because the art consultant held onto it until the right project came along.

A WORD ABOUT WEB SITES

In case you're still sitting on the fence about whether you need a Web site, let me put the issue to rest right now: Yes. Yes, you do. Without one, it's almost as if you don't exist. My Web site has paid for itself several times over in sales—and that's taking into account that I hired someone else to code and upload it. Even though I don't sell directly from the site, it's resulted in sales from art advisors who found it on their own and from the easy access to my portfolio that it provides when I contact prospective clients.

I asked Sara Schnadt, the Web master and one of the masterminds behind the Chicago Artists Resource (www.chicagoartistsresource.org), for her advice

about the components essential for a successful artist Web site. She wrote the following tips especially for this book.

Online presence has become very important for artists, and the tools for building an artist's Web site are becoming increasingly accessible (see the list of resources below). Not all Web sites are created equal, however. Effective artist Web sites can be quite simple or more highly produced, but all follow some simple design strategies. Here are the important ones to keep in mind.

Portfolio Site v. Web Art Site

Web art is often highly interactive, creates its own navigation logic, and is an aesthetic environment unto itself.

A portfolio site uses commonly understood navigation logic, standard categories, and functions as a neutral professional space that lets you focus on the work, much like a gallery space. If your work naturally lends itself to creating an online portfolio that is also a work of art in itself, by all means, do both. If not, focus on being very straightforward and clear in your presentation.

The Audience for Your Site

As you design your site, think about whom you are building it for. Most artists are primarily building their sites to secure shows and funding. Therefore, the primary audiences are curators, gallerists, art advisors, collectors, and critics. These people all look at a high volume of artists' Web sites, so they will want to see your work and understand its context quickly and directly when they come to your site. Context is particularly crucial when it comes to images of your public art installation. Simplicity, standard organization conventions, and clarity go a very long way for this purpose.

Organization Conventions

If you look at several artist Web sites, you will notice a pattern in how they are organized. There is some variance, and it is a good idea to look at a lot of sites to see what your preferences are, but in general, they include a few critical things.

The main site navigation is always on the left, and includes these topics: artwork, information (resume, bio, statement, publications, etc.), and contact. These three content categories are most important.

If you have one section for info and various subsections, be sure that this is done clearly without confusing the main navigation. Look at a few artist sites to see examples of this as well.

When you go to the artwork category, there should be an image gallery. It can be organized chronologically, aesthetically, or by types of work, as long as it is very clear and there is a good cross-section of your work visible right away as smaller thumbnail images. Many artists also include one or more images of recent or representative work on their home page. If you do this, make sure that the images are smaller so they don't take too long to load. Artwork that is sited time-based, or that involves viewer interaction, can be illustrated with sequences of photos.

Bells and Whistles

If you would like to use flash animation, video feeds, or other more involved elements on your site, first consider whether or not they are essential to conveying the intent of your work. If so, use them without undermining the clarity and organization of your site.

Search Engine Optimization

The most important considerations for getting a high ranking for your site by search engines are clear and high-quality content, frequent updates, and links from many other sites. There are also more technical things you can do as you set up your site, like assigning keywords to your pages. You can learn more about this through the resources listed below.

Resources for Building Your Own Web Site

Chicago Artists Resource (*www.chicagoartistsresource.org*)
In the "Web Site Design" section, there are many resource links and articles to guide you in building your own site.

Google Pages
They provide free online applications for building, hosting, and publishing your own site. With a Gmail account, you get access to 100 MB of storage and an easy drag-and-drop interface that is a little crude, but effective for covering the design bases mentioned above.

Flickr (*www.flickr.com*)
This is a great tool for creating an image gallery that links to your site. It's also free, and lets you upload 100 MB of images and share them with the thousands of members on their site.

Creative Capital Artists Toolbox (*http://toolbox.creative-capital.org/articles/webhowto/*)
Excellent tools and guides are provided here for building your own site.

Peachpit Press (*www.peachpit.com*)
They publish easy to follow manuals and guides to software, including Dreamweaver, HTML, and Flash. (Their resources for search engine optimization can be found here: *http://www.peachpit.com/search/search.asp.*)

WebMonkey (*www.webmonkey.com*)
This is a slightly more technical web design resource site that includes many guides and free code.

Safari Bookshelf (*http://safari.oreilly.com*)
Virtual software manual lending library that lets you check out several manuals at a time online and download individual chapters as PDFs for a small monthly fee.

Gallery-Style Templates (*http://allwebcodesign.com/setup/signature.htm*)
Simple Web site templates especially designed for artists, galleries, and museums can be found here. Prices range from $35 to $115, with the ones on the high end including PayPal and Flash animation capabilities. Each template comes with a comprehensive help page.

E-Mail Etiquette

When someone doesn't respond to your e-mail, what does that make you think about them? Do you think that they are (choose all that apply):

_____ Having e-mail problems?
_____ Overwhelmed with work?
_____ Not interested in what you had to say?
_____ Irresponsible?
_____ Unorganized?
_____ Mad at you for having the impudence to e-mail them in the first place?
_____ Passive-aggressive?
_____ On vacation?
_____ No longer in business?
_____ Very ill?
_____ Dead?

Well, those are some of the things that people think about you when you don't respond to their e-mails. No good feeling comes out of not answering a legitimate e-mail, even if it's for reasons that had nothing to do with the sender.

When your e-mail goes unanswered, send another one a week later—not to nag, but "just in case" they didn't get your first one. Every time I've done this, I've gotten a quick, friendly response with an apology saying they were on vacation or sick, or that the spam ate my e-mail. If you are the offender, likewise, apologize with an excuse and never be late in responding to their e-mails again.

Keep your e-mails short. I'm the last person who should be giving this advice, but you can have it—I'm not using it. A friend of mine who has a big executive job told me he's observed that one question or idea—two at the most—is as much as people can absorb per e-mail.

FOLLOW-THROUGH

At a certain point, follow-up upgrades to follow-through. This is about continuing the relationship by promptly doing what you say you're going to do, every time. Generally, being reliable is the goal. Just like you're much more inclined to do repeat business with a store that has good customer service, your clients would rather work with someone who is responsive, pleasant, and easy to deal with than someone they constantly have to remind to get things done on time. This means that when an art consultant says she wants you to send her some images and a price list of your work (or tear sheets, or whatever), you get it in the mail that very day. If she needs it by tomorrow for a presentation, you FedEx it. (It's okay to ask if you can use the clients' FedEx account to send it when they give you such short notice.) Granted, some of you reading this may have so much work that when a client says, "Jump," you no longer have to say, "How high?" If so, please let me know what that feels like.

GET IT IN WRITING

Once you've gotten a verbal go-ahead from your new client, send a brief summary of the project for him to read, sign, and return. You can call it a "proposal" if you're still negotiating the terms and you want to give the client a chance to look it over. Once the client says it looks fine to him, you can rename it a "letter of agreement" and include a place for him to sign, or he can simply sign the proposal with a note saying he agrees to the arrangement you've outlined. Once the client agrees to your terms in writing and gives you a deposit, this document (call it what you will) functions as a contract

giving you written permission to go ahead with the work. More important, it is a demarcation of the client's commitment to move forward. There is no official format, but it should contain the following.

Physical Description of the Artwork
- Title
- Dimensions
- Materials
- Site

Intent of Artwork
- Themes, symbols, and style

 This will be in narrative form using phrases culled from your discussions with the client on the idea you developed for the project. For example: "Abstract Byzantine glass mosaic mural and seating area that creates a welcoming focal point for visitors and tenants entering the lobby and waiting for the elevator. Style will be consistent with the subdued, mid-century Modern aesthetic of the rest of the interior. Palette will consist of light neutral, natural tones with black and burnt orange accents. Simple benches will be created from planks recycled from the original building."

Timeline
- Phases of project from design to installation

 Say how long your work will take. Make sure you include any benchmarks that the client must meet. For example, if you need to order materials or subcontract with a fabricator but can't do so until the client pays you a deposit, put that into the proposal. ("Fabrication—contingent upon receipt of deposit." Or, "Installation—contingent upon completion of wall prep as described in Attachment A.")

Here's a story from glass artist Ken vonRoenn about how he learned this lesson the hard way.

Lesson: Establish dates for when specific information is due, and inform the client of these dates.

Story: After the completion and approval of a design, I told the client and the architect that in order to make the deadline, we needed to have final dimensions by a specific date. When that date came, I sent an e-mail to everyone saying that we had not received the dimensions and that we would be late. After two months of reminding everyone of the need to get sizes, we finally received the dimensions but also learned that we could

not be late on the project because a date for the dedication had been set. We then had to work overtime, delay other projects, and go through tremendous stress to make the deadline, which we did. I explained the extra expense we had to incur to meet the deadline to the client, and they agreed to pay for these additional costs.

Net result: We recovered $20,000, made the deadline, and had a grateful client who appreciated our extra effort.

Payment Schedule

• How much is due, and when?

This list isn't one size fits all because it depends on the complexity of one's work. In general, a payment schedule should contain these phases:

• Design development—time needed to complete, in weeks or months, and amount due to begin design

• Fabrication—time needed to complete in weeks or months, and amount due to begin fabrication

• Installation—time needed to complete in weeks or months, and amount due to begin installation

• Completion—amount due on final acceptance

You will also add any contingencies that apply to each of these benchmarks.

Acceptance of Terms

• Signature and date

End with a line that says something like, "Please sign if you accept these terms." Include space for your date and signature and those of the client. Make him or her a copy and keep one for yourself.

I will end this section with another real-life adventure from Ken vonRoenn. Every artist I know has a similar story from early in his or her career.

Lesson: ALWAYS get a contract.

Story: A long time ago, a very large corporation asked my studio to produce quite a number of commemorative pieces, which they planned to sell. It was a big order, my studio was small, and I was eager for work. I was very naive and trusting when they said the purchase order was held up in the purchasing department. With each phone call that I made inquiring about the status of the purchase order, they would say, "Don't worry, it will be there soon." We finally shipped the order after receiving a 10 percent deposit. Two weeks after delivering the work, we received a

letter stating that 80 percent of the pieces were "rejected" and were being returned. My attorney later learned that they didn't sell the quantity they had expected and therefore used the ruse of rejection to keep from paying us. They only paid for 20 percent of the work and we had to "eat" the rest.

Net result: I lost more than $50,000.

GET A DEPOSIT

Only chumps work for free. Sorry to be so harsh, but I need to get this point across for your own good. It can be a token amount of money compared to the entire cost of the project, or it could be 50 percent down. The point is that when the client parts with his cash, it commits him to working with you. And when you take his money, it obligates you, as well, to deliver what you said you would when you said you would, and to hold his place in your work schedule. Overall, it underscores your professionalism, your self-respect, and your respect for the client's project.

Moreover, this transaction creates a legally binding contract. A contract is an agreement to do or not to do a certain thing. The essential elements of a contract are the capacity of all parties to enter into a contract, consent, a lawful object, and consideration. The consent must be mutual between the parties and communicated to one another. Consideration is typically money; however, it can be any benefit conferred (or agreed to be conferred) or bargained for exchange without any formal requirements.[3] (For a more detailed discussion of contracts, see chapter eight.)

Your letter of agreement or proposal constitutes an offer. When clients sign it and agree to your terms, they've accepted them. When they give you a deposit, that's the consideration. A contract doesn't need to be complicated. You could write on a napkin that you would hand-paint a T-shirt for a friend if she agreed to wash your car. All you need is her signature on the napkin. You don't even need to have it notarized.

It's important to understand when you've entered into a contract agreement with someone because that binds you and the other party to do what you said you were going to do. You probably wouldn't sue your friend for not washing your car after you painted her T-shirt, but if you'd spent four months on a $10,000 commission and the client bailed on you, you'd have legal recourse. It works both ways. You can't flake out on your client and consider his deposit a gift because you changed your mind about doing the work.

One good arrangement is to ask for a nonrefundable deposit to cover your design phase. If the client likes your idea and wants to proceed with commissioning the artwork, then the deposit can be applied to the total cost of production. If the client decides to bail out of the project for any reason,

you've at least been paid for some of your time. Be sure to include any travel costs you will incur when calculating how much to ask for as a deposit.

If you have any hesitation about asking for a deposit, remind yourself that the most valuable part of an artwork is the artist's concept, and for those of us who don't have ideas flowing out of us like a mighty river, it's the most difficult phase. You don't want to give that away—even though people will expect you to because "it's only an idea."

BILLING

Bill early and often. Send an invoice to the client as soon as you've reached the benchmark agreed to in the schedule. Don't let money sit around. Deposit the client's check as soon as you get it. Not only does this show that you're businesslike and that the client's money matters to you, but that you've got it secured should the client have a change of heart or fortune. As artist Guy Kemper advises, "Artists are usually held to strict timelines, but when construction is delayed, the artist is left waiting to be paid. Suppliers are paid within thirty days or begin adding finance charges, and so should artists."[4]

In the next chapter, you'll hear from a few of the many artists who are succeeding at making a living in public art.

Lunch

In the private sector, much business bonding occurs over lunch. There's just something about sitting down and breaking bread with someone that opens doors. You don't need to be a guy in a suit to participate in this time-honored ritual. The main thing to remember is that you're not really there to eat lunch. You invite people to lunch to ask their advice, talk to them about a particular idea you have, or find out if they have any projects coming up. And for Pete's sake, pick up the tab. This person, whom you respect enough to ask her opinion, is taking time out of pursuing her business to help you. It's a small price to pay, and it looks like you're not clued into the tao of business when you split the check (or, god forbid, expect the other person to pay).

Better yet, if you've got a cool studio and at least know how to make a sandwich, invite people to lunch there. One of our prime assets is our artist lifestyle. Nonartists are curious and, perhaps, a bit envious of it. Part of the value they get from us is experiencing *la vie artiste* vicariously through us.

I should probably add that when I was buying art for a living, being invited to lunch or to someone's studio wasn't a guarantee that I'd present

that artist's work to my selection committee. If I showed the committee work that was clearly not a good fit for the collection, my motives would quickly become suspect and I'd lose precious credibility with them.

End Notes

[1] Two good sources of sales tips for small businesses can be found at *http://ezinearticles.com* (go to "Business" > "Sales-Training") and *www.entrepreneur.com* (under "Sales").

[2] Most of the books are targeted to managers in organizations as opposed to the soleproprietor. A good resource for the one-person shop is *Guerrilla Selling: Unconventional Weapons and Tactics for Increasing Your Sales* by Jay Conrad Levinson (New York: Houghton Mifflin Company, 1992).

[3] Thanks to attorney William Baker for help with this section.

[4] Guy Kemper, via e-mail, March 20, 2007.

Chapter 13:
Voices of Experience

I invited eleven artists to answer some of the most pressing questions addressed in this book in their own words. These are artists who have been in the public art trenches for decades, and whose experience has made them justifiably confident in their opinions—even if they don't always agree with mine!

1. *What advice can you give to studio artists who want to make the transition to public art?*

Pam Beyette: A successful transition from studio art to public art is a process that is as individual as the creative process itself. The character, approach, media, and intent of artists shape the course they take in public art. The most prudent advice is to ask studio artists to carefully assess what it would look like for them to be a public artist. Ask them if they are willing collaborators, communicators, creative thinkers, and mediators. Are they interested in sharing their ideas in community outreach environments, city council briefings, neighborhood community meetings, municipal design commissions, and review panel presentations? Question their capacity and aspiration against the skill sets required. Do they feel their approach to art-making could bring compelling qualities that could contribute to the public realm?

Robin Brailsford: You have to want to work big. You have to have a very tough skin—handle rejection on a daily basis with one hand, and juggle a design team top heavy with engineers, insurance agents, and arts administrators for years with the other. You have to be sure of yourself. You have to be trustworthy. You have to know how to build things—all sorts of things, intimately—to be able to design for them, from a neon tube to a turning radius. You have to be strong, tough, resilient, patient, and, of course, bright, creative, and learned. You have to be able to explain yourself and your work through your work, with words (written and spoken), and via images and budgets.

And it's not just about you and your "special (art school) vision." It's about becoming a part of the world at large, being part of and facilitating other people's daily vision. It's about accepting that social responsibility and honoring it.

Dale Enochs: I would suggest that a studio artist should start by thinking that his work will be intended for a specific context. The artist should consider scale, environment, and thematic issues, and how to articulate these ideas to others. I would further suggest that a studio artist begin looking at

his finished work as a maquette for a larger environment and thinking about how that work would be enlarged, constructed, transported, and set. I believe that making maquettes within scaled environments is an excellent way to begin to understand how that work will relate to a specific environment and how it will be perceived therein. Ultimately, much is learned by simply applying to calls for proposals. The process of putting together a proposal is a learning experience in itself. If the artist submits enough proposals, he might land one. Then, he is faced with much more to learn.

Larry Kirkland: First, some important questions should be answered. Why are you interested in making art in the public arena? If it is for money, I would encourage you to think hard about it. The tasks involved in making a permanent artwork—working with contracts, consultants, and construction companies—are very demanding. Artists often get into financial trouble because they lack the experience to understand these demands. If you really think that making public artwork is something you want to pursue, you might try making some studio-related work that explores your potential for creating site-specific art, with materials that have been tested for longevity.

Jack Mackie: Do not get out of bed!!! Run away, run away, run away!!!! O.K. We'll be serious now. The moment that artists understand that they do not have to make "it" (a.k.a. the Work) is perhaps the most freeing moment they will discover. In realizing that he doesn't need to fabricate the artwork, an artist is freed to work in whatever medium a project requires. When asked what medium I work with, I get to ask, "What'd'yagot?" Artists' best fabrication tool is their brain—their methods of thinking, their worldview.

Aida Mancillas: Studio artists need to prepare themselves to move away from solitude and acting solely on their own initiatives and interests to intense engagement with the public. That includes working with a variety of people who may or may not care about the arts in general or understand the nuances of art. A solitary individual who is public-phobic will have a hard time. You have to deal with regulatory folks, bureaucrats, community leaders, politicians, and others. Suddenly, you've moved from private, internal space to public, wide-open space. You're now on a different path.

Tad Savinar: This transition is not an easy one, nor is it a transition for all artists to make. I was an artist who was fortunate—or unfortunate, as time will tell—to have made a shift to public art at a time (1990) which embraced the design team artist. It was a time when the artist's thoughts and intuition were deemed to have almost more value than the objects the artist made. In a gross generalization, I see artists as being from two groups: those who are in love with the act of making things, which borders on hedonism, and those

who are operating scientists using the language of image, content, and humanity. The design team movement encouraged and embraced artists of the latter division. Artists who live in the first group are not well-suited to public art. They should be encouraged to follow the money and the opportunities within the studio. My long-winded point is this: Artists should take a long look at themselves, their works, their aspirations, and their realities to determine which group they feel they are best suited to.

T. Ellen Sollod: Don't think you can simply make what you make bigger. Learn how to budget. Don't lose your soul.

Ken vonRoenn:

- Understand the difference between creating work that is for a public space (rather than a gallery), for people who will view it as they go through their daily life, and for those who don't make a special effort to come see the work.
- Understand that the bureaucratic work is all part of the creative process—something to be valued and nurtured, not dismissed as a necessary evil.
- Understand and encourage the participation of others in the process of executing a project.
- Most importantly: Remember that art has a responsibility to a larger entity and is not just about self-expression.

Clark Wiegman: Develop communication skills. Learn how to navigate ideas through organizations and groups of people who don't necessarily have any art background or training. Check your ego at the door and be willing to learn from the process. Take the long view. Be patient. Find humor in each situation. Sustain willpower.

2. *How did you get your start in public art?*

Pam Beyette: My start in public art was a series of installations in a city public safety building lobby shared by police, a finance department, and the city council in 1994. Although this was a seminal public project, my transition from studio work to public work was more gradual and began several years earlier. Collecting discarded and reusable materials and transforming them into art became my passion in the early nineties. The work became larger in scale, less personal, and more sourced from environmental, historical, and cultural references.

Robin Brailsford: I started very small, initiating projects on my own for a minuscule budget that then got great reviews. In my case, it was a beach shower mosaic in Imperial Beach, California, for which I got a $1,000 grant,

made all the tiles with senior citizens, and then spent six months setting them at the surf's edge. Before that I had been a jeweler. . . .

Dale Enochs: Initially, I began with an interest in creating large-scale outdoor work. I placed much of the work that I did in my yard with a consideration for that space. While in school, the university I attended built the I.M. Pei Art Museum (one of many throughout the country). I was attracted to the museum's atrium and designed a piece specifically for it. I made models, did studies on how the path of the sun would cast shadows within the atrium, and wrote a detailed proposal. I then submitted it. I knew it was unlikely that it would be accepted, but it was a great learning experience. Several years later, the city in which I lived conducted a public sculpture competition, which I entered with a different proposal. That one was accepted.

Guy Kemper: I worked my way into it slowly, doing bigger and bigger jobs, over a period of about twenty years.

Larry Kirkland: I was a studio artist working with impermanent materials for many years. I would exhibit in galleries and competitions. An interior designer saw one exhibition and approached me about working on a commission. More commissions were offered after that, and I eventually started working in materials that were more appropriate for the public arena.

Jack Mackie: Got my start at breakfast, the most important meal of the day! I was plying my artist life as a photographer, black and white, shooting outside, finding a place, waiting for a person or people to fill the place, waiting for the light to move to just so. Click. This in the Jurassic Year, 1978. An artist call came out from the Seattle Arts Commission requesting qualifications from artists to join a streetscape design team. I had no idea what a design team was or what a streetscape project was, but as a photographer, I knew how to look and watch, and how to see.

Aida Mancillas: I was awarded my first public art commission by then San Diego Public Art Coordinator Gail Goldman, who had forged a program for San Diego's Commission for Arts and Culture out of her own conversations with San Diego city heads of various departments. She convinced some of these department heads to include public art in their plans for any capital improvements they were doing. She appealed to engineering to include public art on a replacement pedestrian bridge that had been on the drawing boards. This girder bridge was my first project. It is the Vermont Street Bridge in San Diego, a sandblasted surface with laser cut steel quotation in stainless steel. It received tremendous community support and just celebrated its ten-year anniversary with a community party. The community was heavily involved in its coming together, and still takes care of it. I attended many

community meetings—sometimes to distraction, but you need to do the time to insure a greater buy in for the whole thing. You will need the community support at times when resistance comes from unexpected sources. You need your allies.

Tad Savinar: Mine is not a simple story, nor do I suspect it to be a traditional one. As a studio artist crisscrossing the country for exhibitions in the 1980s, I was unable to find an opportunity which allowed me to translate my text- and image-based temporary museum installations into public art. (Read: I was applying for public art projects, but not getting selected.) Then, an opportunity to be involved in live theater presented itself. To make a long story short, I found it to be such a revelation that, having built a pretty good national studio career, I closed my studio, sold my tools, canceled my subscriptions, and burned my Rolodex. I declared myself no longer an artist. Of course, once you have declared that you no longer do something, it's just about the time someone calls you to say they want to pay you to do that thing. So, after building a career working in the theater, I accepted an offer to make some public art. And in doing so, I found a new world where I could combine all of the core aspects of my studio work (text, image, social comment) with the skills I had learned in the theater (working with a team of skilled craftsmen, dealing with emotional content and an audience, and receiving pay for work completed). Of course, this was only a blip that lasted ten years, for soon after that I began to move beyond the role of the public object-maker and design team member to managing architect teams, authoring design guidelines and land-use master plans, or drafting construction documents. In this work, I am using the artist's brain to problem solve, but the results are not designs or objects, but rather the development of criteria or management opportunities which drive the entire design process. I still make studio work which is very personal, and I still make the occasional public work, but only when it is an extremely compelling project.

T. Ellen Sollod: I had a background in art, arts administration, and public policy. I knew how things worked "from the other side." An urban designer I barely knew, but who knew me by reputation, and an architect who had seen my work in an exhibition took a chance on me. These were my first two experiences, the former as a design team member, the latter as a site-specific commission. It was outside the normal public art channels.

Ken vonRoenn: My first project came by accident, not by planning. The universe had a better idea of what I should do than I did as a twenty-one-year-old man. Lesson: Trust what comes your way and accept that you have less control than you think you do.

Clark Wiegman: I sort of fell into it. I was installing these unsanctioned ephemeral pieces all over the place in the eighties as sort of social and political statements. Upon return from a long road trip through the Midwest in '87, I received a phone call from Jake Seniuk (then an administrator at the Washington State Arts Commission). He told me I'd been selected from a pool of over 200 artists for a commission at Franklin High School, even though I hadn't applied. He said it would take three years before the site was ready for installation and wondered if I'd be interested. I remember thinking $25,000 was like winning the lottery, since I'd never made more than $500 from my art before. Sure I was interested.

3. Do you think it is possible to make a living from public art? Why or why not?
Pam Beyette: Making a living as a public artist is akin to other design professions. There is a vast range of income potential, from the luminaries who appear to land multiple large projects to those that struggle, not quite making ends meet. The challenge is to juggle several projects at once while carefully managing budgets and schedules. Since some projects take years to complete, it takes foresight and long-range planning to stay in play.

Robin Brailsford: Yes—I have done it basically since that beach shower wall.

Dale Enochs: Yes. I think that people within the U.S. are increasingly understanding the importance of the quality of our public environment and the role that it plays in our psyche. Consequently, there appear to be many more calls for public art projects than there have been in previous years.

Guy Kemper: I don't think it's likely one can make a living solely from public art. It's certainly not a line of work you simply enter into. Like most professions, it takes many years of hard work to build credibility and skill. Otherwise, you'd better have another job or a rich daddy or mate, or be in the top 10 percent of the field. A fat line of credit and serious balls also come in handy.

Diversifying your customer base is critical. I would never rely solely on public art for a livelihood.

Larry Kirkland: There are some good examples of contemporary artists making a living in public art. I live with a roller-coaster checking account! It is always a challenge, especially because I believe in what I create and don't want to reduce the quality of materials, proper scale of the work, or level of detail within the work. These factors often combine to make real demands upon the contract budget. I think many artists face these issues. The successful artists spend a lot of time balancing their desire to create meaningful work for tight available funds. Nothing new to that!

Jack Mackie: Of course, I can make a living at this. The key is to be versatile and to have a flexible focus . . . it goes back to, "I don't have to fabricate it." I broadly define what it means to be a public artist. I design, fabricate, have fabricated, install, oversee installation of my work. I also use my take on what public art does and can do to work as a public art planner and as an advocate/speaker for public art. I work on projects that will not have me engaged as a designing artist but as the artist who cuts a path for other artists, like what someone did for me once-upon-a-time-ago.

Aida Mancillas: I believe one can make a living from public art *if* there are the following shifts:

- Artists must receive a living wage. All art contracts must be clear as to what is expected, with clear timelines and duties outlined. No one can pull the plug in the middle or shift without adequate notice. The budget for any project should be realistic and fair. There should be no expectation to do a $250,000 project for $7,000. *Just say no.* These tiny budgets encourage the proliferation of truncated ideas. They are exercises in frustration. The agency should go back to the community for more money, or partner with another agency, or look for more grants from local politicians, but not try to do a bigger idea that is not supported by the initial budget. An artist is a professional and needs to be compensated to the level of skill and education he or she has acquired. Honor your experience.

- Eventually, artists will have to organize, maybe unionize. Certainly, create and/or join together whenever possible. There is strength and support in numbers. Public Address in San Diego is a good example of artists coming together to encourage and support one another. You have to set ego aside and step away from the usual competitiveness that is set up in the art world. That won't work for public art and artists. And it's not good practice, anyway. It's a poverty mentality of "there isn't enough to go around" that generates the competition. There *is* enough, it just needs to be redistributed fairly.

T. Ellen Sollod: Yes. I do it, but I work *very* hard.

Ken vonRoenn: Yes, but only for an artist that approaches it with a serious dedication to a public process and not just as a way to make money doing "his" art.

Clark Wiegman: Possible? Yes. Easy? No. There are so many ways these projects can go sideways, it's amazing most get completed. Over a twenty-year career, I've managed to complete thirty-four out of thirty-six.

Since I started working in the field, contractual, liability, and insurance issues have practically exploded. In this country's litigious climate, there's a huge risk factor now associated with placing anything in a public setting. And while the number of commissioning entities is expanding and more artists are creating public art, there's wide variance regarding program and artist capabilities.

4. *How do you find new projects? For example, do you apply to open calls? Do you cultivate prospects such as art consultants, architects, and engineers? Are you at the stage in your career where the jobs are finding you, or do all of these apply?*

Pam Beyette: Now, with the increase of prequalified artist rosters and registries, I find myself more frequently being short-listed without a query. I also respond to requests for qualifications (open calls) for new projects. I focus on established publications, online listservs, and direct mail or e-mail for opportunities. Because I am also a public art planner, I additionally network with architects, planners, engineers, and agencies for potential projects. Very seldom have I used art consultants, unless they are hired directly by the client.

Robin Brailsford: Listservs—the best for years has been from UrbanArts in Massachusetts, and now, also the one from 4Culture in Seattle.

Guy Kemper: For all practical purposes, there is no such thing as "the jobs finding you." I was shocked when one of the leaders of the field, a giant, told me he still had to work like hell to find his projects. Every morning, you gotta get behind that mule. Amateurs wait for inspiration and the knock on the door; the rest of us get up and go to work. (Claes Oldenburg or somebody said something like that.)

Open calls have given me mostly heartache and revenue loss, which I've learned to take in stride.

Get a media packet together and make sure it looks good. Pay a professional photographer for good photos to document your projects. With promotional materials, pay a professional writer to do the copy and a professional graphic designer to do the layout. Amateurish promotional materials make professional artists look like amateurs. Good designers and photographers can sell anything, even bad work. Packaging is everything.

Don't talk or write too much—no one cares about how clever you are; they just want your work. Let the work speak for itself.

Spend about half the day marketing and the other half working. It's essential to know basic Photoshop and mail merge skills. The wider you cast your net, the more fish you catch.

Larry Kirkland: All of the above. I sometimes apply for open calls, but usually only if I am personally asked by one of the design team or art administrators involved. I have had many good relationships with art consultants, and work steadily with architects and landscape architects.

Jack Mackie: At this point, I'm answering the phone and accepting or turning down work. This means I agree to enter open competitions for massive projects with planners, architects, landscape architects, engineers, et cetera. It also means I get phone calls and am told I'm short-listed for a project that I didn't even know existed. It also means that I've established relationships with planning and design firms or agencies who call me and say they want me to work on XYZ.

However, getting to this point is the drill. I tended to respond to every open call that interested me (which meant that up until 1985, I kept my day job—this being approximately the first twelve years of my illustrious career!). I learned that it's not worth taking on work just to work. When I did, I ended up regretting it. I don't recall ever applying to a project that asked for a proposal up front. The only competitions to which I submit proposals are those that first asked for qualifications and a letter of interest.

The key to a competition, I think, is to take your best shot at each stage. This means that if not selected, I've had the opportunity to define the need and opportunity of the project to the selection panel from my point of view. Each and every other contestant is then weighed against the agenda I've set. Or, at least I like to think so. . . . Plus, I have received plenty of Dear John letters from projects that I applied for. When I see who is selected, I tell my wounded artist soul that I really didn't want the project after all, and that it just would have been a nightmare.

Tad Savinar: I have plenty of work and am continually turning things down. I probably only go after, apply, or compete for a public art project every five years, and I am very picky. I consider:

A. The location of the project—is it a pleasant city to work in, will travel consistency be impacted by weather, how many times zones away is it, et cetera.
B. The timeline of the project—how will it impact the other clients and projects I am already serving?
C. The amount of the budget—is there really enough money to undertake the project, create something timeless that is proper for the site, pay myself a decent fee, and provide a good contingency?
D. The other team members already on board—is the client or agency known for a good process and advocacy, is it an architect or landscape architect that I would choose to work with?

E. The project—is there something extraordinarily compelling about the project that draws me, does it offer an interesting site, does it have charged content opportunities and/or a challenging social climate?

I am really very picky about what I work on. These projects are incredibly complex and time-consuming, and I prefer to only work on projects that are enriching. I have a little sign on my desk that says "Don't work for assholes" as a reminder.

T. Ellen Sollod: I'm on a number of lists that send e-mail announcements of available opportunities fairly regularly, which I peruse. I only apply for open calls when the project really resonates with me. I am on several artist rosters or registries, and consequently, I get a certain number of invitations to apply. I have a community of architects and landscape architects with whom I have a history of working. They will often call me to become part of a team for a project they are going after. It is not easy.

Ken vonRoenn: I rely on a wide range of methods of getting new projects. I don't think anyone could, or should, use any one method.

- Competitions can be very frustrating because they short-circuit the process of working in collaboration with the architect or designer and the client. But they are opportunities to explore new approaches or concepts, something often lacking with a commission because there, a client often hires an artist from something they have seen and has already made a decision that this is a direction they want to go in.
- Consultants and representatives can be very effective agents and should be cultivated.
- Publications—magazines, newspapers, books—are good sources of promotion.
- Previous clients are always the best sources and should be cultivated for future projects.
- Blind introductions can be good if done with taste and *understatement*.
- I do at least twenty presentations every month to architects and designers across the country, which is our primary source of new projects.

Clark Wiegman: All of the above. At this point—after applying to something like 1,000 projects and giving over one hundred interviews or presentations—I feel like it's simply part of the practice to be out in the world, talking to people, getting feedback, presenting, and being a contributing member of a community.

There's an emerging dialog about the state of the planet—reaching beyond the business of art—that we who practice art in a public realm are both privileged and required to participate in as global citizens. Both the urgency of the discussion and the critical role that artists play as imaginers within it maintain my enthusiasm for the entire process. I want to be part of some of the solutions for problems facing the world my children will inherit.

5. What percentage do you budget for your artist's fee?

Pam Beyette: The artist fee can vary by project, depending on the scope of work and the extent of oversight responsibilities. I find it prudent to approach the artist fee on a case-by-case basis. I find that small projects can take just as much effort as very large ones. Typically, I look for between 20 to 30 percent in artist fees, but that is hardly a fixed number!

Robin Brailsford: 15 to 20 percent.

Dale Enochs: Therein lies my greatest stumbling block. Every project has a budget, and I consistently work within that budget. Every project also brings forth new ideas, and with that, a renewed excitement. Over the years, I've gotten pretty good at organizing budgets for projects. I know what it takes to get a project accomplished. However, in my excitement and enthusiasm, I feel that I have been negligent in providing an adequate budget for my labor. I recognize that when I am presented with X amount of dollars, I have a strong desire to do the most that I can with the money available. Paying myself takes a backseat.

I think that many artists (often unconsciously) struggle with meshing the ideals of art with the realities of living. I always want to create the most that I can within a given budget, but I know that I need to provide myself with an adequate income in order to proceed to the next piece. The entire process is a delicate dance.

Guy Kemper: I can't really say what percentage I budget because that depends on the project. Let me answer it this way: I try to end up with 5 to 10 percent net profit.

Larry Kirkland: That is a tough question, with no pat answer. I would love to say I budget 20 percent of a budget for the artist's fee and oversight. However, that also doubles as the contingency fee! It fluctuates with every project. Sometimes, I make no fee. Sometimes, I make a decent fee. I have never made what I projected in a spreadsheet for a contract.

Jack Mackie: It ranges. If there is a high public face—meaning, many community meetings or city council face time—I push towards 20 to 22 percent. If it's

just "shut up and draw," it tends more to 15 to 18 percent. This does not include fees required for engineering or stamping by architect or landscape architect. Also not covered are costs for travel. Travel can consume 20 percent of a budget. So, starting at 100 percent budget minus fee at, say, 18 percent, minus 20 percent for travel, minus another, say, 2 percent, for engineering fees, the client needs to understand way up front that they're getting 60 percent of the budget for the actual work.

I'm in the business to stay in the business . . . ain't gonna play the starving yahoo. . . .

Tad Savinar: When I look at a budget, I immediately reserve 50 percent for my fee. Now, I know that many who are reading this will roll their eyes. But wait, because this is not the way the story ends. That is only at the beginning. I see so many artists who take on a project, come up with a concept that they are really excited about, and then ultimately find out that they don't have enough money to properly pay themselves and make the project. I always start off with 50 percent and ask myself, "Now, what can I make for what's left over in the other 50 percent?" During the conceptual phase, I continue to estimate costs and gauge the progress. Finally, when the concept is completed, I start drawing from my imaginary 50 percent fee for contingency and material upgrades; it's a little game I play with myself. By the time the project is completed, I generally come out with a 25 percent fee. As a matter of information, I track all my time on a project diligently in fifteen-minute increments. This record is a wonderful tool to actually see how much time I really spend on a project, and has been a great clarification of process when there have been questions, legal or otherwise.

When I first started out, I remember trying to work my way up to a $50,000 project. Now, I rarely ever engage in a project that is less than $200,000. However, there were two occasions. One was the opportunity to work with two other artists that I had worked with recently, and we all agreed that we would forgo our fees just to repeat the fun of the partnership. It turned out to be a great piece. And the second was an opportunity to do a sweet little project in a city park in my hometown, where I put every dime into the fabrication and taking no fee was my gift to the city.

T. Ellen Sollod: I usually budget 20 percent for my artist fee. I also do a project management set-aside and calculate an overhead rate as part of the project fabrication expense.

Ken vonRoenn: This will depend on the amount of work required. If there is a model, the fee is usually around 10 percent.

Clark Wiegman: I don't calculate my budgets that way. Instead, I try to place numbers on each area of work: presentation, research, conceptual development, design development, project management, construction documents,

fabrication, installation, documentation, etc. It's probably a bit curmudgeonly to say this, but the approach relates to the old idea of being a "cultural worker," as opposed to a "divinely-inspired artiste." It also helps if there's ever any dispute about project costs to be able to point to all the intellectual as well as physical labor that went into its making.

6. *What percent of your time is spent exclusively on art-making, versus tending to business needs?*

Pam Beyette: This is a tough one! But the truth be told, maybe 10 percent?!

Robin Brailsford: Ninety-five percent business, 5 percent actual art-making.

Dale Enochs: I would guess that the business activities constitute about 15 to 20 percent of my time.

Guy Kemper: Ninety percent business, 10 percent art.

Larry Kirkland: Like most artists, I make most of my creative decisions after "working hours." I work almost every weekend and often late in the evening on the creation of the ideas and the working through of a concept. My work takes a lot of research, so much time is spent reading, listening, and interacting to inform myself about a specific subject. My work is always about something with a narrative thread, and it takes time to understand the story I am trying to form. Weekday working hours are often spent working on contract issues, budget issues, and making decisions with a fabrication and engineering team. All of these are creative endeavors but not the hands-on creation of a "thing." All of this time is about making a creative idea come to life, so I think I spend all my time making art, just not in the romantic sense of what we imagine it to be.

Jack Mackie: One hundred percent to both. I have no idea. Monday is a business day, I know that. The first day of every month is invoice day, I know that.

T. Ellen Sollod: This is difficult to judge because it depends on the various stages of a project; however, administration, marketing, and financial management probably take 80 percent of my work time. Depressing, yes?

Ken vonRoenn: I don't distinguish between "doing business" and "making art," for they are the same thing. One requires artistic skill, and the other requires planning and organization, though both should be done with a sense of creativity and joy.

Clark Wiegman: Unfortunately, probably nearly 50 percent is spent on the business aspect. It's a constant battle to avoid getting lost in business details (attending meetings, managing employees, dealing with subcontractors, balancing books, running errands, etc.) and keep the focus on creativity.

7. *Under what circumstances would you or have you signed away your Visual Artists Rights Act rights or your copyright?*

Pam Beyette: When addressing VARA, I carefully read the contract for each and every project, since many agencies ask the artist to waive these rights for most infrastructure projects. I am mindful that public buildings and their uses change over time, and because my work is often site-integrated and always site-specific, it is essential that the contract provide appropriate protection for the integrity of the artwork. I never agree to allow the agency to relocate or remove the artwork and/or substantially modify the site on which it is built without notifying me of the proposed change. The agency will usually attempt an agreement with the artist regarding the future appearance or location of the artwork.

I would never, under any circumstances, relinquish my copyright to the artwork! It's vital that artists retain their full rights to reproduce images of their work in all media, including books, magazines, promotional materials, and video, with credit to the client or agency. In turn, the client or agency is free to reproduce the artwork crediting the artist as copyright holder.

Robin Brailsford: I turned down a big project in California that would not honor VARA rights a few years ago. It was a shout in the wind that no one heard. . . . I myself have since (and often) signed awful contracts with inexperienced cities; otherwise, they will often just give the opportunity to the next guy. Clients are much more eager to avoid their fear-mongering attorneys than their literati and perceptive art committees.

Dale Enochs: Whenever I end up writing a contract, I include a brief clause saying that I hold the copyright, that the work cannot be destroyed or removed without giving me notice, and that if repairs are needed, I will be notified and given the opportunity to make those repairs. Most clients agree to these requests. At times, particularly on larger projects, I am asked to forgo these issues. In the end, it depends on how much I want to do the project. The same goes for copyright.

Guy Kemper: I've done a couple of large airport projects in Orlando and Baltimore/Washington where I had to sign away all VARA rights and copyright for both commissions. A few observations:

- Clients often need flexibility to change the building over time. They need full freedom to do this without legal interference from past commissioned artists whose work may be affected. In Orlando, they took out a one-hundred-foot-long wall I did so they could expand the concourse. I doubt they'll ever use it again, and if they do, it won't be as good of a site as the original. For me to whine about this would be counterproductive, I think.

- A client may reasonably want ownership of the design to prevent the artist from reusing it, which is more likely than the client copying the work for use in another location. Once something is purchased, it is presumably owned by the purchasers to use as they see fit.

Honestly, why do I need copyright? I don't copy myself. I'm through with it—it's theirs. It belongs to the building and the client, not to me. I'm an architectural artist. My work is part of the public realm and, as such, it is sort of a gift to society when I'm through. Artists are constantly appropriating others' work, and especially in the twenty-first century, I think America's copyright laws are outdated. Of course, there is a blurry line between borrowing and thievery, but it is virtually impossible not to plagiarize. Half of Shakespeare, and probably the same percentage of the best paintings, owe a legal debt to previous works that could be prosecuted under American copyright law. Bob Dylan has never denied a request or charged for another musician to incorporate a sample of his work into his own. What if Picasso (or Cezanne?) copyrighted Cubism? Some things are meant to enter the common public cultural realm, and good artists are flattered when their work enters the realm of common culture; they don't feel they should be paid for parts being appropriated. Most artists are egotistically fooling themselves that their art is unique in the first place.

Jack Mackie: Artists need to waive VARA when working in infrastructure projects. Examples:

1. An artist has designed and installed a discrete stand-alone artwork on a light-rail platform. Many years post-installation, the transit agency determines that the passenger platform needs to be expanded and a passenger shelter must go where the artwork is. In this case, the infrastructure need—the passenger shelter—trumps the artwork, and the artwork will be moved.

2. An artist has designed and installed an integrated artwork in an infrastructure project—say, an artist-designed fence along the perimeter of a wastewater treatment plant outside of Washington, D.C. The plant, due to the ever-expanding amount of unprecedented shit coming out of the White House, must expand, thus requiring a "rearrangement" of the artist's fence work. Shit wins.

Waiving copyright? Short answer? No. Principle: At the end of the day, all an artist has (especially those working in public) is control over how their work is represented, and by whom.

T. Ellen Sollod: I have never completely signed away my VARA rights, though I have agreed to a modification when the artwork includes a landscape component. In those cases, I have agreed to work with the agency to revise the

landscape, if needed, and described what my intent was with the landscape (e.g., scale, color palette, texture). In this case, it was agreed that changes, if necessary, would be made with these artistic guidelines in mind. The VARA applied exclusively to the art elements.

I have never signed away my copyright. This would mean that I was doing work for hire, such as that work done by a graphic designer or copy editor.

8. What lessons from the School of Hard Knocks do you have to share with artists who want to enter into creating art for the public realm?

Pam Beyette: Apply for projects that are compelling and speak to your creative sensibilities.

Create not to please, but to transcend the expected.

Develop designs that leave room for flexibility.

Generate succinct, compelling narratives that augment concepts.

Design proposals or concepts with a budget clearly in mind.

Robin Brailsford: Live in the now—forget the past. Lose to great artists with grace; work harder to beat the lesser ones. Travel, read, go to shows, hike—but always go back to the studio to get to work.

Guy Kemper: Ideally, one wants to deal with, or be in, the top 10 percent of any profession. That bottom 90 percent is not a pretty thing, but often one must rely on it to do one's job properly. Look out for that bottom 90 percent! They can make life miserable. Always remember the two driving forces of bureaucracies: the diffusion of responsibility and CYA (Cover Your Ass), and preservation of job security. These two forces make it difficult for anyone to make a decision or admit a mistake, so often, blame will be placed on the artist. Because the artist stands alone, there is no bush of bureaucracy to melt back into if things go awry. His head, and his alone, is on the chopping block. Of course, many artists are raving narcissists and business nightmares, so it goes both ways.

Larry Kirkland: Ask many, many questions up front. Don't be afraid to ask dumb questions, because there is no such thing. Make sure your contract covers the discovery of unknown environmental, construction, or material issues. Realize that a contract is a document that has a life beyond the personal relationships of the people who made the initial agreement. People change jobs or leave a project for some reason, and then, you are left working with a very different personality with different agendas than the initial contracting officer. Understand who is allowed to install your completed work—you or a labor union. Make sure your own team of engineers and fabricators has a clear line of communication with you and your contract agency.

Jack Mackie: This work isn't for everyone. I can no longer imagine going through the demands of making boutique art for gallery sales. It's the same with public art. In working outside in the messy grays of sidewalks, there is no such thing as a white room, a freshly gessoed canvas, or a white page. Somebody is always standing squarely on that page, and they have an idea about what's supposed to happen on the page. And whether an artist agrees with that point of view or not, it is valid and must be considered. This is hard, hard work for artists who need to be right.

Aida Mancillas: Don't hold on to a bad project or a bad client. Let go. We artists tend to go the extra distance out of guilt or poverty mentality or something. Believe me, other licensed professionals don't. They do the work contracted, pick up the check, and go home. We artists need to do likewise. Treat it like a job.

Tad Savinar: Never take on a project "for the money." Always ask yourself if you would choose to take on this project, or is it just for money. This act is demoralizing for any artist. Never say in an interview that you will have no problem with a schedule when you know this is not true. This is my public art world pet peeve. Once, on a large light-rail design team project, there were five artists selected, the project was supposed to start immediately, and all had said in the interview that they were ready to go with no conflicts. I actually promised in the interview that I would take on no new work for the upcoming year so that I could be available. However, when the five of us sat down to figure out when we would have our first design session, none of the other four artists could agree on four days until two and a half months out. Public art is more than a job. It is not an assignment I take lightly. I am always amazed when I encounter other artists who are stretched too thin to really take the time to consider the importance of what they are engaged in, who have been greedy in their project loads, who are lazy in their service of clients, or who are cavalier in their treatment of the public.

More importantly, I am amazed at the number of public artists who do not consider the push-me/pull-you of artistic trends and fashion versus the need for timelessness in the public realm. There is a difference between studio art and public art. In the studio, the artist is the client. In public art, the artist is engaged in a partnership with the public realm. There is a very big difference and a very different set of responsibilities.

T. Ellen Sollod: It doesn't seem to me that my years of hard work and projects have made it easier to get work. Public art should not be something one pursues because one thinks one can make a living at it. There should be something about the idea of working in the public realm that drives you. Be willing to walk away from a situation that is clearly not going well. This

doesn't mean to easily throw in the towel, but there are times when a graceful exit is the best strategy. Develop a thick skin. Learn to be patient. It takes years to get things completed. This is a challenge, because the excitement you had when you started a project wanes through the delays of getting it done. Learn how to be collaborative. You need partners in other disciplines (engineers, landscape architects, or architects) with whom you enjoy working. If you can, develop a relationship with a structural engineer who likes your work and wants to help you achieve your goals in the manner which fits you best—you want a problem solver. If you aren't going to fabricate your own work, develop relationships with fabricators on whom you can rely. Treat them well. Pay them on time.

Clark Wiegman: Here are a few mantras I've shared with younger artists: Don't assume anything. Negotiate contracts carefully. Push gently for imaginative solutions. Dream big, but focus on "essential gestures." Try to keep as much fabrication in-house as possible. Wear a respirator. Get several bids. Be persistent and tenacious. Document early and often. Take time to go fishing. Breathe deeply and often.

"Voices of Experience" Artists
Many thanks to the artists who contributed to this chapter:

__Pam Beyette__ is a public artist living in Seattle, Washington. Her site-specific artwork, inspired by environmental, historical, and cultural experiences, is incorporated into schools, parks, libraries, universities, transit stations, and justice centers nationally.

In addition to being a full-time artist, __Robin Brailsford__ is a founding and board member of Public Address, an association of public artists in the San Diego area.

__Dale Enochs__ is a stone sculptor. His numerous public works can be seen throughout Indiana, Indiana's sister state in China, and in Osaka Prefecture in Japan. He lives and works near Bloomington, Indiana.

__Guy Kemper__ makes architectural paintings in blown glass. His projects include installations at Orlando, Baltimore/Washington, and Chicago O'Hare International Airports, Mount Baker station in Seattle, and the Catholic Memorial at Ground Zero. He resides in Versailles, KY.

Since 1974, __Larry Kirkland__ has collaborated with design professionals and community leaders creating meaningful places throughout the world. Over the past several years, he has been a juror for both art and architecture programs throughout the country. He resides in Washington, D.C.

Jack Mackie works as a public artist and arts consultant on major civic projects throughout the country and Great Britain. He resides in Seattle.

Aida Mancillas creates large-scale public artworks. She is a commissioner with San Diego's Commission for Arts and Culture, where she sits on the diversity, policy, and creative communities committees.

Tad Savinar is an artist based in Portland, Oregon, who has focused much of his work on urban design teams, master planning exercises, downtown revitalization plans, urban waterfronts, and regional infrastructure projects.

T. Ellen Sollod has been involved in public art as an artist, art planner, and art policy maker for over twenty years. She lives in Seattle.

Ken vonRoenn stumbled into becoming an artist of large architectural glass installations in the 1970s when, only two weeks away from entering law school, he had an accident and, because he had no health insurance, was no longer able to afford school and went to work in a small stained-glass studio. It inspired him to obtain a master's degree in architecture and to found a large studio in Louisville, KY, where he resides today.

Clark Wiegman has been a professional multimedia artist for the past twenty-five years. His projects include civic planning, plaza and transit center design, earthworks, fountains, landmarks, soundworks, and illuminations.

Bibliography

ART ECONOMICS

Abbing, Hans. *Why Are Artists Poor? The Exceptional Economy of the Arts.* Amsterdam: Amsterdam University Press, 2002.

Grampp, William D. *Pricing the Priceless: Art, Artists, and Economics.* New York: Basic Books, 1989.

BUSINESS SKILLS

Fisher, Roger, and William L. Ury. *Getting to Yes: Negotiating Agreement Without Giving In.* 2nd ed. New York: Penguin Books, 1991.

Fox, Jeffrey J. *How to Become a Rainmaker: The Rules of Getting and Keeping Customers and Clients.* New York: Hyperion, 2000.

Gitomer, Jeffrey. *Little Red Book of Sales Answers.* Upper Saddle River, N.J.: Prentice Hall, 2005.

Grant, Daniel. *The Business of Being an Artist.* New York: Allworth Press, 2000.

Levinson, Jay Conrad, Bill Gallagher, and Orvel Ray Wilson. *Guerrilla Selling: Unconventional Weapons and Tactics for Increasing Your Sales.* New York: Houghton Mifflin Company, 1992.

CONTROVERSY AND PUBLIC ART

Americans for the Arts. *Public Art Controversy: Cultural Expression and Civic Debate.* Washington, D.C.: Americans for the Arts, 2006.

Bogart, Michele H. *The Politics of Urban Beauty: New York and Its Art Commission.* Chicago: The University of Chicago Press, 2006.

Doss, Erika. *Spirit Poles and Flying Pigs: Public Art and Cultural Democracy in American Communities.* London: Smithsonian Institution Press, 1995.

Jordan, Sherrill, Lisa Parr, Robert Porter, and Gwen Storey, ed. *Public Art/Public Controversy: The Tilted Arc on Trial.* New York: American Council for the Arts, 1987.

Kammen, Michael. *Visual Shock: A History of Art Controversies in American Culture.* New York: Alfred A. Knopf, 2006.

Mitchell, W.J.T. *Art and the Public Sphere.* Chicago: The University of Chicago Press, 1992.

Senie, Harriet F. *The Tilted Arc Controversy.* Minneapolis: University of Minnesota Press, 2001.

Senie, Harriet F., and Sally Webster, eds. *Critical Issues in Public Art: Content, Context, and Controversy.* New York: HarperCollins, 1992.

Legal Guides for Artists

Bielstein, Susan M. *Permissions, A Survival Guide: Blunt Talk about Art as Intellectual Property.* Chicago: The University of Chicago Press, 2006.

Crawford, Tad. *Legal Guide for the Visual Artist: The Professional's Handbook.* New York: Allworth Press, 1995.

Leland, Caryn R. *Licensing Art and Design: A Professional's Guide to Licensing and Royalty Agreements.* New York: Allworth Press, 1990.

Wilson, Lee. *Fair Use, Free Use, and Use by Permission: How to Handle Copyrights in All Media.* New York: Allworth Press, 2005.

Place-making

(Most of these contain sections on the history and evolution of public art from varying perspectives.)

Bach, Penny Balkin, ed. *New Land Marks: Public Art, Community, and the Meaning of Place.* Washington, D.C.: Grayson Publishing, 2001.

Bala, Iwan. *Art and the Changing Landscape.* Chicago: Independent Publishers Group, 2003.

Berry, Ian, and Bill Arning. *America Starts Here: Kate Ericson and Mel Ziegler.* Cambridge: MIT Press, 2003.

Bloodworth, Susan, and William Ayres. *Along the Way: MTA Arts for Transit.* New York: Monacelli Press, 2006.

Brenson, Michael, Eva M. Olson, and Mary Jane Jacob, eds. *Culture in Action.* Seattle: Bay Press, 1995.

Clifford, Sue. *Places: The City and the Invisible.* London: Public Art Development Trust and Common Ground, 1993.

Cockcroft, Eva, John Pitman Weber, and James Cockcroft. *Toward a People's Art: The Contemporary Mural Movement.* Albuquerque: University of New Mexico Press, 1977, 1998.

Finkelpearl, Tom. *Dialogues in Public Art.* Cambridge, Mass.: MIT Press, 2000.

Fleming, Ronald Lee. *The Art of Placemaking: Interpreting Community through Public Art and Urban Design.* London: Merrill, 2007.

Florida, Richard. *The Rise of the Creative Class: And How It's Transforming Work, Leisure, Community and Everyday Life.* New York: Basic Books, 2002.

Gerace, G. *Urban Surprises: A Guide to Public Art in Los Angeles.* Glendale, Calif.: Balcony Press, 2002.

Gooding, Mel, ed. *Public:Art:Space: A Decade of Public Art Commissions Agency, 1987–1997.* New York: Merrell, 1998.

Gude, Olivia, and Jeff Huebner. *Urban Art Chicago: A Guide to Community Murals, Mosaics, and Sculptures.* Chicago: Ivan R. Dee, 2000.

Heartney, Eleanor, and Adam Gopnik. *City Art: New York's Percent for Art Program.* New York: Merrell, 2005.

Huebner, Jeff. *Murals: The Great Walls of Joliet*. Champaign: University of Illinois Press, 2001.

Jacob, Mary Jane. *Places With a Past*. New York: Rizzoli, 1991.

Jacobs, Jane. *The Death and Life of Great American Cities*. New York: Vintage Books, 1991.

Janney, Christopher and Ellen Lampert-Greaux, et al. *Architecture of the Air: The Sound and Light Environments of Christopher Janney*. New York: Side Show Media, LLC, 2007.

Kastner, Jeffery, Anne Wehr, and Tom Eccles. *Plop: Recent Projects from the Public Art Fund. New York*: Merrell, 2004.

Kwon, Miwon. *One Place After Another: Site-Specific Art and Locational Identity*. Cambridge: The MIT Press, 2004.

Lacy, Suzanne. *Mapping the Terrain: New Genre Public Art*. Seattle: Bay Press, 1995.

Lippard, Lucy. *The Lure of the Local: Senses of Place in a Multicentered Society*. New York: The New Press, 1997.

Magie, Dian. *On the Road Again: Creative Transportation Design*. Hendersonville, N.C.: Center for Craft, Creativity, and Design, 2005.

Marschall, Sabine. *Community Mural Art in South Africa*. East Lansing: Michigan State University Press, 2003.

Matzner, Floria. *Public Art: A Reader*. Ostfildern-Ruit: Hatje Cantz Publishers, 2003.

Miles, Malcolm. *Art, Space and the City: Public Art and Urban Futures*. New York: Routledge, 1997.

Miss, Mary, and Daniel Abramson. *Mary Miss*. New York: Princeton Architectural Press, 2003.

Nash, A. Leo. *Burning Man: Art in the Desert*. New York: Harry N. Abrams, 2007.

Nawrocki, Dennis Alan. *Art in Detroit Public Places*. Detroit: Wayne State University Press, 1999.

Norkunas, Martha K. *Monuments and Memory: History and Representation in Lowell, Massachusetts*. Washington, D.C.: Smithsonian Institution Press, 2002.

Pasternak, Anne. *Creative Time: The Book*. New York: Princeton Architectural Press, 2007.

Pearson, Lynn F. *Public Art Since 1950*. Miami: Parkwest Publications, 2006.

Phoenix Office of Arts and Culture. *Infusion: 20 Years of Public Art in Phoenix*. Phoenix: Phoenix Office of Arts and Culture, 2005.

Project for Public Spaces. *How to Turn a Place Around: A Handbook for Creating Successful Public Spaces*. New York: Project for Public Spaces, 2000.

Roots, Garrison. *Designing the World's Best Public Art*. Victoria, Australia: The Images Publishing Group, 2002.

Spaid, Sue. *Ecovention: Current Art to Transform Ecologies*. Cincinnati: Contemporary Arts Center, 2002. (Also available online from *www.greenmuseum.org*.)

Willet, John. *Art in a City: Revised Edition*. Chicago: University of Chicago Press. Distributed by Liverpool University Press 2007.

PRIVATE SECTOR AND PUBLIC ART

Flood, Bill. *Public Art in Private Development*. Washington, D.C.: Americans for the Arts, 1989.

Uhlir, Edward K. "The Millennium Park Effect: Creating a Cultural Venue with an Economic Impact." *Economic Development Journal* 4, no. 2 (Spring 2005).

Wu, Chin-Tao. *Privatising Culture: Corporate Art Intervention Since the 1980s*. London: Verso, 2002.

PUBLIC ART ADMINISTRATION

Banyas, Rebecca, and Mary Priester. *Westside Light-Rail Public Art Guide*. Portland, Ore.: Tri-Met, 1998.

Korza, Pam. *Going Public: A Field Guide to Developments in Art in Public Places*. Amherst: Arts Extension Service, University of Massachusetts, 1988.

Feuer, Wendy. *Art in Transit: Making It Happen*. Washington, D.C.: Federal Transit Administration, 1996.

Goldstein, Barbara, ed. *Public Art by the Book*. Seattle: University of Washington Press, 2005.

MidAtlantic Arts Foundation. *Millennium Book: Artists and Communities: America Creates for the Millennium*. Baltimore: MidAtlantic Arts Foundation, 2003.

National Association of State Arts Agencies. *Arts and Transportation: Connecting People and Culture*. Washington, D.C.: NASAA, 2002.

Public Address. *Public Art Is a Verb: A Policy Paper on Public Art*. San Diego: Public Address, 2002.

Raine, Nancy, and Linda Coe, ed. *Arts on the Line: A Public Art Handbook*. Boston: Massachusetts Bay Transportation Authority, 1987.

Shaboy, Benny. *The Art Opportunities Book: Finding and Winning*. Benicia, Calif.: studioNOTES, 2004.

PUBLIC ART DIRECTORIES AND STATISTICS

Becker, Jack. "Public Art: An Essential Component of Creating Communities." *Americans for the Arts Public Art Network* monograph series (March 2004).

Gillespie, Susan. *2005–2006 Public Art Program Directory: A Comprehensive Guide to Public Art Programs in the United States.* Washington, D.C.: Americans for the Arts, 2005.

JOURNALS

Public Art Review. Forecast Public Artworks (publisher), St. Paul, Minn.

Sculpture Magazine. International Sculpture Center (publisher), Washington, D.C.

VIDEO

Art: 21. Produced by Susan Sollins. PBS, 2001–2005.

Millennium Park: Five Perspectives. Produced by Doug vanderHoof. Chicago: Modern Media, 2005.

Index

Books from Allworth Press

Allworth Press is an imprint of Allworth Communications, Inc. Selected titles are listed below.

The Business of Being an Artist, Third Edition
by Daniel Grant (paperback, 6 × 9, 354 pages, $19.95)

Selling Art without Galleries: Toward Making a Living from Your Art
by Daniel Grant (paperback, 6 × 9, 256 pages, $19.95)

The Artist-Gallery Partnership: A Practical Guide to Consigning Art, Third Edition
by Tad Crawford and Susan Melton (paperback, 6 × 9, 216 pages, $19.95)

Fine Art Publicity: The Complete Guide for Galleries and Artists, Second Edition
by Susan Abbott (6 × 9, 192 pages, paperback, $19.95)

Legal Guide for the Visual Artist, Fourth Edition
by Tad Crawford (paperback, 8 1/2 × 11, 272 pages, $19.95)

Business and Legal Forms for Fine Artists, Revised Edition
by Tad Crawford (paperback, includes CD-ROM, 8 1/2 × 11, 144 pages, $19.95)

Guide to Getting Arts Grants
by Ellen Liberatori (paperback, 6 × 9, 272 pages, $19.95)

The Artist's Complete Health and Safety Guide, Third Edition
by Monona Rossol (6 × 9, 416 pages, paperback, $24.95)

Artists Communities: A Directory of Residences that Offer Time and Space for Creativity
by the Alliance of Artists Communities (6 × 9, 336 pages, $24.95)

Creative Careers in Museums
by Jan E. Burdick (paperback, 6 × 9, 256 pages, $19.95)

Caring for Your Art: A Guide for Artists, Collectors, Galleries and Art Institutions, Third Edition
by Jill Snyder (paperback, 6 × 9, 256 pages, $19.95)

The Fine Artist's Guide to Marketing and Self-Promotion, Revised Edition
by Julius Vitali (paperback, 6 × 9, 256 pages, $19.95)

An Artist's Guide: Making it in New York City
by Daniel Grant (paperback, 6 × 9, 224 pages, $18.95)

To request a free catalog or order books by credit card, call 1-800-491-2808. To see our complete catalog on the World Wide Web, or to order online for a 20 percent discount, you can find us at ***www.allworth.com.***